ART & DESIGN

HITLER'S STATE ARCHITECTURE
The Impact of Classical Antiquity

HITLER'S STATE ARCHITECTURE

The Impact of Classical Antiquity

ALEX SCOBIE

Published for
COLLEGE ART ASSOCIATION
by
The Pennsylvania State University Press
University Park and London
1990

Monographs on the Fine Arts
sponsored by
COLLEGE ART ASSOCIATION
Volume XLV
Editors, Isabelle Hyman and Lucy Freeman Sandler

Figures 49 and 56, from W. L. MacDonald, *The Architecture of the Roman Empire*, vol. 1 (New Haven, 1982), © Yale University Press, are reproduced with permission.

Library of Congress Cataloging-in-Publication Data

Scobie, Alexander.
 Hitler's state architecture : the impact of classical antiquity /
Alex Scobie.

 p. cm.—(Monographs on the fine arts ; 45)
 Includes bibliographical references.
 ISBN 0-271-00691-9
 1. Architecture and state—Germany. 2. National socialism and
architecture. I. Title. II. Series.
NA1068.5.N37S26 1990
720'.1'03—dc20 89-39018

It is the policy of The Pennsylvania State University Press to use acid-free paper for the first printing of all clothbound books. Publications on uncoated stock satisfy the minimum requirements of American National Standard for Information Sciences—Permanence of Paper for Printed Library Materials, ANSI 239.48–1984.

ANNAMARIAE UXORI CARISSIMAE
QUAE ME PER LABYRINTHUM
ROMANUM PERITE PERDUXIT

CONTENTS

LIST OF ILLUSTRATIONS

The photographic sources normally accessible to the historian of Nazi and Fascist architecture are of a generally indifferent or poor quality. This is because original negatives or prints are difficult or impossible to trace. In some cases where original negatives can be traced and access obtained (for example, Fig. 5), deterioration of the negative leads inevitably to a defective print. For this reason, most of the illustrations reproduced in this book derive from photographs originally published in Fascist and Nazi sources.

ACKNOWLEDGMENTS

This book could not have been written without generously given help and advice from many people: Professors Isabelle Hyman and Lucy Sandler, whose editorial guidance and encouragement were a spur to the improvement and completion of this book; the Bayerisches Hauptstaatsarchiv, Munich, and the Staatsarchiv, Nuremberg; Professor Lars Olof Larsson, who read and made encouraging remarks about an early draft of this book; Cäsar Pinnau, who generously supplied me with information about his Thermen planned for Berlin's north-south axis; Luciana Valentini and Valery Scott at the British School at Rome; Amanda Claridge, who gave me the opportunity to spend a sabbatical at the school; Maria Pia Malvezzi, who arranged access to the archives of the Museo della Civiltà Romana at EUR; Pia Scambelluri of the Biblioteca Alessandrina at the University of Rome; and the German Archaeological Institute in Rome, where I was granted access to archival materials.

I am also indebted to many colleagues and staff at Victoria University of Wellington: Mrs. Patricia Murray, the secretary of the Classics Department, who typed several drafts of this book without losing patience; Maria Laws, who typed a revised version of the book under difficult circumstances in Rome; John Casey, Imelda Anderson, and Brett Robertson for expert photographic services; the Reference Department of the University Library, in particular Celia Dunlop for persuading German libraries to interloan books essential for the completion of this book; Hans Karl Opfermann and Mrs. Frances Dienish of the National Library of New Zealand, who permitted me access to the library's archive of Nazi materials before they had been officially accessed; and the Internal Research Committee of Victoria University for generously funding my research activities.

Roman history in broad outline, and correctly understood, is and remains the best instructress, not only for today, but indeed for all periods.
—*Adolf Hitler**

We are not Romans, and the world around us is different from the Mediterranean world. Nevertheless we can learn endless lessons from Roman history.
—*Helmut Berve***

If one thinks of the Greek, one considers that the Roman had bad taste. . . . Rome was concerned with conquering the universe and controlling it. . . . Roman order is a straightforward and precise type of order. If it is brutal, so much the better or worse. The Romans had a deep desire to dominate, to organize.
—*Le Corbusier†*

*"Römische Geschichte in ganz grossen Linien richtig aufgefasst, ist und bleibt die beste Lehrmeisterin nicht nur für heute, sondern wohl für alle Zeiten"; *Mein Kampf,* Munich, 1933, 469–70.

**"Wir sind keine Römer, und die Welt rings um uns ist eine andere als die Mittelmeerwelt. Trotzdem können wir aus der römischen Geschichte unendlich lernen"; "Antike und Nationalsozialistischer Staat," *Vergangenheit und Gegenwart* 24 (1934): 287.

†"Si l'on songe au Grec, on pense que le Romain avait un mauvais goût. . . . Rome s'occupait de conquérir l'univers et de la gérer. . . . L'ordre romain est un ordre simple, catégorique. S'il est brutal, tant pis ou tant mieux. Ils avaient d'immenses désirs de domination, d'organisation"; A. Muñoz, "Le Corbusier parla di urbanistica romana," *L'Urbe* 1, 2 (1936): 29.

INTRODUCTION

Mussolini turned the monuments of Augustan Rome into political symbols partly to validate his own role as the founder of a new Roman empire and partly to rekindle a new spirit of "heroism" in the Italian people.[1] He clearly saw himself as a successor to Roman emperors who aspired to immortality through their beneficence to their subjects.[2] Greek mythology provided the model of Herakles the mortal hero, who after performing arduous labors in the service of mankind was admitted to Olympus through a fiery apotheosis. Augustus followed Romulus and became a god after his death,[3] an appropriate reward for Rome's first and second founders. After Augustus, however, deification tended to be regarded by many as a less than serious matter. The seeds of cynicism had been sown when Augustus's ambitious wife paid a witness of her husband's transit from his funeral pyre to heaven a very large sum of money.[4] Later an emperor could quip about his predecessor: *Sit divus dum non sit vivus* ("Let him be a god, provided he's dead").[5]

To some, the emperor's residence on the Palatine already symbolized and prefigured its occupant's future divinity.[6] After the advent of the emperor Domitian (A.D. 81–96), there could no longer be any doubt about the emperor's divine aspirations. Augustan prudence had evaporated. Now it was time for the rule of a man who styled himself *dominus et deus* ("master and god") and who did not shrink from associating himself with

1. For a detailed examination of the relationship between Augustus and the Fascist regime, see Mariella Cagnetta, "Il mito di Augusto e la 'rivoluzione' fascista," *Quaderni di Storia* 2 (1976): 139–81.

2. A. R. Anderson, "Hercules and His Successors," *Harvard Studies in Classical Philology* 39 (1920): 7–58; R. Syme, *The Roman Revolution*, Oxford, 1939, 472; M. Jaczynowska, "Le culte de l'Hercule romain au temps du Haut Empire," in *Aufstieg und Niedergang der römischen Welt*, 2.17.2, Berlin, 1981, 631–61.

3. Mussolini's aspirations are clearly represented by P. Morbiducci in his relief sculpture *La storia di Roma attraverso le opere edilizie* at the entrance of the Palazzo degli Uffici at EUR. The historical cavalcade begins with a depiction of Romulus and Remus in the top left-hand corner of the relief and ends with Mussolini

helmeted and on horseback. The Duce's face is the only part of the relief that has suffered mild modification at the hands of vandals; M. Calvesi, E. Guidoni, S. Lux, eds., *E42 Utopia e scenario del regime: Urbanistica, architettura, arte e decorazione*, Venice, 1987, 309. For a similar historical cavalcade in mosaic depicting Roman history from Evander to Mussolini, see A. Libera, "I mosaici del Palazzo dei Ricevimenti all'E42," *Civiltà* 2.5 (1941): 11–16.

4. Suetonius, *Divus Augustus* 100. Dio Cassius 56.46 reports that Livia paid the witness, Numerius Atticus, one million sesterces for swearing he had seen Augustus ascending to heaven. Cynicism about apotheosis set in very quickly; see Seneca, *Apocolocyntosis* 1.2.

5. Scriptores Historiae Augustae, *Geta*, 2.8.

6. Ovid, *Metamorphoses* I, 176.

Jupiter *tonans* ("the thunderer"). The Palatine and the palace, now monopolizing virtually its entire summit, had become Olympus.[7] Absolute power was now revealed unambiguously in absolute architecture, which provided the emperor and his successors with a stage set for intimidating rituals of encounter between mortal subjects and their divine ruler. Imperial megalomania had been translated by Nero into palatial extravagance in the form of his "Golden House," but its associations with its tyrannical, if artistic, owner had guaranteed its destruction by the Flavian dynasty. Domitian's residence was on a more appropriate site and more compact. It endured in fact to the end of the Western Empire.

Mussolini saw himself as a successor and reviver of Roman imperial grandeur. Hercules once more became a theme of officially sponsored regime art. A gigantic new forum planned for the center of Rome was to have been graced by a colossal bronze statue representing Mussolini as Hercules. The forum was never built. When the bronze for a foot had been poured, the project for the statue was abandoned. Hercules was too expensive.[8] Nor did any apotheosis follow Mussolini's summary execution before a firing squad of Communist partisans. Nor did the Duce build himself any grandiose palaces in the tradition of Nero or Domitian. His office, the Sala del Mappamondo in the Palazzo Venezia, was vast and intimidating enough. The fact that this building had once belonged to Austria and that it was situated in the heart of Rome's most venerated historical center conferred sufficient prestige on Mussolini, who delivered more than sixty discourses from its balcony overlooking the Piazza Venezia.[9] Plans for building a vast headquarters for the Fascist party opposite the Basilica of Maxentius and adjacent to the Colosseum came to nothing. Eventually, after the rejection of yet another site near the Porta San Paolo, the Casa Littoria was built as the centerpiece of Foro Mussolini. The Duce's office was situated on the first floor and centrally situated in the front of the building. The ceiling rose to the level of the second floor to signal its occupant's importance and stature.[10]

Hitler, too, admired imperial Rome and its efficient militarism, which enabled it to conquer the world. Above all he admired the state architecture of Rome itself, a world capital furnished with monuments that bore everlasting witness to Rome's power and achievements. He could identify himself and his political ideology with Roman models. He admired the Roman obsession for order, discipline, and a clearly defined social and political hierarchy spearheaded by an autocrat endowed with an almost divine authority. Berlin, destined under Hitler to become the capital of a world empire, was to be embellished with

7. W. L. MacDonald, *The Architecture of the Roman Empire*, New Haven, 1982, i, 56. See also page 98 below.

8. D. M. Smith, *Mussolini*, London, 1981, 137. A marble statue of Hercules stands at the entrance of Stadio Mussolini (Stadio dei marmi) at Foro Mussolini (Italico) today. See too the sketch by A. Funi, "Ercole che lotta con il leone Nemeo," intended as part of a series of frescoes to decorate the "atrio" of the Congress Hall at EUR; M. Calvesi, S. Lux, eds., *Utopia e scenario del regime*, Venice, 1987, ii, 248, pl. 3.

9. Mussolini moved into the Palazzo Venezia on 16 September 1929. The building had been confiscated by Italy from Austria on 28 May 1916. In a sense, then, Mussolini's seat of power was situated in a victory monument. For an excellent account, see I. Insolera, F. Perego, *Archeologia e città. Storia moderna dei fori di Roma*, Rome and Bari, 1983, 66–76.

10. "Il progetto definitivo della Casa Littoria a Roma," *Architettura* 16 (1937): 699–753. The building today houses the Italian Ministry of Foreign Affairs.

state buildings that in their dimensions and significance would surpass the monuments of the capital of the Roman Empire. Hitler, who expressed the wish to find Caesar or Augustus in the Olympus he hoped to enter,[11] did not openly identify himself with Herakles, though the classicist Joseph Vogt pointed out in an article dealing with antiquity and its relevance to Nazi Germany that Herakles was an appropriate mythological model for the Nazi hero in the service of the community (im Dienst der Gemeinschaft).[12] That Hitler anticipated a posthumous personal cult is clear from his plan to build a mausoleum in the shape of Hadrian's Pantheon in Munich, the cradle of the Nazi party, to whose headquarters the mausoleum was to be attached.[13] But the Führer's effigy was not seen ascending to Olympus after his corpse was unceremoniously cremated in the shell-pocked garden of the Berlin Chancellery. Like Nero and Domitian, Hitler thought he deserved a better residence in his capital than had been occupied by previous heads of state. He too felt the need for impressive architectural scenography to disorient other heads of state and their representatives. His chief architect, Albert Speer, accordingly obliged by building the new Chancellery in Berlin (1938) and by planning a huge Führerpalais that was to be twice the size of Nero's "Golden House." To it, attached by a cryptoporticus, was a vast dynastic temple, a gigantic inflation of Hadrian's Pantheon, where, in the manner of a Hellenistic ruler, Hitler and his successors would be venerated by future generations of grateful Germans.[14] The religious as well as the architectural links with the ancient world were here blatantly obvious. The hoped-for disappearance of Christianity in Nazi Germany would have made way for the new pagan cults of Nazi heroes and leaders—a return of emperor worship almost as the Romans had known it. In this sphere Mussolini was no competitor, since the Fascists in Italy had no comparable plans for the destruction of the Church: Mussolini might be a Hercules *redivivus*, but he could not be God.

Architects and town planners in Fascist Italy deliberately and directly revived typical features of Roman imperial architecture and town planning to emphasize a continuity of tradition between the ancient Roman and modern Fascist empires. Accordingly, new towns in Italy, such as Littoria (Latina; 1932) or L'Esposizione Universale di Roma (EUR) (1937), and plans for reshaped towns outside Italy, such as Addis Ababa,[15] recalled the orthogonal plan of a typical ancient Roman town with a forum placed at the meeting point of its north-south (*cardo*) and east-west (*decumanus*) axial roads. The point where these two axes intersected was sometimes marked by a *mundus*, or stone sphere, reminiscent of the "navel" of the city of Rome (*umbilicus urbis*), or *mundus*, systematized in the Forum Romanum by Augustus.[16]

Arches, columns, pillars, exedrae, domes, and the use of "noble" materials such as

11. J. C. Fest, *Hitler*, London, 1973, 532. Fest also reports Hitler as saying he would rather be a dead Achilles than a living dog (749).

12. "Unsere Stellung zur Antike," *110. Jahresbericht der schlesischen Gesellschaft für vaterländische Cultur*, 1937, Geisteswissenschaftliche Reihe, no. 3, 7f.

13. See page 117.

14. See pages 109–13.

15. A. Boralevi, "Le 'città dell'impero': Urbanistica fascista in Etiopia," in A. Mioni, ed., *Urbanistica fascista*, Milan, 1986, 254–64.

16. P. Verduchi, "Lavori ai rostri del Foro Romano: L'esempio dell' umbilicus," *Rendiconti della Pontificia Accademia Romana di Archeologia* 55/56 (1982–84): 329–40.

marble, granite, or travertine helped to establish stylistic links between the architecture of Mussolini's Italy and the buildings of the Roman imperial past. The lavish use of statuary for the decoration of representative structures such as Stadio Mussolini at Foro Mussolini (Italico), or the Palazzo della Civiltà Italiana at EUR, also recalled Roman imperial precedents. The imperial Roman predilection for the axial emphasis of buildings of political and religious importance, as well as a liking for bilateral symmetry, was also reflected in Fascist town plans and buildings. The art of mosaic work was revived on a grand scale as a vehicle for political emblems and slogans in both open and closed spaces. The vast expanse (5,000m²) of black and white mosaic pavements at Foro Mussolini illustrates how this medium was employed not just to establish a link with ancient Rome but to hammer home messages fundamental to the ideology of the Fascist regime. Inscriptions in *litterae quadratae* once more appeared on the architraves of many regime buildings: "The Third Rome will spread over other hills along the banks of the sacred river to the shores of the world."[17] So reads the inscription on the architrave of the colonnade of the Office Building (Uffici) at EUR. Thus Fascist architecture and decorative art combined to form a mass medium. Public buildings partly functioned as billboards on which to hang political slogans or artwork intended to influence public thinking about Fascist aims and ideology. Ancient Roman *opera publica* had also been used in similar ways to advertise the real or illusory achievements of Rome's leaders.[18] In every respect, then, regime buildings of the Fascist period revived Roman architectural traditions to bolster a determination to "win back" a lost empire and regain national self-respect. The Roman *imperium* began "to breathe again," as Hitler phrased it.[19]

Nearly all the features of Fascist architecture and town planning mentioned above are also characteristic of state architecture and planning in Nazi Germany, a country with no native traditions based on *romanità,* though Roman towns had flourished on its southern borders, for example, Cologne, Augsburg, and Trier, an imperial residence in Late Antiquity. Hitler, unlike the Nazi party's ideologue Alfred Rosenberg, had little time for German prehistory and tribal society. He admired Arminius, who in A.D. 9 slaughtered three of Augustus's legions in the Teutoburgerwald, both as a national leader (*Volksführer*) and as an architect of German unity, albeit transitory, but he considered credit had to be given to the Romans for teaching the tribal Germans the art of disciplined warfare.

Greek architecture, particularly the "Doric" style, received some publicity at the time the Nazis reshaped Königsplatz in Munich (1933–37) and also at the time preparations

17. La terza Roma si dilaterà sopra altri colli lungo le rive del fiume sacro sino alle spiagge del terreno." Inscriptions were also lavishly used on the buildings of Rome's new university; see S. D. Squarzina, "Architettura come servizio, come linguaggio, come propaganda," in *1935/1985 "La Sapienza" nella città universitaria*, Rome, 1985, 59–61, for the artistic sources of Fascist epigraphy; cf. D. Ghirardo, "Politics of a Masterpiece," *Art Bulletin* 62 (1982): 469. For Nazi views on monumental inscriptions, see P. Renner, "Die monumentale Inschrift," *Die Kunst*

im Deutschen Reich 8 (1944): 62–88 (Pantheon architrave, 66; for *Res Gestae*, 86–88).

18. See W. L. MacDonald, *The Architecture of the Roman Empire*, New Haven, 1986, II, 19. For a survey of the role of propaganda in Roman art, see N. Hannestad, *Roman Art and Imperial Policy*, Aarhus: Aarhus University Press, 1986. R. Brilliant, "Roman Art and Roman Imperial Policy," *Journal of Roman Archaeology* 1 (1988): 110–14.

19. See page 93.

were being made for the Berlin Olympic games (1936), but Hitler was far more interested in Roman imperial architecture, which symbolized the power and authority of a people who dominated the ancient world for centuries, a worthy model for his own plans for a thousand-year Reich. Even architect Werner March's Olympic sports complex in Berlin, the Reichssportfeld, bore little resemblance to its ancient counterpart at Olympia; in its overall spatial arrangement it resembled Trajan's Forum.[20] Art for art's sake appealed no more to Hitler than it did to Roman rulers, whose state art and architecture was primarily political. Every artifact was to breathe the spirit of domination and the glorification of the regime.

The Italian architect Plinio Marconi, the author of one of very few articles on Nazi state architecture to appear in an Italian Fascist architecture journal,[21] commented generally that the Nazis poured scorn on "functional rationalism not only because it was international" and "Jewish" but also because it was "Mediterranean." Such terms and concepts, Marconi noted, were confusing. He also pointed out that, lacking ancient indigenous German architecture as a source of inspiration for their buildings, the Nazis tried to evoke the architecture of their presumed Indo-European ancestors. But, as this too was not possible, they fixed their attention on the structures realized by "the blond Doric conquerors of Greece."

"The thesis . . . that all western civilisation is of Indo-Germanic origin is disputed," Marconi continues, "and even if it were true, the fact that the talent of these hypothetical Nordic conquerors was acquired after contact with Mediterranean civilisation, does not count for the enraged theoreticians of race, for whom a drop of blood matters more than anything. This is the reason for the rediscovery in Greek architecture of the precedent typical of the new German architecture. . . . Hence at Munich the almost completed Königsplatz in a style close to Neo-Doric."[22] Marconi then remarks, as Rodenwaldt was to note a year later, that March had taken the road to Rome, not to Greece, for the inspiration for the design of the Berlin Reichssportfeld. It is worth remarking that Marconi saw in March's sports complex the influence of the new (Fascist) university buildings in Rome (1932–35), in particular that of its monumental propylaeum at the entrance to the Berlin sports forum.[23]

The question raised by Marconi in his article is an interesting one: To what extent, if any, were Hitler's architects, Paul Ludwig Troost, Albert Speer, and Hermann Giesler, influenced by architecture and town planning in Fascist Italy? This question has hardly

20. As G. Rodenwaldt was to remark; see page 34.

21. "Il foro sportivo Germanico a Berlino," *Architettura* 15 (1936): 465–86.

22. "La tesi . . . della derivazione Indo-Germanica di tutta la civiltà occidentale non è certo universalmente accettabile . . . ma, anche se essa fosse vera, il fatto che l'ingegno di cotesti ipotetici conquistatori nordici si sia acceso proprio a contatto della civiltà mediterranea non conta per gli accaniti teorici della razza, per i quali una goccia di sangue val più di tutto.

Ecco dunque riscoperto nell' architettura ellenica il precedente tipico per la nuova architettura tedesca; . . . ecco a Monaco già sorgere, a completamento della Königs Platz, in stile all' incirca neo-dorico, la Führerhaus, il Verwaltungsgebaude e, dietro, gli edifici della Karolinen Platz"; ibid., 477.

23. ". . . se non erriamo, alcuni accenti della Città Universitaria Mussoliniana e specialmente del suo Ingresso echeggiano nel portico circuente lo Stadio Olimpionico e nella Langemarckhalle"; ibid., 478.

been addressed by any architectural historian as yet, but a start will be made in this book to identify and confront some of the interrelationships between the state architecture of the two totalitarian regimes. Speer's town plan for the new Berlin and Giesler's plan for the reshaping of Munich's center both resembled the "Roman" plan already realized in Fascist new towns such as Littoria and EUR. Plans to systematize the chaotic center of Rome were published and discussed by Marcello Piacentini in 1925 in the first volume of the Fascist journal *Capitolium*, [24] and more ambitious plans showing a *cardo* and *decumanus* were published in *Architettura e Arti Decorative* in 1929–30. [25]

When the Italian architect Luigi Lenzi visited Berlin in 1938 to collect material for his article "Architettura del III Reich," published in 1939 in *Architettura*, he immediately labeled Speer's new north-south and east-west axes for Berlin "il cardo e il decumano," [26] these being the familiar terms for an Italian architect of the period. However, Lenzi stops short of saying that Speer's new plan was derived from Fascist town plans. Again, on 20 June 1940, the Italian ambassador in Berlin was invited by Speer to visit his studio in order to be briefed about the plans for the restructuring of the center of Berlin. After the ambassador inspected Speer's plans and models and commented on the "Roman" character of most of the buildings, Speer said that "he and his collaborators had learned how to build in a more Roman manner than the Romans themselves." [27] There are also close resemblances between the typical Nazi platz and the Fascist piazza. Both were situated at the center of a town at the junction of its *cardo* and *decumanus*. The Volkshalle, the culmination point of the main axis of the platz, corresponded to the Casa Littoria, the headquarters of the Fascist party. Both platz and piazza usually had a clocktower, perhaps a reflection of the campanile tradition. Because of the chronological priority of the Fascist plans, it is clear that they owe nothing to their Nazi equivalents. But despite the close and numerous coincidences between the town plans and buildings of the two totalitarian regimes, it is not impossible that two similar political systems should produce similar architectural configurations that reflect such central concepts as the supremacy of state and party. Hitler's admiration for imperial Rome and its state buildings, in combination with his personal interest in and direction of the work of his architects, could account for many similarities between Nazi and Fascist state architecture.

Fascist architects, to judge from the literature of the time, seem to have been generally unaware of state buildings in Nazi Germany, or if they were, they expressed little admira-

24. "La grande Roma," 418f.

25. L. Piccinato, "Il momento urbanistico alla Prima Mostra Nazionale dei Piani Regolatori," *Architettura e Arti Decorative* 9 (1929/30): 195–235, especially 220–27.

26. Page 474: "Il 'cardo' e il 'decumano' nella capitale della Germania assumono respettivamente il nome di asse Nord-Sud e asse Est-Ovest."

27. ". . . mi rispose che egli e i suoi collaboratori avevano appreso a construire più romanamente dei romani stessi." R. Mariani, *Fascismo e "città nuove,"* Milan, 1976, 235. In a personal letter to Luciano Canfora dated

15 July 1976 Speer denied that Roman state architecture had influenced him in a direct manner (es kann kaum die Rede davon sein, dass wir in direkter Weise die römische Staatsarchitektur kopiert haben). However, Rudolf Wolters, Speer's lifelong friend, denies Speer's claim in a separate letter to Canfora dated 20 August 1976, in which he stresses the importance of German archaeologists such as Rodenwaldt and Rave as mediators between classical (Roman) archaeology and the architectural plans of the Third Reich; L. Canfora, *Ideologie del classicismo*, Turin, 1980, 143–44.

tion for them. Lenzi confessed his own ignorance of the subject despite the fact that he was acquainted "with almost all the architectural publications of the Reich."[28] Piacentini, who wrote a short preface to Lenzi's article, had already remarked elsewhere that Italian architects had their own ancient traditions in architecture as the basis for their modern architecture, which he saw as a combination of the spirit of imperial Roman architecture with modern building techniques and materials.[29] He also noted the military nature of the Reich's new state architecture: its emphasis on discipline and order, and a consequent lack of *finezza*.[30]

The aim of this book is to suggest how two authoritarian regimes led by dictators with an undisguised admiration for the autocratic political and social systems of imperial Rome translated political power into architectural forms that facilitated the realization of political objectives dictated by their respective leaders. Specific Greek or (more frequently) Roman state buildings, or building types, and town plans are identified as models selected by Hitler's architects to satisfy their patron's political wishes.

28. *Architettura* 18 (1939): 473.

29. ". . . tutta la nostra architettura antica esprime mirabilmente il senso di imperio della romanità. Quando il fatto spirituale coincide con i trovati tecnici, allora nasce in architettura il grande stile," A. Muñoz, "Mar-

cello Piacentini parla di Roma e di architettura," *L'Urbe* 2.5 (1937): 27.

30. "Premessa e carattere dell' architettura attuale tedesca," *Architettura* 18 (1939): 468.

I

MUSSOLINI, HITLER, AND CLASSICAL ANTIQUITY

On 31 December 1925 in the Hall of the Horatii and Curiatii in the Campidoglio, Mussolini delivered a brief speech, "La Nuova Roma," as part of the installation ceremony of Rome's first Fascist governor, Filippo Cremonesi. After mentioning improvements in Rome's housing, roads, and sanitation, the Duce continued:

> My ideas are clear, my orders are exact, and certain to become a concrete reality. Within five years Rome must strike all the nations of the world as a source of wonder: huge, well organized, powerful, as it was at the time of the Augustan Empire. You will continue to free the trunk of the great oak from everything that still clutters it. You will create spaces around the Theater of Marcellus, the Capitol, the Pantheon. Everything that has grown up around these buildings during centuries of decadence must be removed. Within five years the mass of the Pantheon must be visible from the Piazza Colonna through a large space. You will also free from parasitic and profane architectural accretions the majestic temples of Christian Rome. The millenniary monuments of our history must loom larger in requisite isolation.[1]

1. "Le mie idee sono chiare, i miei ordini sono precisi e sono certo che diventeranno una realtà concreta. Tra cinque anni Roma deve apparire meravigliosa a tutte le genti del mondo; vasta, ordinata, potente, come fu ai tempi del primo impero di Augusto. Voi continuerete a liberare il tronco della grande quercia da tutto ciò che ancora la intralcia. Farete dei varchi intorno al teatro Marcello, al Campidoglio, al Pantheon; tutto ciò che vi crebbe attorno nei secoli della decadenza deve scomparire. Entro cinque anni, da Piazza Colonna per un

As is clear from the above bombastic extract, it was not the glory of Republican Rome Mussolini and the Fascists strove to evoke, but the Rome of Augustus, the second founder of the *patria* and shrewd architect of a political system that effectively concentrated all executive political power in the hands of one man, who fostered the belief that he was first among equals (the Principate). Grandiose parallels were drawn between the Duce and Augustus, most notably by Giuseppe Bottai, Governor of Rome (1935–37),[2] in his *L'Italia d'Augusto e l'Italia d'oggi*, the first monograph in a series entitled "Quaderni Augustei," published by the Istituto di Studi Romani to mark the bimillennial of the emperor's birth, which was celebrated with great pomp in Rome between September 1937 and September 1938. A similar work by E. Balbo, *Protagonisti dell'impero di Roma, Augusto e Mussolini*, written in 1937 and published in 1941, aimed to establish striking resemblances between Augustus and the Duce,[3] even to the extent of equating Augustus's Spanish campaign with Mussolini's support of Franco in the Spanish Civil War.[4]

As a result of Mussolini's infatuation with the Augustan Age, the ancient monuments that received most attention as potential political symbols validating the Duce's own aspirations were: the Forum of Augustus (excavations begun in 1924), the Ara Pacis, and Augustus's Mausoleum,[5] which since 1909 had been buried beneath a concert hall ("Augusteo") used by the Fascist party for meetings in 1921 and 1925, when Mussolini confidently predicted the triumphant resurgence of Roman imperialism.[6] In the following year the excavation of the site was initiated under the supervision of Giulio Quirino Giglioli, who, according to Spiro Kostof, "conceived of a vast all-inclusive exhibition of

grande varco deve essere visibile la mole del Pantheon. Voi libererete anche dalle construzioni parassitarie e profane i templi maestosi della Roma cristiana. I monumenti millenari della nostra storia debbono giganteggiare nella necessaria solitudine"; Benito Mussolini, *Scritti e discorsi*, definitive edition, writings, and discourses from 1925 to 1926, Milan, 1926, V, 244–45; a plan of mass destruction worked out by the group "La Burbera" to clear these ancient monuments was never fully realized; M. de Michelis, "Faschistische Architekturen," in H. Frank, ed, *Faschistische Architekturen*, Hamburg, 1985, 27. However, more than seventeen churches and many other buildings were destroyed to "liberate" such ancient sites as the Capitol, the mausoleum and forum of Augustus, the Theater of Marcellus, and the Colosseum, and hundreds of people, made homeless by the Fascist mania for reviving the spirit of imperial Rome by politicizing its monuments, were rehoused in places remote from the center of Rome (e.g., Acilia); see A. Cederna, *Mussolini urbanista*, Rome and Bari, 1981, 5–45, for an excellent discussion.

2. R. C. Fried, *Planning the Eternal City*, New Haven, 1973, 30; cf. A. J. De Grand, *Bottai e la cultura fascista*, Bari, 1978.

3. S. Kostof, "The Emperor and the Duce: The Planning of Piazzale Augusto Imperatore at Rome," in H. A. Millon, Linda Nochlin, eds., *Art and Architecture in the Service of Politics*, Cambridge (Mass.), 1978, 302. For a review of Italian and foreign books published on Augustus, see M. Pallottino, "Profili di Augusto," *Roma* 18 (1940): 168–78. See M. Cagnetta, "Il mito di Augusto," *Quaderni di Storia* 2 (1976): 151–54, for literature on Augustus published at this time (1937–38). For Mussolini and Augustus in Fascist comics, see C. Carabba, *Il fascismo a fumetti*, Rimini, 1973, 45.

4. As part of the bimillenniary celebrations, Mussolini donated a bronze copy of the Prima Porta statue of Augustus to the town of Zaragoza (Caesaraugusta) so that its citizens might have a visible reminder of their founder; "La Semana Santa de Zaragoza," *Emerita* 7 (1939): 195–98.

5. The largest of Augustus's buildings, begun when he was only thirty-one or thirty-two years old. According to K. Kraft, "Der Sinn des Mausoleums des Augustus," *Historia* 16 (1967): 200, this structure was intended to give Romans visible proof that the *princeps*, unlike Antony, intended to live and die in the capital of the empire.

6. Kostof, 284f., 287.

Roman antiquity to coincide with the bimillennial. . . . the Mostra Augustea della Romanità [which] was not intended as a scholarly exhibition, but as one of propaganda."[7]

The reassembled Ara Pacis was housed in 1938 (inaugurated on 23 September) in a new structure facing the Tiber and next to the mausoleum. A copy of the emperor's personal account of his own achievements, the *Res Gestae*, was housed in the same building.[8] Thus the Piazzale Augusto Imperatore became a Fascist shrine where celebratory ancient monuments carefully restored and, in the case of the altar, resited became symbols of authority for the new Fascist *imperium Romanum*, which under the Duce was "legitimately" to reclaim the Mediterranean (*mare nostrum*).

Just as Rome's ancient monuments were to assume a new political validity, so, in Henry Millon's view, the contemporary architecture of the regime was to be a blend of new and old "that would both demonstrate continuity with the past and provide adequate, permanent evidence of the imperial glories of the present."[9] In Rome a group of "moderates" led by the architect Marcello Piacentini sought to synthesize traditional Roman types of structure and decoration, and by a process of simplification (for example, columns and pillars without traditional capitals) make these buildings "modern," but not so modern as to create a visible discontinuity with the Latin past.[10]

Opinions on the degree of success likely to be achieved by such architectural aims varied as much as the buildings designed by Fascist architects. Le Corbusier, interviewed in 1936 for readers of the Fascist journal *L'Urbe*, asserted that the links between the (Fascist) present and the (Roman) past that Italian architects like Piacentini were trying to forge could not be achieved: "Between the ancient and the new there is a distance, a breach. . . . Bury the past and life resumes; the past cannot be continued. As for urbanism, it is a chimera to wish to reconnect oneself with the past; . . . every archaeological imitation is a profanation of ancient objects."[11]

A year later the same journal published an interview between the planner Antonio Muñoz and Piacentini concerning the city of Rome and its architecture. Piacentini accused Le Corbusier of being "too much of a machine" and a "fanatical Lutheran" who saw nothing but technical facts. Piacentini claimed that new buildings in Rome should

7. Kostof, 295.

8. Kostof, 304. Paul Bonatz, an architect who accepted many commissions from Nazi patrons, visited the temple of Augustus in Ankara, where the complete text of the *Res Gestae* had been found. He remarks that it is a notable piece of propaganda from which even Goebbels could have benefited. ("Es ist eine bemerkenswerte Propagandainschrift in fünfunddreissig Paragraphen, von der sogar Goebbels noch hätte lernen können.") *Leben und Bauen*, Stuttgart, 1950, 208.

9. H. Millon, "The Role of History of Architecture in Fascist Italy," *Journal of the Society of Architectural Historians* 29 (1965): 54.

10. For an elaboration of these points, see Diane Y.

Ghirardo, "Italian Architects and Fascist Politics: An Evaluation of the Rationalists' Role in Regime Building," *Journal of the Society of Architectural Historians* 39 (1980): 112, 114

11. "Tra l'antico e il nuovo c'è un distacco, una rottura; . . . Seppellite il passato e la vita riprende; non ci può essere continuazione. In materia d'urbanesimo è una chimera volersi ricollegare col passato; tout imitation archéologique est une profanation des choses anciennes." A. Muñoz, "Le Corbusier parla di urbanistica Romana," *L'Urbe* 1.2 (1936): 34, 36. Cf. G. Pagano, "Alla richerca dell' Italianità" (1937), in C. de Seta, ed., *Giuseppe Pagano, Architettura e città durante il Fascismo*, Bari, 1976, 65–70.

not be too modern lest they not harmonize with their surroundings: "We Italians are artists, and we have no difficulty in knowing how to adapt and mold ourselves to the ancient. . . . We should not be frightened by the new style. . . . the Romans took their architecture from the Greeks and adapted it to Latin taste."[12]

The tension between the modern and the ancient (*romanità, latinità*) inherent in the Fascist concept of architectural continuity, and evident in so many buildings of this period, was never resolved to the satisfaction of all the architects who participated in such important building programs as L'Esposizione Universale di Roma (EUR). For example, Giuseppe Pagano criticized Piacentini's work at EUR as being Neronian scenography, and called him a "jumped-up Vitruvius" who caused architectural good taste to commit "harakiri on the altar of the grossest exhibitionism." "Would it not have been better," he continues, "to rebuild Pompeii, Herculaneum, or the Roman Forum with all their archaeological apparatus rather than to bear witness to them in this sterile academic exercise?"[13] The materials employed by Fascist architects in their state buildings varied greatly, since there was no ideological taboo placed on the use of glass, concrete, and steel. In fact, Mussolini liked to refer to Fascism as a "house of glass" (una casa di vetro),[14] so that glass and concrete buildings in Fascist Italy demonstrated the transparency of the Fascist idea. These concepts were incorporated into Giuseppe Terragni's plan for the Casa del Fascio at Como (1932–36), which combined modern building substances (glass, ferroconcrete) with traditional materials (marble). Another example of such a combination of modern and traditional materials is provided by Terragni's Danteum (1938) in Rome, the "Paradise Room" of which was to incorporate glass columns.[15]

The case was otherwise with Hitler's state architecture after Speer's "law of ruin value" had won the Führer's official approval.[16] In Germany where the modernist movement in architecture preceded Nazism, Bauhaus architecture was not approved, though as will be seen, its influences were not entirely absent either from the buildings Troost erected for

12. "Le Corbusier è troppo macchina, è un luterano fanatico che non vede che il fatto technico. . . . Noi italiani siamo artisti, e sappiamo facilmente plasmarci e adattarci all'antico. . . . Non bisogna aver paura del nuovo stile . . . i romani presero la loro architettura dai greci, e la adattarono al gusto latino." A. Muñoz, "Marcello Piacentini parla di Roma e di architettura," *L'Urbe* 2.8 (1937): 25f. For Fascism and classicism in general, see C. de Seta, *La cultura architettonica in Italia tra le due guerre*, Bari, 1983, 331 n. 86.

13. "Piacentini . . . riesce a 'monumentalizzare' la futura esposizione di Roma da far gola al più forzanesco scenografo del Nerone. Nelle mani di questo artificiale Vitruvio. . . . Buon gusto . . . onestà costruttiva hanno fatto karakiri sull'altare del più grottesco esibizionismo. . . . Non sarebbe stato meglio ricostruire Pompei, Ercolano o il Foro di Roma con tutto il loro apparato archeologico piuttosto che intestarci in questa sterile

esercitazione accademica?" I. Insolera, L. di Majo, *L'EUR e Roma dagli anni Trenta al Duemila*, Rome and Bari, 1986, 52.

14. See C. de Seta, *La cultura architettonica in Italia tra le due guerre*, 234.

15. H. Frank, ed., *Faschistische Architekturen*, 35, 131f. C. Magi-Spinetti, "Tradizione e autarchia nel materiale edilizio," *Capitolium* 15 (1940): 575–78; G. Pagano, "Potenza del marmo," *Casabella* 110 (1937): 6–10; M. M. Cianetti, "L'uso dei materiali costruttivi nella realizzazione delle opere per L'E42," in M. Calvesi, E. Guidoni, S. Lux, eds., *Utopia e scenario del regime*, Venice, 1987, II, 168–75.

16. See Barbara Miller Lane, *Architecture and Politics in Germany, 1918–1945*, Cambridge (Mass.), 1968, 163; on the issue of "stone instead of iron" (Stein statt Eisen) as a reflection of Semper's attitude toward the use of iron in buildings, see pages 93–96 below.

Hitler in Munich or from those Speer designed for Nuremberg.[17] In Italy, on the other hand, where Fascism preceded the modernist movement, there was no official ban on the use of modern materials in state buildings. In this sense, as Diane Ghirardo has pointed out, state architecture in Mussolini's Italy was less reactionary than Hitler's architecture in Nazi Germany,[18] where, unlike Italy, modernist architecture was not accepted as a child of the Nazi revolution. It was much rather a victim of this revolution, as the careers of some Bauhaus architects show.[19] And yet a book written for propaganda purposes on Nazi architecture, and aimed at American readers, shows that this rejection of modern architecture was not absolute. In one breath it condemns architects of the "International Style" for "producing an architecture fit only for the robot," and a few pages later it is observed in connection with Troost's House of German Art in Munich that "contemporary German Classicism is no mere imitation of the temple motif, it has made a harmonious correlation between Hellenic serenity and the austere simplicity of modern functional architecture."[20]

Hitler's attitude toward classical antiquity was more complex and ambivalent than Mussolini's political infatuation with Augustan *romanità* and his lack of concern for ancient Greece.[21] Hitler, however, regarded the ancient Greeks as "Nordics," and as the racial ancestors of the Germans: "When people enquire about our ancestors, we must always point to the (ancient) Greeks."[22] This view was expounded at great length by the

17. See page 58 below; cf. now Barbara Miller Lane, "Architects in Power Politics and Ideology in the Work of E. May and A. Speer," *Journal of Interdisciplinary History* 17 (1986): 299–300, G. Fehl, "Die Moderne unterm Hakenkreuz," in Frank, ed., *Faschistische Architekturen*, 88–122.

18. Ghirardo, "Italian Architects," 119f.; L. O. Larsson, "Classicism in the Architecture of the Twentieth Century," in L. Krier, ed., *Albert Speer. Architecture 1932–1942*, Brussels, 1985, 233f.

19. After 1933 few commissions were received by architects of the Bauhaus. Walter Gropius and others emigrated from Germany soon after this date; Barbara Miller Lane, *Architecture and Politics*, 162f., 165f., 184; in July 1933 Rosenberg proclaimed the rejection of modernist architecture; Larsson, "Classicism," 239.

20. *A Nation Builds: Contemporary German Architecture*, German Library of Information; New York, n.d., 15, 18; Speer also admits to having been influenced by his professor at the Berlin Institute of Technology, Heinrich Tessenow, who belonged to the "Ring" school, which counted Gropius and Mies van der Rohe among its members; Albert Speer, Playboy Interview, *Playboy*, June 1971, 76. This interview (69–96, 168, 190–203) contains valuable material overlooked by most students of Speer, except Giesler, who gives it his close critical scrutiny in his much neglected *Ein anderer Hitler: Bericht*

seines Architekten, 5th ed., Leoni, 1982, 318–29. Giesler's book deserves to be translated into English, since, although its admiring attitude toward Hitler is offensive, it contains valuable information about Hitler's views on architecture and Giesler's own projects for Hitler, which his archrival Speer says almost nothing about in his memoirs.

21. Mussolini's cultivation of Roman ruins as Fascist imperial stage sets obscured his earlier hatred of archaeological ruins and monuments. He also hated tourists, especially Germans, "armed with the most helpful Baedeker," who swarmed over Italy. A. Cederna, *Mussolini urbanista*, Rome and Bari, 1980, 24, traces this hatred to the early influence of the Futurists, who scorned an Italy that serviced the curiosity of foreign tourists. Thus Marinetti refers to Florence, Venice, and Rome as "the three purulent sores of our peninsula." The *Mostra Augustea*, which opened in September 1937 in the Palazzo delle Esposizioni, was intended by its creator, Giglioli, as a well-timed advertisement for Roman architecture, "too ignored and abused by fanatics of Greek and oriental art"; "La Mostra Augustea della Romanità," *Palladio*, 1 (1937): 203. For a full discussion of the *Mostra*, see page 28 below.

22. "Wenn man uns nach unseren Vorfahren fragt, müssen wir immer auf die Griechen hinweisen"; H. Picker, *Hitlers Tischgespräche im Führerhauptquartier,*

Nazi chief ideologue on racial matters, Alfred Rosenberg,[23] an architect who sat his final qualifying examinations in Moscow.[24] Of all the Greeks, the Spartans were singled out for particular praise. Hitler especially admired the way Spartans as "Herrenvolk" mastered thousands of subservient Helots. Sparta was also the clearest example in history of a city-state based on race.[25] The domination and exploitation of a "racially inferior" indigenous population by a disciplined and ruthless group of "racially superior" masters provided Hitler with an ideological model for the state he envisaged for his own Reich and its annexed territories. Similarities between Sparta and Hitler's state were quickly drawn by classicists receptive to the Nazi point of view. Walter Eberhardt, for example, saw a connection between Sparta's confraternities of adult and adolescent males (Männer-und Jugendbunden), and the Brown Shirts (SA) and Hitler Youth (HJ).[26] Among ancient historians there was a veritable boom in the field of Spartan studies.[27] Even in the closing phases of the war (February 1945) the Spartans were not forgotten by Hitler, who drew courage from the recollection of Leonidas's last stand at Thermopylae.[28]

Hitler's admiration for Spartan racial purity and militarism did not extend to the Doric style in architecture championed by Rosenberg, whom Speer says Hitler disliked for precisely this taste that he had articulated in his Mythus:[29] "The classical Doric building is

Stuttgart, 1976, 85; G. Troost, Das Bauen im Neuen Reich, Bayreuth, 1939, 5; A. Speer, Erinnerungen, Berlin, 1970, 110; B. Hinz, Art in the Third Reich, Oxford, 1980, 16.

23. Der Mythus des 20. Jahrhunderts, Munich, 1935, 34–54. Some ancient historians wrote grotesque studies of alleged racial continuities between Germans and Greeks, e.g., W. Sieglin's Die blonden Haare der indogermanischen Völker des Altertums, Munich, 1935. For an account of the academic study of ancient history under the Nazis, see V. Losemann, Nationalsozialismus und Antike: Studien zur Entwicklung des Faches Alte Geschichte, 1933–1945, Hamburg, 1977, 11–26; K. Christ, Römische Geschichte und deutsche Geschichtswissenschaft, Munich, 1982, 195–260.

24. In 1918. He began his architectural studies in Riga. The drawing he submitted for his qualifying examination was grimly prophetic: a crematorium; C. Cecil, The Myth of the Master Race: Alfred Rosenberg and Nazi Ideology, London, 1972, 19; see also R. R. Taylor, The Word in Stone, Los Angeles, 1974, 55–63; K. Backes, Adolf Hitlers Einfluss auf die Kulturpolitik des Dritten Reiches, Heidelberg, 1984, 126–44.

25. ". . . den klarsten Rassenstadt der Geschichte"; Zweites Buch, 2.17; Hitler's Table Talk, 1941–1942, London, 1973, 116; E. Rawson, The Spartan Tradition in European Thought, Oxford, 1969, 342; Losemann, Nationalsozialismus, 11.

26. "Die Antike und Wir," Nationalsozialistische Monatshefte 6 (1935): 115.

27. H. Berve, Sparta, Leipzig, 1937; O.-W von Vacano, ed., Sparta: Der Lebenskampf einer nordischen Herrenschicht, Kampten, 1940; F. Miltner, "Sparta, Vorbild und Mahnung," Antike 19 (1943): 1–29; P. Villard, "Antiquité et Weltanschauung Hitlérienne," Revue d'histoire de la deuxième guerre mondiale 22 (1972): 5f.; L. Canfora, "Classicismo e fascismo," Quaderni di Storia 3 (1976): 35, 38. The racial purity of some ancient Greek authors was closely scrutinized. Herodotus, though from a Dorian colony, was "doubtless a mongrel" (zweifellos Mischblut); F. Pfister, "Der politische Humanismus," Bayerische Blätter für das Gymnasialschulwesen 70 (1934): 72. For unfavorable remarks about parallels between Sparta and the Nazi state, see V. Ehrenberg's "A Totalitarian State," originally delivered on Prague radio in 1934, and published later in the same author's Aspects of the Ancient World, Oxford, 1946, 94–104.

28. Losemann, 20; cf. G. Troost's remarks on "the severe, noble beauty of the soldiers' cemetery at Thermopylae," which was "a symbol of the German spiritual inheritance of the ancient hellenic culture." H. Lehmann-Haupt, Art under a Dictatorship, New York, 1954, 112.

29. "Hitler blocked him from exerting any influence because he wanted to exert his own influence. . . . Hitler did not like him very much, he was really too much inclined to the Doric style." F. Dal Co, S. Polano, "Interview with Albert Speer, October 1977," Oppositions 12 (1978): 45; cf. 51 n. 10.

the most perfect, static orchestration of space . . . no line, no decoration which detracts from the form of the temple itself. Everything is pure, clear, comprehensible, yet with a function which is the fruit of experience."[30]

There is no doubt that Hitler admired the Parthenon, which he saw not so much as a symbol of Athenian democracy but as a reflection of the personalities of Perikles, Iktinos, its architect, and the sculptor Phidias,[31] whose statue of Athena Hitler cites to support his claim that all cultures have expressed themselves through colossal sculpture (Grossplastik).[32]

However, the Führer's admiration for the Parthenon, a building he never visited, despite a wish to do so,[33] and even though he was not averse to being compared to Perikles,[34] was never translated into architectural reality by any of his chief architects—Troost, Speer, or Giesler. The only visible presence of the Parthenon in Hitler's environs was the reproduction of the temple's maeander pattern on silver cutlery designed by Troost's wife for use by intimate groups of guests at Hitler's Austrian refuge, the Berghof: "By means of this Greek ornament on his spoons, knives, and forks, Hitler wished to manifest his deep inner union with Greek antiquity, which for him was the giver of light to humanity, that is, to Western culture."[35]

30. "Der klassische dorische Bau ist die vollendetste, in sich ruhende Rythmisierung des Raumes . . . keine Linie, kein Schmuck, der über die Tempelform selbst hinausweist. Alles ist geläuterte anschauliche, fassbare, oder doch erlebte Funktion"; *Mythus*, 253.

31. Giesler, 203; cf. 294 for a quip to the effect that a Phidias would be needed to execute a mythological frieze for the party's victory monument in Munich; Arno Breker, who was to provide monumental relief sculptures for Hitler's triumphal arch in Berlin, was also flippantly compared to Phidias; A. Breker, *Hitler et moi*, Paris, 1970, 166.

32. Giesler, 204. In a speech on 11 September 1935 at the Nuremberg Parteitag, Hitler called leaders of modern art cultural Herostratuses, an allusion to Herostratus, who in 356 B.C. set fire to the temple of Artemis at Ephesus. The anecdote is related by Valerius Maximus 8.14.5. In the same speech Hitler called the Parthenon a visible ground for pride for the Greeks; N. H. Baynes, ed., *The Speeches of Adolf Hitler, 1922–1939*, Oxford, 1942, 570, 575.

33. A. Speer, *Spandauer Tagebücher*, Berlin, 1975, 166. See also G. Pagano, "Partenone e partenoidi," *Domus* 168 (1941): 26–31.

34. Speer, *Erinnerungen*, 110; cf. A. Speer, *Architektur-Arbeiten 1932–1942*, Berlin, 1978, 1. Krier, ed., *Albert Speer*, 1, where Speer says Perikles built the Parthenon to raise the self-esteem (Selbstachtung) of the Greeks and to make Athens the center of the Greek world. The German and French/English editions of this lavishly illustrated book contain different essays (apart from Larsson's contribution, which is reproduced in both), as well as many different illustrations. It is therefore somewhat misleading to refer to a first and second edition of the work without calling attention to the substantial differences between them.

35. "Mit diesem griechischen Ornament auf seinen Löffeln, Messern und Gabeln wollte Hitler seine tief innere Verbindung mit der griechischen Antike bekunden, die für ihn die Spenderin des Lichts der Menschheit, d.h. der abendländischen Kultur war"; Picker, *Tischgespräche*, 334 n. 309. A large head of Pallas Athena was carried in a procession held on the "Day of German Art" in Munich in 1938. See R. Müller-Mehlis, *Kunst im Dritten Reich*, Munich, 1976, 27, 165. The "teahouse" of the Berghof refuge in Obersalzburg was also decorated with two oval relief sculptures by J. Wackerlei: one depicted a nymph, the other a youthful Pan; idem, 115. The Berghof had been vandalized by 1946; see G. Huster, "Inszenierung der Macht: Hitlers Berghof," in Neue Gesellschaft für Bildende Kunst, *Inszenierung der Macht: Ästhetische Faszination im Faschismus*, Berlin, 1987, 156f. For a photograph of Hitler beside a copy of Myron's "Discobolos," which Hitler donated to the Munich Glyptothek, see *Ausstellungskatalog. Auf den Spuren der Antike. Theodor Wiegand, ein deutscher Archäologe*, Städtische Museum, Bendorf am Rhein, 1985, 35 and 50 for "Die Integration des griechischen Körperideales in den Nationalsozialismus." The Discobolos generated

The goddess Athena fared better, and became part of the official iconography of the Nazi party. Her helmeted profile graced the cover of the party's art journal, *Die Kunst im Deutschen (Dritten) Reich,* edited by Rosenberg.[36] Her head, again helmeted, also appeared in a marquetry triptych by Hermann Kaspar set in the front of Hitler's desk (Fig. 51) in Speer's new Chancellery in Berlin.[37] A statue of Athena (along with Dionysus) was also placed in the Chancellery's library, situated above the ground-floor dining room. In his table talk (25 and 26 January 1942), when praising Greek beauty of thought and form, Hitler emphasized the superiority of the Greeks in these areas over their successors. The differences could be seen, he pointed out, if one compared "the head of Zeus or Athena with that of a medieval crusader or saint."[38]

In Hitler's first cultural speech as Chancellor (1 September 1933) he stated: "It is therefore no surprise that each politically historical epoch searches in its art for the link with a period of equally heroic past. Greeks and Romans suddenly stand close to Teutons."[39] Four years before he had already associated the Greeks and Romans with his architectural ideas.[40] Direct or literal quotations of Greek or Roman buildings were not one of the products of this attitude of Hitler toward classical antiquity. As Leon Krier puts it, Hitler did not wish "to copy historic styles, but to create a new style which was itself to become historical" and that went beyond the "coarse Latinism of Italian Fascism."[41]

The difference in architectural stylistic preference between Hitler and Speer is clearly expressed by Speer in a passage he wrote on 20 October 1948 in his prison diary: "I still find it difficult . . . to grasp the difference between antiquity, the Renaissance, European Classicism, and my own endeavors. At best I can say that Paestum or the Greek temples of Sicily made a stronger emotional impact on me than the whole Italian Renaissance, Prussian Classicism, and everything before Gilly and Schinkel. With Hitler it was quite different. . . . Naturally he was fanatical about antiquity . . . his world was one of arcades, domes, vaults, didactic architecture."[42] Thus it is possible to see in patron and

a great deal of literature in the Nazi press in 1938; see O. Thomae, *Die Propaganda-Maschinerie: Bildende Kunst und Öffentlichkeitsarbeit im Dritten Reich,* Berlin, 1978, 116, 130.

36. Hinz, *Art in the Third Reich,* plate opposite p. 1.

37. Angela Schönberger, *Die Neue Reichskanzlei von Albert Speer,* Berlin, 1981, 98; a statue of Athena was to be placed near the entrance of Kreis's German Museum, part of the new museum quarter in Berlin, where Nazi racial theories were to be emphasized; W. Schäche, in W. Arenhövel, C. Schreiber, eds., *Berlin und die Antike,* Berlin, 1979, 566, 568.

38. ". . . den Kopf des Zeus oder der Athene mit dem eines mittelalterlichen Gekreuzigten oder eines Heiligen"; Picker, 93. Greek rather than Roman or German mythological figures featured prominently in officially approved Nazi paintings. Hinz, 161, suggests that Greek subjects lent themselves readily "to the depiction of beauty and nudity." See, for example, the

many paintings of Leda, and the Judgment of Paris (136–38, 138f., 152); for the prurience of much Nazi painting and sculpture, see H. Rosenberg, *Discovering the Present,* Chicago, 1973, 98f.; the Greek delight in physical beauty (die Freude am Körper) was also emphasized by some Nazi aesthetes; B. Schweitzer, "Die griechische Kunst und die Gegenwart," *Die Antike* 13 (1937): 109.

39. Hitler quoted by L. O. Larsson, "Classicism in the Architecture of the Twentieth Century," in Krier, ed., *Albert Speer,* 239.

40. Kunstrede of 3.4.1929, Bundesarchiv (Koblenz), Hauptarchiv der NSDAP 26/56 Bl. 70ff.

41. "An Architecture of Desire," in Krier, ed., *Albert Speer,* 226.

42. "Es fällt mir immer noch schwer, über allgemeine Wendungen hinweg den Unterschied zu begreifen zwischen der Antike, der Renaissance, dem europäischen Klassizismus und meinen eigenen Bester-

architect the two souls of Nazi classicism: one philoroman (Hitler) and one philhellene (Speer). It is worthwhile briefly to examine Speer's two visits (1935 and 1939) to Sicily, the south of Italy, and Greece to study Doric architecture, in relation to the visits of earlier German architects to the same parts of the ancient world.

Gotthard Langhans's Brandenburg Gate (1789–91) is usually regarded as marking the break in Germany with the late baroque. This gate, unlike many of Berlin's earlier gates,[43] is mainly Greek in inspiration, not Roman. The design is not based on that of a Roman triumphal arch but was inspired by the propylaeum of the Acropolis at Athens, which Langhans mistook as Athens' city gate.[44] This change to a style based on Greek sources of inspiration was a reflection not merely of a shift in taste but also of political symbolism. The traditional Roman model (triumphal arch) was now regarded unfavorably by some architects because it had been inevitably linked with France and associated with Napoleon's imperialistic aspirations. With Napoleon's retreat and the struggle of the Greeks against the Turks for independence, Greek architecture became a symbol of freedom.[45] The Roman-inspired facade architecture of the Ecole des Beaux-Arts no longer attracted the undivided attention of the Prussian architects of the early and mid-nineteenth century. Consequently, many well-known Prussian architects visited Doric sites in southern Italy and Sicily: In 1795 Heinrich Gentz visited Doric temples at Paestum and Agrigento. Three years earlier Friedrich Gilly visited Sicily and expressed a preference for Greek architecture: "Athens is a paragon: Acropolis. Rome is not."[46] Yet like Langhans's gate, many of Gilly's buildings displayed a mixture of Greek and Roman elements, as evidenced in his planned monument for Frederick the Great in Berlin (1797), a Doric temple on a vast (Roman) substructure, situated in an oval platz on the *cardo* of Friedrichstadt.[47]

In 1935 Speer made his first visit to Greece to see Doric architecture[48] and also perhaps to follow the example of earlier German architects such as Gilly, "my true genius and

bungen. Allenfalls könnte ich sagen, das Paestum oder die griechischen Tempel auf Sizilien stärker und emotionaler auf mich gewirkt haben als alle italienische Renaissance, ebenso der preussische Klassizismus, allen voran Gilly und Schinkel. Bei Hitler war es ganz anders. . . . Naturlich hatte er die Schwärmerei von der Antike . . . seine Welt waren Bogengänge, Kuppeln, Geschwungenes, Repräsentation"; *Spandauer Tagebücher*, 166.

43. For an account of these, see F. E. Keller, "Triumphbogen in der Berliner Architektur des 17. und 18. Jahrhunderts," in Arenhövel, Schreiber, eds., *Berlin und die Antike*, II, 99–112.

44. R. Bothe, "Antikenrezeption in Bauten und Entwürfen Berliner Architekten zwischen 1790 und 1870," in Arenhövel, Schreiber, eds., *Berlin und die Antike*, 298. There are, however, Roman elements incorporated into the gate: a quadriga on its attic and Roman Doric columns.

45. For A. Borbein, "Klassische Archäologie in Berlin vom 18. zum 20. Jahrhundert," in Arenhövel, Schreiber, eds., *Berlin und die Antike*, I, 102, the Brandenburg Gate was not so much a symbol of freedom as a link between Prussia and its monarchy and Greece. Bothe, 294–96.

46. "Gilly gab der griechischen Architektur endgültig den Vorrang: Athen ist ein Muster. Acropolis. Rom nicht so"; Bothe, 302. See generally, J. R. Serra, ed., *Paestum and the Doric Revival, 1750–1830*, Florence, 1986.

47. G. Rodenwaldt, "Römische Staatsarchitektur," in H. Berve, ed. *Das Neue Bild der Antike*, Leipzig, 1942, II, 356; cf. 362, where K. F. Schinkel's Neue Wache is explained as a combination of a Greek facade with a Roman fortification (Kastell).

48. *Erinnerungen*, 76. Bonatz, a less well known architect of the Nazi period, had visited sites in Sicily in 1911, and in 1943 visited Greece to see Doric temples;

model."[49] Instead of visiting Italy to see Renaissance palaces and monumental Roman buildings, he chose to visit the source of his architectural inspiration. Yet, paradoxically, what impressed him most in Athens was not the Parthenon but the (Roman) stadium of Herodes Atticus, the *largest* building he saw but which had no Doric features.[50] At Delphi Speer thought he discerned how the purity of Greek artistic creativity had been quickly corrupted by wealth won in the Asiatic colonies of Ionia. He concludes his reflections on Greece with the remark that his own work for Hitler might have been corrupted in a similar fashion, believing in retrospect that the buildings he designed for Hitler had been adversely affected by despotic (that is, Asiatic) tendencies.[51]

In March 1939, after a visit to Rome in 1936,[52] Speer visited Doric sites at Paestum and in Sicily: Agrigento, Segesta, Selinunte, and Siracusa. The large temples at Agrigento and Selinunte reminded him that the ancient world was not free from "megalomaniacal impulses" (megalomanische Anwandlungen). In Magna Graecia, Paestum was a high point, whereas Pompeii, which had delighted Karl Friedrich Schinkel,[53] disappointed him, since its buildings lacked Paestum's "pure forms" (reinen Formen).[54] Later he contemptuously characterized the Führerpalais he designed for Hitler on Grosse Platz in Berlin as a "combination of Pompeian ideas of two-storied pillared halls with imperialistic extras in gold and bronze."[55] In another passage of his memoirs,[56] where he explains why Hitler always strove for massive proportions in state buildings, Speer comments that the largest buildings in the ancient Greek world were in Sicily and Asia Minor, where cities were frequently ruled by despots, a reflection that was perhaps the fruit of retrospection during Speer's captivity.

If Speer's admiration for the Doric style was as sincere as his respect for Gilly and Schinkel,[57] it would seem that he might have been more contented designing buildings for an Alfred Rosenberg rather than for Hitler, since the only state building designed for

P. Bonatz, *Leben und Bauen*, Stuttgart, 1950, 61, 190. The architecture of ancient Egypt also made a deep impression on him when he viewed it in 1913 (64).

49. ". . . der mir das eigentliche Genie und Vorbild war"; *Tagebücher*, 166, where he also expresses disappointment that Hitler said nothing when Speer gave him a book on Gilly.

50. Herodes' stadium was to be the model for Speer's Deutsche Stadion in Nuremberg; see page 75.

51. *Erinnerungen*, 162.

52. Speer, *Architektur*, 2; the visit was in connection with Hitler's plans for a gigantic Kuppelhalle in Berlin; see page 109 below.

53. Bothe, 324.

54. *Erinnerungen*, 162.

55. ". . . eine Abwandlung pompejanischer Ideen zweigeschossiger Säulenhallen mit empirehaften Zugaben aus Gold und Bronze"; *Tagebücher*, 167.

56. *Erinnerungen*, 82f.

57. "My dreams were concerned purely with buildings; I did not want power, but to become a second Schinkel" (Meine Träume galten immer nur den Bauten, ich wollte keine Macht, sondern ein zweiter Schinkel werden!); Giesler, 340; G. F. Koch, "Speer, Schinkel und der preussische Stil," in Speer, *Architektur-Arbeiten*, 136–50, notes (137) that Roman and baroque architecture was more to Hitler's taste than Greek and Prussian classicism: for Schinkel's buildings in the Doric style, see W. Hoepfner, "Zur Dorischen Ordnung bei K. F. Schinkel," in Arënhovel, Schreiber, eds., *Berlin und die Antike*, 481–90. See also K. Winkler, "Schinkel-Mythen. Die Rezeption des preussischen Klassizismus in der Kunstpublizistik des Nationalsozialismus," in Neue Gesellschaft für Bildende Kunst, *Inszenierung der Macht: Ästhetische Faszination im Faschismus*. Berlin, 1987, 225–42; H. Delius, "Vitruvius und der deutsche Klassizismus: C. F. Schinkel und F. Weinbrenner," *Architectura* 1 (1933): 56–62, a valuable reminder that Schinkel was as concerned with Roman architecture as he was with Greek.

the Führer that was explicitly related to a Greek model was the main stand of the Zeppelinfeld stadium in Nuremberg, and this was inspired not by Doric temple architecture but by the west front of the Pergamum altar.[58] Again it was gigantic proportions, not purity of style, that interested Hitler. However, the prospect of becoming the architect of some of the most colossal buildings in the world outweighed any qualms Speer might have felt about compromising his stylistic preferences and integrity: "The designs for his [Hitler's] new Berlin were truly staggering and my execution of them, I was convinced, could make me one of the most famous architects of history."[59]

Why Speer made this compromise[60] and remained the Führer's principal architect will only be properly understood after new material on Hitler's views of the Romans and their imperial architecture is published. Hitler's knowledge of architecture and architectural history was inevitably eclectic, since it lacked a professional as well as a technical basis. Robert R. Taylor has reviewed in some detail the diverse sources of Hitler's knowledge of architecture from his early years in Vienna onward, and it is not necessary to rehearse it here.[61] However, it is worth adding to Taylor's surmise that Hitler might have read Gottfried von Semper's *Über Baustyle* (1869), in which the architect stressed that monumental architecture was a useful instrument for the control of "apathetic and restless masses."[62] There can be little doubt that Hitler's vast stadia and assembly halls were designed with a view to influencing people en masse. Werner Maser has shown that Hitler had an intimate knowledge of two works on mass psychology:[63] William McDougall's *The Group Mind: A Sketch of the Principles of Mass Psychology* (1920) and Gustave Le Bon's *Psychologie der Massen* (1912). Speer also recognized the importance of Hitler's "Versammlungsarchitektur" as part of his plan to establish his domination over masses of people who could be molded into a single unified body when enclosed in one all-embracing building. Goethe, as Speer noted, had already observed that the mass of people inside a Roman amphitheater, as they swayed backward and forward, would feel themselves to be a single unity with one spirit.[64] This point will be resumed below in association with Hitler's Nuremberg buildings.

58. See page 90. Bonatz (note 48 above) refers to this building as "imposing but inhuman" (150)

59. Playboy Interview, 80.

60. Speer fully understood the nature of this compromise: "When I think about it, he took me far away from my beginnings and ideals" (Wenn ich es bedenke: er hat mich weit von meinen Anfängen und Idealen weggebracht); *Tagebücher*, 167.

61. *The Word in Stone*, Los Angeles, 1974, 19–54; cf. Lehmann-Haupt, 45–61. W. Maser, *Hitler's Letters and Notes*, London, 1974, 108, quotes a *curriculum vitae* written in 1921 in which Hitler stated that from his twenty-second year onward his final objective was absolutely fixed: "I would become an architect." He kept the architectural sketches he drew in Landsberg prison until the end of his life. Before he shot himself in the bunker

of the Chancellery, he told his secretary, Christa Schröder, to remove the sketches from his desk. At her trial Schröder claimed the sketches were the work of her grandfather (20).

62. Semper, like Hitler, disliked the Gothic style; W. Herrmann, *Gottfried Semper: In Search of Architecture*, Cambridge (Mass.), 1984, 124–38; he was also the architect of Hitler's favorite opera houses in Dresden and Vienna; B. Hinz, *Die Malerei im deutschen Faschismus*, Munich, 1974, 184.

63. *Mein Kampf: Der Fahrplan eines Welteroberers*, Esslingen, 1974, 106.

64. "In diesem Sinne sah Hitler in der Versammlungsarchitektur eines der Mittel, um den Mechanismus seiner Herrschaft zu stabilisieren. Goethe (Italienischer Reise) erkannte vor zweihundert Jahren

Although the ancient Greeks provided Hitler with a paradigm of racial purity, they could not supply him with a suitably impressive model of world empire and domination. Even Alexander the Great, whom Hitler admired, failed to provide a sufficiently respectable or durable model, since he was blamed for causing "racial chaos" by encouraging intermarriage between Greeks and Asiatics.[65] Alexander's empire was vast, but most of it was in Asia, and like its creator, short-lived. The model was flawed and discredited. By contrast the empire of the Romans was immense and durable, and a large part of it was in Western Europe. Its capital city, Rome, was a world capital, the "crystallization point of a world empire," to use Hitler's own phrase.[66]

Like the Greeks, the Romans were regarded by Nazi ideologues and their sympathizers as racially acceptable forebears: "Rome is the foundation of a Nordic "Völkerwelle' . . . it enforced more rigidly and deliberately than Hellas the Apollonian principle of paternity."[67] The Romans were also "the firstborn of the Aryan nations" (die Erstgeborenen der arischen Völker), but the Etruscans were suspect, since Rosenberg saw them as the "mainstays of Mediterranean racial chaos" (Hauptträger des mittelmeerischen Rassenchaos), and their circular buildings and arches were characterized as feminine and Asiatic.[68]

The victory of Rome over Carthage ensured that Europe kept at bay the "Near Eastern spook" (vorderasiatischen Spuk), but when Caracalla granted citizenship in A.D. 212 to all free inhabitants of the Roman Empire, "that was the end of the Roman world" (das war das Ende der römischen Welt).[69] Eberhardt, who also raised an eyebrow at "Etruscan blood," drew attention to the rustic aspect of early Roman society and relates this to the "Blood and Soil" (Blut und Boden) concept of R. Walter Darré's policy of settling the urban poor in small settlements in the countryside.[70] Hitler himself attributed Rome's political success to the fact that its power derived from the circumstance that it was a community of peasant farmers (Bauernstaat).[71] But Hitler was more fascinated by the *scale*

bereits diese Wirkungen—in einem römischen Amphitheater sähe sich das vielköpfige, vielsinnige schwankende, hin und her irrende Tier in einer Einheit bestimmt, in einer Masse verbunden und von einem Geist belegt. Der Bau sei gemacht, um dem Volk mit sich selbst zu imponieren"; Speer, *Architektur-Arbeiten*, 8; cf. K. Arndt's observations on this same point, ibid., 113, 115.

65. A. Demandt, "Politische Aspekte im Alexanderbild der Neuzeit," *Archiv für Kulturgeschichte* 54 (1972): 325–63, surveys interpretations of Alexander in Germany from Niebuhr to Hitler; see also E. Badian, "Some Interpretations of Alexander," in *Alexandre le Grand: Image et réalité*, Geneva, 1975, 281–86.

66. ". . . der Kristallisationspunkt eines Weltreiches"; G. L. Weinberg, ed., *Hitlers Zweites Buch*, Stuttgart, 1961, 119. The expression recurs in a speech delivered by Hitler on 27 November 1937 in Nuremberg; Baynes, *Speeches*, 600.

67. "Rom ist die Gründung einer nordischen Völkerwelle . . . setzte schroffer und bewusster als Hellas das apollinische Paternitätsprinzip"; J. Vogt, "Unsere Stellung zur Antike," 110. *Jahresbericht der schlesischen Gesellschaft für vaterländische Cultur*, 1937, Geisteswissenschaftliche Reihe, III, 7; cf. Pfister, 74; Rosenberg, 54.

68. Rosenberg, 382–85; Losemann, 22f. M. Cagnetta, *Antichisti e impero fascista*, Bari, 1979, 147 n. 4.

69. Rosenberg, 54f., 58; Cato the Elder's hatred of Carthage and his blond hair "proved" he was an Aryan, according to Hitler's minister of agriculture, W. Darré, *Das Bauerntum als Lebensquell der nordischen Rasse*, Munich, 1938, 305.

70. "Die Antike . . . ," 122.

71. J. Thies, *Architekt der Weltherrschaft: Die Endziele Hitlers*, Düsseldorf, 1976, 72; Hitler compared the German body politic (Volkskörper) to Antaeus, whose

of Rome's political power, and by the *size* of the state buildings that symbolized and represented it: "The Roman Empire never had its like. To have succeeded in completely ruling the world! And no empire has spread its civilization as Rome did."[72] "Italy is the original home of the concept of the state."[73] Whereas Rosenberg saw Rome's downfall as the consequence of racial contamination and the destruction of social hierarchy through Caracalla's "indiscriminate" grant of citizenship, Hitler stated repeatedly that the fall of Rome was the direct result of Christianity: "The mobilizing of the mob under the banner of Christianity caused Rome's downfall."[74] "Rome was ruined by Christianity, not by Germans and Huns."[75] This belief was reiterated in various contexts: The Christian concept that all men are equal before God was bound to undermine the Roman world.[76] The concept undermined the basis of hierarchy. It was Christian Bolshevists, not Nero, who were responsible for burning Rome in A.D. 64.[77] In his attitude toward Christianity and the Church, Hitler differed markedly from Mussolini, who was careful to incorporate Christian Rome in his wider concept of Rome's past glory and hoped-for future greatness. Thus when he signed the Lateran Accords in 1929 between the state and Pope Pius XI, the Duce's action could then be compared with Augustus's restoration of state religion.[78]

Hitler also blamed Rome's destruction on the Jews.[79] Saint Paul was singled out for having transformed a local movement of Aryan (*Christus war ein Arier*) opposition to Jewry into a supratemporal religion that postulated the equality of all men among themselves.[80] This ruined Rome. The Romans are praised for their tolerant polytheism, which is adversely contrasted with the intolerant and dangerously egalitarian monotheism of Christianity. Christianity, along with the pox, is said to be the greatest scourge of the modern world.[81] Hitler also praised the Romans for civilizing the early tribal Germans, whom he confessed were culturally backward, though no worse than the contemporary Maori, whom Hitler mistook for blacks.[82] Among the Romans blond hair was fashionable.[83] Arminius, the first architect of German liberty, was honored by being given the rank of *eques* by the Romans, who gave Germans the opportunity to become disciplined

strength could not be overcome so long as his feet rested on Mother Earth; Giesler, 197.

72. *Table Talk*, 111.

73. "Italien ist die Heimat der Staatsidee . . ."; Picker, 58f.

74. "Der Untergang der antiken Welt was die Mobilisierung des Mobs unter dem Motto Christentum"; Picker, 106.

75. "Durch das Christentum ist Rom gebrochen wurden, nicht durch Germanen und Hunnen"; Picker, 95.

76. Picker, 95.

77. *Table Talk*, 87–89, where Julian is eulogized and the Christians blamed for destroying the libraries of the ancient world.

78. Kostof, 302; "Just as the birth of the first Roman empire coincided with the birth of Christianity, so in the second empire Mussolini restored the ancestral faith of the people by his conciliation of the Vatican. The reason why M. could revive the Roman empire was precisely that the Church had maintained the universality of Rome after the close of the pagan era. . . . the Lateran pact was the new Ara Pacis of the resurgent empire, and the Duce the new Augustus"; idem, 303. See P. Fedele, "Risonanze storiche degli Accordi del Laterano," *Capitolium* 5 (1929): 58–62, where the pope (Pius XI) is reported as saying: "Noi abbiamo restituito i'Italia a Dio e Dio all' Italia." C. Cecchelli, "Laterano e Vaticano," ibid., 63–78.

79. *Table Talk*, 118.

80. *Table Talk*, 77f.; Picker, 80f., 422.

81. *Table Talk*, 7, 75f.

82. *Table Talk*, 7; Picker, 101 (Maori).

83. *Table Talk*, 7.

soldiers, thus giving the nation a virile education.[84] It is noteworthy that it is nearly always the Romans, and not the Spartans, to whom Hitler refers when praising military discipline and expertise in the ancient world. In fact the similarities between Hitler's opportunistic diplomacy and ruthless militarism and Rome's predatory imperialism were explored in depth in two essays published by Simone Weil in 1939 and 1940.[85] Weil refers to such points of similarity as the Roman conviction in their own superiority and right to conquer and rule the world and the Roman use of terror as a weapon of conquest and intimidation. The aqueducts, roads, and masses of monuments all made the grandeur and authority of Rome's power palpable to her subjects.[86]

Hitler also praised Roman roads and makes a direct comparison between roads built by the Romans through the forests of Germany and roads he planned to build in Russia with forced labor. He also remarked on the astonishing speed of the Roman legions, made possible by a combination of straight roads and well-prepared camps. It is therefore hardly surprising that Hitler associated his autobahns with Roman road networks, which he saw initially as serving a strategic rather than a commercial function.[87]

All this evidence perhaps suffices to demonstrate Hitler's overwhelming admiration for the more aggressive aspects of Roman culture, and above all for Rome's autocratic and hierarchical political system established by Augustus and consolidated by his successors. The glaring inequalities within this system between slaves and freeborn, rich and poor,[88] met Hitler's approval, just as Christian attempts (as perceived by Hitler) to undermine Roman hierarchy and replace it with an egalitarian order aroused his angry disapproval.[89] It was for this reason that Christianity and Marxism were bracketed together: Both ideologies were seen as social and political levelers incompatible with the aims of Nazism.

84. *Table Talk*, 78, 486f.; cf. Picker, 493f., where Arminius (Hermann der Cherusker) is called the uniter of the German nation.

85. Simone Weil, "Hitler et la politique extérieur de la Rome antique"; "Hitler et la régime intérieur de l'empire romain" (1939/40), in idem, *Ecrits historiques et politiques*, Paris, 1960, 23–50, especially 34.

86. Weil, 37; she acknowledges (49) that the comparisons she draws between Hitler and the Romans are difficult to admit when Roman literature and history provide most Europeans with material that is collectively labeled "the Humanities." For assessments of Roman imperialism and the fate of Rome's subjects, see W. V. Harris, *War and Imperialism in Republican Rome*, Oxford, 1979; P. Garnsey, *Social Status and Legal Privilege in the Rome Empire*, Cambridge, 1970; J. M. Kelly, *Roman Litigation*, Oxford, 1966; G. E. M. de Saint-Croix, *The Class Struggle in the Ancient Greek World*, London, 1981, 328–32; P. A. Brunt, "Provincial Maladministration," *Historia* 10 (1961): 189–227; Klaus Wengst, *Pax Romana*. London, 1987; Naphtali Lewis, *Life in Egypt under Roman Rule*, Oxford, 1985.

87. *Table Talk*, 111, 338, 537f., Mussolini in 1929

declared he had a passion for roads: "Roads are the nervous system of the organism of a nation; they are useful for economic ends, as they are for strategic purposes." (Le strade sono il sistema nervoso dell' organismo di un popolo, sono utili ai fini economici, sono utili ai fini strategici); Cederna, *Mussolini urbanista*, 27. The Fascist-backed Istituto di Studi Romani published *Le grandi strade del mondo romano* in Rome in 1939. In volume 15 of *Roma* (also an organ of the Fascist party), published in 1937, two essays on Roman roads were included: C. Praschiuker, "Le grandi strade romane nel territorio dell' Austria" (437–52), and P. Romanelli, "Le grandi strade romane nell' Africa settentrionale" (366–81). For Hitler's roads as the subject of German art, see *Die Strassen Adolf Hitlers in der Kunst*, Ausstellung Breslau Dez. 1936–Jan. 1937, Breslau, 1937. The catalogue lists 508 items in this exhibition.

88. These inequalities are discussed in A. Scobie, "Slums, Sanitation and Mortality in the Roman World," *Klio* 68 (1986): 399–433; see also note 86 above.

89. A book comparing Hitler favorably with Jesus was published in 1937 in Weimar: J. Kuptsch, *Nationalsozialismus und positives Christentum*. Hitler was here

Yet unlike Mussolini, Hitler did not try to identify himself too closely or explicitly with Augustus, or with any other Roman ruler. There were, after all, famous German leaders from the remote as well as from the not so distant past, such as Arminius, and Bismarck,[90] not to mention a foreign leader such as Napoleon, for whom he had great respect. Besides, Mussolini had preempted Augustus, and the Duce's attempt to present himself as a reincarnation of a Caesar met with derision, which in the 1920s could still be openly expressed in Germany. For example, the front cover of the satirical review *Eulenspiegel* (July 1928) shows the Duce with arms crossed over his chest and the following subscript: "Caesar Mussolini: Caesar led his legions to the edge of the Red Sea—whereas I will make the whole world into a red sea."[91]

On 3 May 1938 Hitler began a state visit to Rome to cement an alliance with Mussolini. The visit was to make a deep and lasting impression on Hitler, who for the first time was able to view Roman buildings with his own eyes. Mussolini, who had made an official visit to Berlin in the autumn of 1937, lost no chance to impress the Führer and his large entourage with the "grandezza" of his capital city and its refurbished ancient monuments. The journalist G. Ward Price, who witnessed Hitler's arrival in Rome, reported: "Never has so costly and elaborate a display been made not only of a country's historical and artistic treasures, but also of its aerial, naval and military resources, as was arranged for the Führer."[92] For Hitler this visit was not to be an informal, postconquest tour of monuments and galleries like his later visit to Paris in June 1940 with Speer, Giesler, and the sculptor Arno Breker as his guides;[93] it was to be a formal state occasion. Mussolini, disturbed by Hitler's entry into Austria on 14 March 1938, still had to demonstrate his solidarity with a partner who was rapidly growing in strength and confidence. Accordingly, no architects or sculptors accompanied Hitler, whose entourage included such luminaries of the Nazi regime as Hess, Goebbels, Himmler, Ribbentrop, Bormann, the

hailed as a savior of the world (47). No doubt Kuptsch knew Virgil's Fourth Eclogue, where Augustus was hailed as a messiah (though not explicitly).

90. Portraits of both heroes hung in Hitler's Arbeitszimmer in the new Chancellery in Berlin. Napoleon was not represented. Schönberger, *Die Neue Reichskanzlei von Albert Speer,* Berlin, 1981, 128. J. C. Fest, *Hitler,* London, 1974, 200, sees Hitler as a combination of Caesar and Lederhosen.

91. "Caesar führte seine Legionen bis ans Rote Meer—Ich aber werde aus der ganzen Welt ein Rotes Meer machen." On the other hand, books appreciative of Mussolini's Roman revivalism did appear later in Germany, e.g., S. Schuller's *Das Rom Mussolinis,* Düsseldorf, 1943. Mussolini referred to his war in Ethiopia as the "Fourth Punic War," Insolera, Di Majo, *L'EUR e Roma,* 61.

92. *Year of Reckoning,* London, 1939, 182. Hitler's visit to Rome had already been discussed in 1932 when he was "dying to meet the Duce" (muore dal desiderio di

incontrare il Duce), whom he had idolized for several years. He had in fact kept a bust of the Duce on his desk in his office in the Brown House at Munich (Seit über drei Jahren steht die Büste Mussolinis in meinen Arbeitszimmer in Braunen Haus in München, vor meinem Schreibtisch); J. Petersen, *Hitler-Mussolini: Die Entstehung der Achse Berlin-Rom 1933–1936,* Tübingen, 1973, 104f., 124f., 158. The two dictators met for the first time in Venice on 14 and 15 June 1934; 344–54. Göring, who did not accompany Hitler in 1938, visited Rome on 10 to 18 April 1933; 166f. Himmler and his wife had visited Italy in 1937. He stayed for a while at Taormina, in Sicily, where he discovered the Aryan Sikels. Local antiquarians showed him flutes and shepherds' crooks belonging to the Sikel period, but which had been hurriedly manufactured for Himmler's visit; E. Kuby, *Il tradimento tedesco,* Milan, 1983, 47; cf. 48 for another archaeological trick played on Himmler.

93. See page 109.

commander-in-chief of the Wehrmacht, General Keitel, and ninety German journalists dressed for the occasion in brown tunics and black trousers.[94] This was not the sort of company Speer, as architect, liked to keep. Moreover, he had already visited Rome in 1936 for architectural purposes.[95]

Hitler arrived at night at the rebuilt Ostia railway station.[96] Mussolini seized the opportunity to give the Nazis a display that Speer, with his flair for the illumination of beflagged monuments, would perhaps have relished. A hundred miles of electric cable and 45,000 groups of lamps totaling 3,500 kilowatts[97] lit up Hitler's route (Fig. 1) from the railway station to the Quirinal Palace, where he was to be the guest of the king until his departure from Rome on 9 May.

The "triumphal" route included the Via dei Trionfi and the Via dell'Impero, where large-scale demolitions begun in 1931[98] had "liberated" Roman monuments such as the imperial fora and, at the culmination point of the road's axis, the Colosseum (Fig. 2), on this festive occasion ablaze with red lights. Such sights were intended to give Hitler "an immediate vision, as unexpected as a fantasmagorical revelation, as a miraculous journey in the time . . . of the glorious past."[99] The "fantasmagorical" effects were achieved by means of ingenious methods of lighting to create a "symphony of lights" of different colors and substances. The dominant color was the red of naked gas flames along with mercury and magnesium flares. The spectacular "conflagration" in the ruins of the Colosseum threw into ghostly relief the Palatine and Oppian hills, and the temple of Venus and Rome. No doubt the red fire suggested to some the predominant color of the Nazi flags draped over so many buildings at the time. To others it brought to mind the "noble blood of countless martyrs."[100]

Another writer, with more enthusiasm than critical sense, gave a rapid survey of the *triumphatores* who had entered Rome from the time of Augustus to the present. Hitler's triumphal route was equated with that taken by Charles V after his victory at Lepanto: "The route that goes from Ostia station to Piazza Venezia—through the Viale Africa, the Piazzale del Circo Massimo, the Via dei Trionfi, and the Via dell'Impero—provides an incomparable series of monuments and ruins, imperishable symbols of power."[101]

The most important road on the route was the Via dell'Impero (Fig. 3), inaugurated by Mussolini on 20 October 1932, and ecstatically praised by Giuseppe Marchetti-Longhi in 1934 as "the most beautiful, the most singular, the most grandiose road in the world," which reveals "to our astonished gaze and that of the world three millennia of 'grandezza' and glory."[102] The road began from the Piazza Venezia, where Mussolini had his "seat of

94. Price, *Year of Reckoning*, 182.

95. To look at Saint Peter's in connection with the Berlin Volkshalle plans, which were already well advanced by this date: "Als ich im Herbst 1936 zum erstenmal in Rom vor der Peterkirche stand, wären die Pläne für die Grosse Kuppelhalle Berlins weit gediehen." Speer, *Architektur-Arbeiten*, 2.

96. For an illustration of the station, see F. Mastrigli, "Roma Pavesata," *Capitolium* 13 (1938): 220.

97. Price, 183.

98. I. Insolera, F. Perego, *Archeologia e città: Storia moderna dei fori di Roma*, Rome and Bari, 1983, 77.

99. Mastrigli, "Roma Pavesata," 226.

100. Mastrigli, 227f.

101. L. Huetter, "Gli ingressi trionfali di Roma," *Capitolium* 13 (1938): 245.

102. "La via dell' Impero," *Capitolium* 10 (1934): 54, 56.

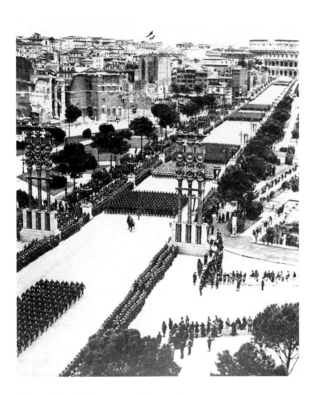

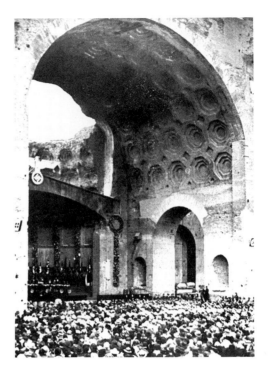

Fig. 4. Hitler (not visible) addresses German expatriates in the Basilica of Maxentius, 4 May 1938

Fig. 3. Via dell'Impero, May 1938

Augustan Exhibition (*Mostra Augustea della Romanità*),[105] which had opened on 23 September 1937 in the Palazzo delle Esposizioni in the Via Nazionale to celebrate the bimillenniary of Rome's "second founder," Augustus, to the political advantage of Rome's "third founder," the Duce. In Germany the event had not gone unnoticed, since not only had the German press given the opening of the *Mostra* full publicity,[106] but German museums had contributed exhibits to the *Mostra*. Indeed, a reviewer of German press reports concerning the excavation of major archaeological sites in Rome praised Hitler's Germany for assuming "the most noble task of cooperating in the salvation of European civilization, and feeling the necessity to investigate that renewed expression of the civilization of Rome represented by the great and constructive political and social revolution created by the Roman genius of the Duce."[107] The Nazi party's newspaper, *Völkischer*

105. For a general account of the history of this lavishly presented exhibition, see A. M. L. Silverio, "La Mostra Augustea della Romanità," in *Dalla mostra al museo: Dalla mostra archeologica del 1911 al Museo della civiltà romana*. Rome, 1983, 77–90.

106. For a summary of more than twenty German newspaper reports published between 20 August 1937 and 4 November 1937, see *Capitolium* 13 (1938): 46f.

107. "La Germania di Hitler che si è assunta il compito nobilissimo di cooperare alla salvazzione della civiltà europea, sente la necessità di indagare quella rinnovata espressione della civiltà di Roma rappresentata dalla grande e costruttiva Rivoluzione politica e sociale creata dal genio romano del Duce"; *Capitolium* 13 (1938): 43.

Beobachter,[108] noted that the Exhibition of the Fascist Revolution (Mostra della Revoluzione Fascista) associated with the *Mostra Augustea* formed the two bases (ancient and modern) for a bridge of continuity.

There was no doubt that the *Mostra Augustea* was approved and financed by Mussolini for propaganda purposes and not as an apolitical academic exercise, although many scholars, under the direction of Giulio Quirino Giglioli, the director of the exhibition, contributed much to its success. The exhibition included no original artifacts. Only carefully presented and exquisitely made models and photomontages were used in order to give a completely homogeneous impression of every aspect of the Roman world. The architect Italo Gismondi was responsible for the supervision and production of the models, all of which were made in Rome. The most spectacular architectural model (Scale 1:250) in the exhibition was of the city of Rome in the time of Constantine, made by Gismondi and others, and occupying a surface area of 80 square meters.[109] The basis for the model was Rodolfo Lanciani's *Forma Urbis*, brought up to date with information derived from new excavations promoted by the Fascist government.

At 16.00 hours on 6 May 1938 Hitler, Mussolini, and their respective entourages made an official visit to the *Mostra Augustea* (Fig. 5). Their guide was Giglioli, who was not only the director of the exhibition but was also a fluent speaker of German. The party entered the octagonal hall that housed the figure of Victory from Brescia. According to reports of the visit published in many Italian newspapers, Hitler showed particular interest in objects that had been found in Germany, models of triumphal arches, Augustus's account of his own achievements (*Res Gestae*), the victory column of Duilius, erected after his naval victory over the Carthaginians, Caesar's pithy war report *veni, vidi, vici* ("I came, I saw, I conquered") inscribed in gold letters on a wall of the "Sala di Cesare," the rooms devoted to the Roman armed forces, and last, the chamber devoted to the new empire won by Fascist Italy, a room dominated by a statue of Victory by the academician Selva. Thus the official tour began and ended with a victory statue, the first ancient, the second modern, and both Italian.[110] The visitors left the Palazzo delle Esposizioni at 17.05 hours for an official reception in the Hall of Julius Caesar in the Palazzo Capitolino, where the reigning Italian tenor Beniamino Gigli sang for the Führer. At the same time Hitler's deputy, Rudolf Hess, and other officials were given an offical banquet at Foro Mussolini in the building that housed the covered swimming pool, with its mosaics of athletes reminiscent of those portrayed on the mosaic from Caracalla's *thermae*.[111]

When Hitler left the *Mostra Augustea* on the afternoon of 6 May, he expressed the wish to see more of it. The following morning his wish to see more of the *Mostra*, as well as

108. Dated 25 September 1937.

109. The model is exhibited today in room 37 of the Museo della Civiltà Romana at EUR. Dr. di Tanna of the museum estimates the cost of the model at today's prices at approximately 2 milliards of lire. Hansen, *Der Schlüssel zum Frieden*, 72, provides photographs of two parts of the model: the Campus Martius and the Circus Maximus. Both were of special interest to Hitler.

110. *Il Telegrafo*, 7 May 1938; *L'Unione Sarda*, 7 May 1938; *Corriere Istriano*, 7 May 1938.

111. *La Gazzetta del Mezzogiorno*, 7 May 1938; *Giornale di Genova* 7 May 1938. For the mosaics at the swimming pool at Foro Mussolini (Italico), see page 127.

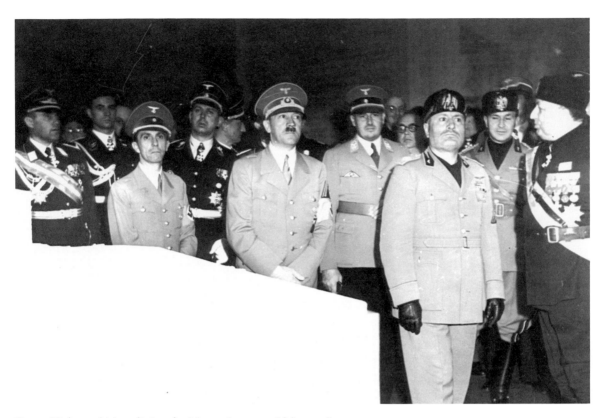

Fig. 5. Hitler and Mussolini at the *Mostra Augustea*, 6 May 1938

other museums and monuments, was unexpectedly granted. Heavy rain on the morning of 7 May caused the postponement of displays by the Italian air force and army. And so Hitler devoted the day to cultural pursuits.

At 9.30, accompanied by Hess, Himmler, Goebbels, Ribbentrop, and former governor of Rome and now the Italian Minister of Education, Giuseppe Bottai, Hitler returned to the *Mostra* for a private visit, and again was guided by Giglioli. This time Hitler examined exhibits illustrating commercial, religious, and private life in the Roman Empire. Religious cults from ancient Germany were noticed with particular interest. In a room dedicated to the cult of the dead in the Roman world, Hitler stopped to contemplate a sarcophagus depicting a woman weeping at the death of her husband. The inscription explaining the scene made it clear that the woman blamed her husband's death on his doctors. This amused Hitler, who summoned his own private doctor and asked him to read the inscription, and with a grin quipped: "Do you see the opinion the ancient Romans had of doctors?"[112] At 10.30 Hitler left the *Mostra* to visit the Capitoline

112. *Corriere della Sera*, 8 May 1938; *Il Messaggero*, 8 May 1938; *Il Telegrafo*, 8 May 1938. Only *Il Telegrafo* reports the anecdote about Hitler and his doctor:

"Vede—gli ha detto sorridendo—l'opinione che i romani antichi avevano dei medici?"

Museum, where he admired the "Capitoline Venus" and the "Dying Gaul," and looked down on the Forum Romanum, which he had seen briefly the previous day from a window in the Tabularium.[113]

After closely inspecting the *Forma Urbis* in the Palazzo dei Conservatori, Hitler moved on to the mausoleum of Hadrian, where his guide was Bianchi Bandinelli, who spoke "perfect German." After looking at all the rooms in this museum, he glanced briefly at Saint Peter's in the distance but did not express a wish to visit it. The Vatican had not invited him to do so, and the pope had moved to his summer residence before Hitler's arrival in Rome. This was not surprising, since on 21 March 1937 the Papal Encyclical ("With urgent concern") condemning Nazi racial policies and the failure of the German state to observe the terms of the Concordat (8 July 1933) was read out in all Catholic pulpits.[114]

From Hadrian's mausoleum Hitler moved on to his favorite Roman building, also of Hadrianic date, the Pantheon, which influenced the design of three of his politically most significant buildings. On the first day of his visit he had laid a wreath there to honor the Italian kings entombed in the building's rotunda.[115] On this occasion, after admiring the porch with its "gigantic ten columns," Hitler asked to be left alone to enter the rotunda. In fact he did not go in alone but entered with the ever-present minister Bottai and Professor Terenzio. Hitler stared in wonder at the dome, and "with a display of reverent emotion" he approached the tomb of Raphael,[116] and with the help of Professor Terenzio read the inscription on the sarcophagus.

The untiring dictator, now joined by Mussolini, next proceeded to the Museo Nazionale in Diocletian's baths where he was received by the museum's director, Professor Moretti. Immediately Hitler was taken to see the reconstructed Ara Pacis Augustae (Fig. 6), which had not yet been resited at the edge of the Tiber in front of Augustus's "liberated" mausoleum. The polygot Bandinelli once more turned up to expound on the main themes of the monumental relief sculptures, which thanks "to the will of the Duce" had now been reassembled after so many centuries.[117] Knowing the Führer's liking for the gigantic, his hosts next showed him the largest Roman mosaic known at that period, discovered at Castel Porziano, and measuring 130 meters in length. At the same time he viewed a recently recovered geometric mosaic discovered beneath the Via Gaeta. The party then went to the first floor of the museum to view Greek sculptures, as well as the garden frescoes removed from the House of Livia on the Palatine.

From Diocletian's baths Hitler went to the Villa Borghese. The time was 17.15 hours. Hitler had been walking through galleries, museums, and monuments for nearly eight

113. *Il Popolo di Sicilia*, 8 May 1938.

114. Baynes, *Speeches*, 372f., 389: The pope kept the Vatican museums closed for the entire duration of Hitler's visit; E. Kuby, *Il tradimento tedesco*, 58.

115. *Hitler in Italia*, 42; "An der Gräbern von Italiens Königen"; Victor Emmanuel II was buried in the second niche on the right, Umberto I in the second on the left.

Hansen, *Schlüssel zum Frieden*, 70, adds that Hadrian added the dome "aus zyklopischen Mauern," and that the porch was built by Septimius Severus and Caracalla. Brick stamps show that the porch and the rotunda of the Pantheon are of Hadrianic date.

116. *Il Telegrafo*, 8 May 1938.

117. *Giornale d'Italia*, 8 May 1938.

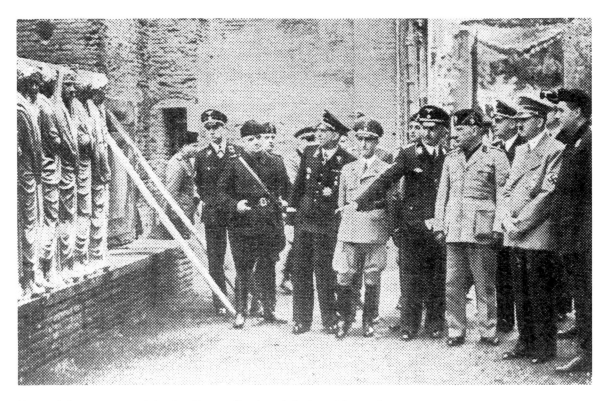

Fig. 6. Hitler views part of the Ara Pacis at Diocletian's baths, 7 May 1938

hours. However, the Villa Borghese was full of Renaissance paintings admired by many in the Nazi hierarchy. Accordingly, Mussolini and Hitler were now joined by Hess, Goebbels, Himmler, Ribbentrop, and others, who perhaps thought the opportunity might provide a useful preview in case in the not too distant future paintings might be "borrowed" for some private collections in Germany or Austria.[118] The director of the gallery, Professor di Rinaldis, and, again, Bandinelli were the guides for this visit. The whole gallery had been specially illuminated to reveal the frescoes of pagan myths on the ceilings of the rooms. Mussolini, who had once proudly, if imprudently, confessed, "Basically, I'm an enormous barbarian, insensitive to beauty,"[119] often acted as guide ("Cicerone"), and showed delight in the presence of such fine works of art.[120] After viewing Florentine paintings, the group was given refreshments in the Egyptian room, "resplendent with African marbles." The visit then concluded, and Hitler was taken by car back to the Quirinal. In the evening Hitler gave an official speech in reply to the welcoming address

118. On the looting of art by the Nazis, particularly by Hitler for his planned museum in Linz, see pages 131–33.

119. "In fondo, vedete, io sono un enorme barbaro,

insensibile alla bellezza"; M. Sarfatti, *Dux*, Milan, 1926, 262.

120. ". . . sente in lui il godimento delle cose belle"; *Il Telegrafo*, 8 May 1938.

from Mussolini in the Palazzo Venezia. He recalled the centuries of strife that had existed between Romans and Germans and attributed this to a lack of clearly defined boundaries between the two nations. Things would now be different. The Italians would stay behind the Alps.[121]

Before Hitler left Rome on 9 May, he was given two official gifts: a fourth-century B.C. vase, a present bestowed at the Palazzo Littorio (Fig. 7), the headquarters of the Italian Fascist party. The second gift was a silver replica of the Capitoline wolf, symbol of Rome's legendary beginnings and an emblem to Rome's subjects of their master's predatory nature. Thus his Fascist hosts ensured that both Greek (South Italian) and Roman antiquity were equally represented by these two official gifts.[122]

At some point in his visit, Hitler spent several hours in the ruins of the Colosseum (Fig. 8) to meditate on the plans of Ludwig Ruff's Congress Hall, already under construction at the rally grounds in Nuremberg.[123] He also visited the ruins of Caracalla's *thermae*,[124] which, like Diocletian's baths, was to be echoed in Cäsar Pinnau's Thermen at the southern end of Berlin's north-south axis.[125]

It is worth noting that archaeologists from the German Archaeological Institute in Rome seem to have played no major part in guiding Hitler and his entourage around the monuments of the Italian capital. Gerhart Rodenwaldt (1886–1945), the president of the institute at the time,[126] had contributed to the flood of material on Augustus's bimillenniary by publishing a celebratory article on the emperor, "Kunst um Augustus," in *Die Antike* (13 [1937]: 1–40).[127] The opening pages of this essay reveal the tension felt by Hitler, Rosenberg, and other Nazis with regard to the relative merits of Greek and Roman art and architecture. Rodenwaldt, who had published several books on Greek sites,[128] pointed out in his essay on Augustus that Homer would mean more to Germans than Virgil, the Acropolis more than the Roman Forum, and sculptures of Olympia more than

121. *Hitler in Italia*, 16; "Indem ich hier auf diesem ehrwürdigsten Boden unserer Menschheitsgeschichte stehe, empfinde ich die Tragik eines Schicksals, das es einst unterliess, zwischen diesen so hochbegabten und wertvollen Rassen eine klare Grenzscheide zu zeichnen. Unsagbares Leid von vielen Generationen war die Folge . . ."

122. For the gift of the vase, see Domarus, who reprints the speeches given by Hitler on this visit; *Hitler, Reden und Proklamationen 1937–1945*, Munich, 1965, II, 856–62. For the silver wolf photographed crated, see *L'Urbe* 3 (1938): 45. Hitler must have seen the Etruscan bronze original, the base of which rests on a Roman mosaic pavement decorated with swastikas, when he visited the Palazzo dei Conservatori.

123. Thies, *Architekt*, 76.

124. Taylor, *The Word in Stone*, 39.

125. See page 119.

126. Rodenwaldt and his wife took their own lives in Berlin on 27 April 1945. Though he never belonged to a Nazi organization, he viewed the Nazi regime, at least initially,. with an enthusiasm that shows through in several of his works; see A. H. Borbein, "Gerhart Rodenwaldt," *Archäologischer Anzeiger*, 1987, 697–700.

127. Subsequently reprinted as a book of the same title in 1942 by de Gruyter in Berlin.

128. *Olympia* (1936), coinciding with the Olympic Games in Berlin in the same year. German excavations had been carried out at Olympia between 1875 and 1881, but not completed. Hitler decided after gaining the permission of the Greek government to complete the excavations of the festival and sports grounds; Baynes, *Speeches*, 604. Other works on Greek sites by Rodenwaldt were *Altdorische Bildwerke in Korfu* (1938), *Die Bildwerke des Artemistempels von Korkyra* (1939), and *Die Akropolis* (1941). He also wrote an essay on the Via dell' Impero, published in Berlin in 1934.

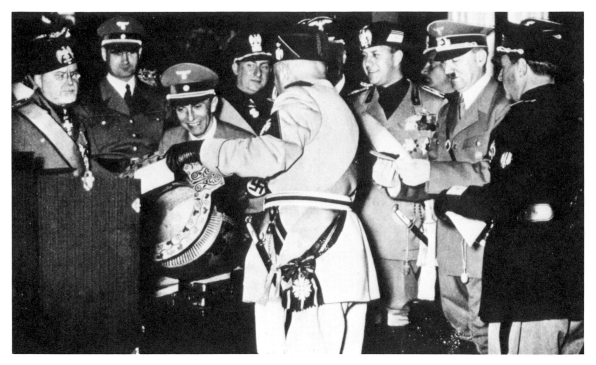

Fig. 7. Hitler receives an "Etruscan" vase from the Italian Fascist party

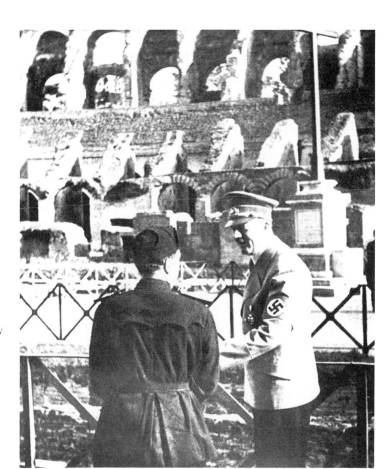

Fig. 8. Hitler in the Colosseum, May 1938

Roman portrait sculptures, yet there were more parallels between contemporary German art and Roman art:

> The Reichssportsfeld is less reminiscent in its overall plan of the shrine of Olympia than of the Forum of Trajan [129]. . . . The Olympic Stadium in Berlin has the shape of a Roman amphitheater; the Congress Hall at Nuremberg puts motifs of the Roman theater in the service of a new task. When we experience that architectonic complexes like Königsplatz in Munich and the Forum of Frederick in Berlin produce a new effect through the liberation of their axes and the completion of their spatial composition, we organize and see in a Roman way and with Roman eyes.[130]

It is important to stress that Rodenwaldt's work on Augustus, unlike the works by Bottai and Balbo on the same emperor (also written in 1937), which sought to establish precise parallels in policy between Mussolini and Augustus, did not make tasteless and extravagant comparisons between Hitler and Augustus.[131] It is clear from Hitler's later recollections of this visit that the magnificence of Rome's architecture impressed him more than the achievements of Mussolini. His visit to the *Mostra* is enthusiastically recalled in his table talk in 1941,[132] and on returning to Berlin from his sightseeing visit to Paris in June 1940, he claimed he had already forgotten the French capital, which apart from the Arc de Triomphe had nothing on the same scale as the Colosseum, Hadrian's mausoleum,[133] or Saint Peter's. He also found Hadrian's Pantheon superior to the Panthéon in Paris. Thus Hitler concludes his eulogy of Rome with the exclamation: "Rome completely bowled me over!"[134] Yet he could rarely admire a city or monument

129. Cf. Borbein, "Rodenwaldt," 698.

130. "Das Reichssportsfeld erinnert in seinem Gesamtplane weniger an das Heiligtum von Olympia als an das Forum des Trajan. . . . Das Olympiastadion zu Berlin hat die Gestalt eines römischen Amphitheater, die Nürnberger Kongresshalle stellt Motive des römischen Theaters in den Dienst einer neuen Aufgabe. Wenn wir erleben, das architektonische komplexe wie der Königliche Platz in München und das Forum Fridericianum in Berlin durch Befreiung und Betonung ihrer Achsen und Vollendung ihrer räumliche Komposition zu neuer Wirkung erstehen, so gestalten und sehen wir in römischen Sinn und mit römischen Augen"; *Kunst um Augustus*, Berlin, 1942, 7f. Prior to this Rodenwaldt claimed that Germans, Celts, and Italians were racially closer to each other than they were to the Greeks (4). He also illustrated the difference between Greek and Roman architecture by contrasting the randomly organized buildings of the Athenian Acropolis with the organized overall plan of a Roman imperial forum: "Kaiserforum und Parthenon repräsentieren den tief im Volkstum wurzelnden

Unterschied von griechischen und römischen Architektur"; "Via dell' Impero in Rom," *Zentralblatt der Bauverwaltung vereinigt mit Zeitschrift für Bauwesen* 23 (1934): 311. He here again explicitly compares the Olympic sports field to Trajan's Forum (ibid.).

131. For Bottai and Balbo, see page 20 above; a discreet link between Augustus and Hitler was made by E. Sturzenacker, "Die deutsche Baukunst und die Antike," *Baugilde* 19 (1938): 624, where it is said that Vitruvius lived in the time of an outstanding leader and was the interpreter of a heroic worldview that reached over the centuries "to our times."

132. *Table Talk*, 111.

133. Which was larger than the mausoleum of Augustus (and not closely associated with Mussolini). Hitler owned a painting by Rudolf Alt depicting Hadrian's mausoleum and Saint Peter's; Backes, *Adolf Hitlers Einfluss*, 361.

134. "Rom hat mich richtig ergriffen"; Picker, 112. Thus, the sentiments expressed in the telegram sent by Hitler to the Italian king on the eve of his return to

without at the same time wishing to emulate and, if possible, to surpass it. Thus his plans for Berlin, which as the capital of his world empire was to be renamed Germania, were intended to make its architecture more "breathtaking" than Rome's, "our only rival in the world."[135]

Just as a brief indication of Greek architectural influences on prominent German architects of the nineteenth century provided some background for the avowed "Doric" preferences of Rosenberg and Speer, so a similar consideration of Roman influences on German architects of the same period will serve to explain continuities in Hitler's state architecture and town planning.

It is important to appreciate that interest in Greek architecture on the part of German architects in the nineteenth century did not displace but was often combined with Roman architectural interests, which architects like Gilly acquired at least in part through familiarity with the French imperial architecture of the late eighteenth century. An instructive example of this combination of Greek and Roman elements is provided by Gilly's plan for an Exchange[136] (Börse; 1799) copied by Leo von Klenze in 1802, the central part of which was based on Hadrian's Pantheon; yet its diagonal axes show a debt to Ledoux's plan for Château de St. Vrain,[137] an influence not unexpected, since Gilly drew his plan after his visit to France. Yet instead of designing a Corinthian pronaos congruent with that of its Roman model, Gilly drew a Doric porch with four columns, perhaps influenced by his visit to Doric temples in Sicily in 1792.

Schinkel, whom Speer professed to be one of his inspirational models, produced plans that reveal similar eclectic tendencies. His plan for Schloss "Belriguardo," based on ideas sketched by Friedrich Wilhelm IV of Prussia in 1823, is reminiscent in several of its features (hippodrome, triumphal arch, and massive substructures) of Roman imperial palaces, but these are combined with a number of Greek prototypes.[138]

Another important source of Roman influence can be traced to the sumptuously illustrated books on Pompeii, such as François Mazois's *Les ruines de Pompéi*, the four volumes of which were published in Paris between 1824 and 1838. Illustrations from this book provided Carl F. Busse with ideas for a villa he designed in 1827. The plan incorporated a columned hall leading directly into a peristyle, which Bothe suggests is derived from Domitian's *Domus Augustana*,[139] known from illustrations in Giuseppe Antonio

Germany (11 May 1938) seem sincere: "The period of my stay in places of an antiquity worthy of admiration, and of a proved and self-assured present will belong to the most precious memories of my life." (Die Tage meines Aufenthaltes an Stätten einer ehrwürdigen Vergangenheit und einer stolzen selbstsicheren Gegenwart werden zu meinen kostbarsten Lebenserinnerungen zählen); *Hitler in Italia*, 130. On 12 September 1938 in Nuremberg he remarked that the Roman Empire "begins to breathe again," with reference to Mussolini's Italy: Baynes, *Speeches*, 1498.

135. *Table Talk*, 81; cf. Baynes, *Speeches*, 600f.

136. Figure 602 (plan) and 603 (elevation) in Bothe, 303.

137. Bothe, 315; "Gilly was, probably, the last of the revolutionary architects, the last follower of Boullée"; J. Posener, *From Schinkel to the Bauhaus*, London, 1972, 12.

138. Bothe, 315; Eva Börsch-Supan, "Friedrich Wilhelm IV, und das antike Landhaus," in Arenhövel, Schreiber, eds., *Berlin und die Antike*, 491–94.

139. Bothe, 315f: "Die Eingangssituation, eine direkt ins Peristyl führende Säulenhalle, entnahm Busse der sogenannten Domus Augustana."

Guattani's *Roma descritta ed illustrata* (1805). Other elements of Busse's villa were derived from the villa of Diomedes, illustrated by Mazois.[140] At this period the Greek house was not known from archaeological remains, so many stately homes (herrschaftlichen Wohnbauten) were inspired by Roman villas and imperial palaces.

German architects were also familiar with Pliny's descriptions of his Tuscan and Laurentine villas (*Epp.* 5.6; 2.17). Schinkel's plans for a villa at Charlottenhof (1833–35) included a stibadium resting on a rectangular substructure, with four Ionic columns framing a fountain, and a garden hippodrome—both derived from Pliny's account of his Tuscan villa. Schinkel drew plans of this villa as he envisaged it from Pliny's letter—one drawing of the stibadium (1841)[141] and two of the entire villa complex (1846).[142] The interior decoration of Pompeian houses also influenced the decoration of some German aristocratic houses of the period. Some architects visited Pompeii, as Schinkel did in 1824, whereas others derived their knowledge of Pompeian art from the lavish publications already referred to (see note 140). Schinkel's *Festsaal* for the palace (1829–31) built in Berlin (Unter den Linden) was decorated with wall paintings inspired by Pompeian *trompe l'oeil* architectural devices (Scheinarchitekturen).[143]

Knowledge of the great Roman *thermae* was also advanced during this period through the publication of Guillaume Abel Blouet's *Restauration des thermes d'Antonin Caracalla à Rome* (1828). The teaching of architecture in Berlin was as closely associated with archaeology in the nineteenth century[144] as it was when Speer studied architecture at the Berlin Technical Institute (Technische Hochschule) from 1925 to 1927, and taught there as Heinrich Tessenow's assistant from 1927 to 1932. His principal professor of architectural history was the archaeologist Daniel M. Krencker (Rector 1930–31), the author of many studies of Roman architecture, including the still-indispensable *Die Trierer Kaiserthermen* (1929), as well as a work that might also have attracted Speer's attention, *Vom Kolossalen in der Baukunst* (1926).[145]

140. For other lavish publications like that of Mazois, see W. Zahn, *"Die schönsten Ornamente und merkwürdigsten Gemälde aus Pompeji,* Berlin, 1829–58; W. Ternite, *Wandgemälde aus Pompeji und Herculaneum,* 11 vols., Berlin, 1859ff.; F. and F. Niccolini, *Le case ed i monumenti di Pompei disegnati e descritti,* 4 vols., Naples, 1854–96; H. Roux, L. Barré, *Herculaneum et Pompéi,* 8 vols., Paris, 1840; P. Werner, *Pompeji und die Wanddekorationen der Goethezeit,* Munich, 1970.

141. Helen H. Tanzer, *The Villas of Pliny the Younger,* New York, 1924, 128; the drawing shows four columns that are not Ionic, as Bothe (316) describes them.

142. Tanzer, 125 (plan), 127 (elevation).

143. Bothe, 326.

144. A. Borbein, "Klassische Archäologie in Berlin vom 18. zum 20. Jahrhundert," in Arenhövel, Schreiber, eds., *Berlin und die Antike,* 49–150.

145. Barbara Miller Lane in her review of Speer's *Memoirs* also mentions Speer's exposure while at the Berlin Institute to Krencker's assistant, W. Andreae, whose main field was Near Eastern archaeology; *Journal of the Society of Architectural Historians* 32 (1973): 344 and nn. 17, 18; cf. idem, *Journal of Interdisciplinary History* 17 (1986): 302f.

II

THE STATE, THE INDIVIDUAL, AND THE NAZI CITY

In book 1, chapter 10, of *Mein Kampf,* Hitler states that industrialized German cities of his own day lacked dominating public monuments and a central focus for community life.[1] The salient feature of ancient towns was their community buildings (Gemeinschaftsbauten), built to last an eternity and that were reflections of the greatness and wealth of the community as a whole. In the ancient city, the buildings of private individuals did not surpass in size and splendor the buildings of the state, which served to unite the individual citizen to his city. In ancient Rome pride of place was assigned to temples, baths, stadia, theaters, circuses, and aqueducts. If the fate of Rome were to overtake Berlin, the only monuments to survive would be the department stores of a few Jews and the hotels of a few corporations. Hitler concludes this passage with the remark that insufficient funds were being allocated to state buildings in Germany and that the materials being used for such structures were not sufficiently durable.

Whether or not these statements were accurate at the time Hitler wrote them is of little concern here.[2] The important point is that this passage enunciated principles of organization and emphasis that after Hitler's assumption of power in 1933 were to dominate Nazi

1. Adverse criticism of the rapid industrialization of German cities after 1870 had already been voiced by J. Ruskin and W. Morris; see Krier, ed., *Albert Speer,* 219; A. Lees, *Cities Perceived: Urban Society in European and American Thought, 1820–1940,* Manchester, 1985, 269–88.

2. On 11 September 1935 in Nuremberg, Hitler repeated these ideals with little change. Having again pointed out the prominence of private buildings in the cityscapes of modern Germany, he emphasized it was the task of National Socialism to abandon this tendency; Baynes, *Speeches,* 583.

town planning and state architecture.[3] The ideal Nazi city was not to be too large, since it was to reflect preindustrial values,[4] and its state monuments, the products and symbols of collective effort (Gemeinschaftsarbeiten), were to be given maximum prominence by being centrally situated in the new and reshaped cities of the enlarged Reich. Moreover, these community buildings were to be built from the most durable natural materials (preferably granite),[5] which, so Hitler thought, would ensure that the Reich's monuments would endure for thousands of years, just as the Colosseum had "survived all passing events."[6] The emphasis on monumental community buildings was consistent with the anticipated role of the individual within the emergent Nazi state, in which selfless heroism in the interests of the *Volk* was to be the encouraged norm, one that was to assume lethal dimensions upon the outbreak of war.[7] Classical scholars receptive to the new ideal were not slow to see parallels in the ancient world. For example, Joseph Vogt noted that "the powerful effect of creative personalities gave the Greek polis in war and peace, in secular and religious pursuits, the fulfillment of a self-conscious community. The poet was prophet and singer of the community, not the interpreter of his own private emotions," and *res publica,* the commonwealth (Gemeinwesen), belonged to the whole nation (Gemeinvolk).[8]

At the end of the Roman Republic it was commonplace for writers to moralize about a

3. The passage was quoted at length by Speer in his earliest Nazi publication, "Die Bauten des Führers," in *Adolf Hitler: Bilder aus dem Leben des Führers,* Hamburg and Barenfeld, 1936, 77, where he says the large buildings designed by Troost on Königsplatz and the House of German Art (Munich) were to be viewed as realizations of the principles embodied in this part of *Mein Kampf.* Speer later claimed he did not write this article, even though it appeared under his name; W. Hamsher, *Albert Speer,* London, 1970, 85; eight years later Speer changed his mind when he wrote the preface to *Albert Speer: Architektur-Arbeiten,* 1978, 1, where he refers to this article as his own work.

4. R. W. Darré's ruralism was fundamentally antiurban. There was a basic contradiction in Hitler's own "centralized urban projects representing the power-dictator ideal, and the rural housing and labour schemes suggestive of the decentralised state which did not exist"; J. Elderfield, "Total and Totalitarian Art," *Studio International,* April 1970, 153f. Barbara Miller Lane analyzes a variety of ideological conflicts and contradictions inherent in Nazi thinking as it affected architecture, 185–90. For antiurban policies in Italian Fascism, see di Anna Treves, "La politica antiurbana del fascismo e un secolo di resistenza all'urbanizzazione industriale in Italia," in A. Mioni, ed., *Urbanistica fascista,* Milan, 1986, 313–30.

5. *Table Talk,* 81; hardness and coldness ("Eiskalt"

was one of Hitler's favorite epithets) were qualities cherished by the Führer; cf. Picker, 102. Paintings of granite quarries appeared to be fashionable topics for Nazi painters, e.g., Erich Mercker's *Granite Quarry, Flossenbürg* (1941); see Hinz, *Art in the Third Reich,* 202 and plate 111 for other paintings of quarries.

6. *Table Talk,* 82.

7. Official Nazi art hammered home the concept; see Hinz, 213–25. "Fascism, unlike Marxist orthodoxy, did not exclude the cult of the individual, provided that the individual could be seen as the executor of some organic national force; G. L. Mosse, S. G. Lampert, "Weimar Intellectuals and the Rise of National Socialism," in J. E. Dimsdale, ed., *Survivors, Victims and Perpetrators,* Washington, D.C., 1980, 85.

8. "Die starke Wirkung schöpferischer Persönlichkeiten gab der griechischen Polis in Krieg und Frieden, in Spiel und Kult die Vollendung selbstbewussten Gemeinwesens. Der Dichter war Seher und Sänger der Gemeinschaft, nicht der Höriger seiner privaten Gefühle . . . "; "Unsere Stellung" 12f.; cf. Eberhardt, "Die Antike," 115. Vogt's words reflect those of Hitler when opening the House of German Art in Munich on 18 July 1937: "Der Künstler schafft nicht nur für den Künstler, sondern er schafft genau so wie alle anderen für das Volk"; Frank, ed., *Faschistische Architekturen,* 11; Baynes, *Speeches,* 591f.

conflict between private *luxuria* and public *magnificentia*.[9] Augustus set an example for self-indulgent aristocrats by living in a modest house on the Palatine,[10] which contrasted starkly with the palatial houses of people like Scaurus, the tetrastyle atrium of which was supported by marble pillars eleven meters high. Assuming that the atrium was in proportion to the dimensions of its pillars, no room in the *domus Augusti* approached it in size.[11] Instead, Augustus spent heavily on the restoration of *opera publica*.[12]

Hitler's comments in *Mein Kampf* (1.10) indicated that he saw buildings such as the Colosseum and the Circus Maximus as symbols of the political might and power of the Roman people and its empire. The view that state architecture is a manifestation of the authority of the empire was expressed by Vitruvius, who states in his preface addressed to Augustus: "I observed you cared not only about the common life of all men . . . but also about the provision of suitable public buildings, so that the state was not only made greater through you . . . but the majesty of the empire (*maiestas imperii*) also was expressed through the eminent dignity of its public buildings."[13] The same phrase, *maiestas imperii*, is employed in an architectural context by Suetonius in his biography of Augustus where he says the emperor considered the capital's architecture did not match the majesty of the empire.[14] Augustus's boast that he found Rome built in sun-dried brick and left it in marble is the best-known part of this passage, a boast that Dio Cassius interpreted as a metaphor for the soundness of the empire at the end of Augustus's reign.[15]

It is interesting to see Rodenwaldt drawing an explicit comparison between Nazi state architecture planned to enhance Berlin "pro maiestate imperii" and Roman state architecture.[16] In so doing he refers to Speer's *Neue Deutsche Baukunst* (Berlin, 1941, 76), where a comparison is made between the Forum of Trajan and the model of the Wehrtechnische Institut in Berlin. Rodenwaldt has to confess that "the Greek temple is dead; but from its ruins comes an unceasing current of productive vigor."[17] In this same essay the German archaeologist comments that "like almost all great constructive statesmen he [Augustus]

9. Cicero, *pro Murena* 76: odit populus Romanus privatam luxuriam, publicam magnificentiam diligit: cf. Sallust, *Cat.* 52.22; Velleius 2.1.2. See further H. Drerup, *Zum Ausstattungsluxus in der römischen Architektur*, Münster, 1957, 7.

10. Suetonius, *Divus Augustus* 72; G. Carettoni, *Das Haus des Augustus auf dem Palatin*, Mainz, 1983. For a useful survey of all imperial palaces on the Palatine, see H. P. Isler, "Die Residenz der römischen Kaiser auf dem Palatin," *Antike Welt*, 9 (1978): 2–16.

11. F. Coarelli, *Roma sepolta*, Rome, 1984, 127. This house (built in 58 B.C.) was later bought by Clodius for HS 14,500,000.

12. *Res Gestae*, 19–21.

13. Vitruvius 1.2 *On Architecture*, trans. F. Granger, London, 1970, I, 3.

14. ". . . urbem neque pro maiestate imperii orna-

tam . . . excoluit adeo ut iure sit gloriatus marmoream se relinquere quam latericiam accepisset"; *Dirus Augustus*, 28.

15. "He did not thereby refer literally to the appearance of the buildings, but rather to the strength of the empire" (56.30.4). A view supported by Tacitus's description of the appearance of Rome at the time of the A.D. 64 fire; *Annals* 15.43.

16. "Röm. Staatsarchitektur," 373.

17. "Der griechische Tempel ist tot; aber aus seinen Trümmern kommt ein unablässiger Strom fruchtbarer Kraft"; this comes after saying that despite the Roman aspects of Nazi town planning, fora, and axial symmetry, "form strives after the simplicity of the Doric style" (strebt die Form nach der Einfachheit des dorischen Stil); ibid.

considered architecture the most political of arts as an expression of power,"[18] words that might have been spoken by Hitler himself: "Architecture is not only the spoken word in stone, it is the expression of the faith and conviction of a community, or else it signifies the power, greatness, and fame of a great man or ruler."[19] Likewise in his "cultural" address, "The Buildings of the Third Reich," delivered in September 1937 in Nuremberg, Hitler affirmed that the new buildings of the Reich were to reinforce the authority of the Nazi party and the state, and at the same time provide "gigantic evidence of the community" (gigantischen Zeugen unserer Gemeinschaft). The architectural evidence of this authority could already be seen in Nuremberg, Munich, and Berlin, and would become still more evident when more plans had been put into effect.[20]

Pliny the Elder went further than Vitruvius in expressing his views on the meaning of Rome's *opera publica,* "by which we have conquered the world." The main emphasis of Pliny's panegyric is the intimidating grandeur arising from the colossal dimensions of the public works with which the Romans tame and dominate the natural environment.[21] This is illustrated by Pliny's account of the Cloaca Maxima, praised not for its contribution to urban hygiene but because of the durability of its fabric, which confines raging underground torrents and resists the collapse of Rome's jerry-built *insulae.*[22]

Nazi architecture was also both in appearance and symbolically intimidating—an instrument of conquest; total architecture was an extension of total war.[23] "My architecture represented an intimidating display of power," Speer wrote in 1978.[24]

The colossal dimensions of Roman and Nazi buildings also served to emphasize the insignificance of the individual engulfed in the architectural vastness of a state building. Rousseau's reactions on visiting the Pont du Gard in 1737 produced in the philosopher the response that Hitler hoped Berlin, after its transformation into a world capital, would

18. "Wie fast alle grossen konstruktiven Staatsmänner hat er die Architektur, die dadurch zur politischten aller Künste wird, als Ausdruck der Macht betrachtet"; 358. Rodenwaldt had already in 1934 tried to explain the significance of *maiestas imperii* and *publicorum aedificiorum egregias auctoritates:* "Wort und Begriff 'auctoritas' sind spezifisch römisch, kaum übersetzbar und schwer zu umschreiben. . . . Der Begriff 'auctoritas' enthält die Vorstellung einer dynamischen Kraft, von der eine Wirkung ausgeht. Die Majestät der Herrschaft erfährt durch die den öffentlichen Bauten sichtbar innewohnende und von ihnen austrahlende Macht eine Steigerung. Diese Wirkung setzt ein Volk voraus, das zu sehen und, wie die Bedeutung der Malerei in Rom zeigt, nicht nur durch das gesprochene und gelesene wort, sondern auch durch das anschaulich gemalte Bild zu lernen gewonnt war . . . römische Architektur kann nicht rein ästhetisch, sondern erst aus dem Begriff der 'auctoritas' heraus ganz gewürdigt werden"; "Via dell' Impero," 309.

19. "Architektur ist nicht nur die Sprache in Stein, sie ist der Ausdruck von Glaube und Überzeugung einer Gemeinschaft, oder sie kennzeichnet Macht, Grösse und Ruhm einer Persönlichkeit, eines Herrschers . . ."; Giesler, 203; see further H. Frank, "Welche Sprache sprechen Steine?" in idem, *Faschistische Architekturen,* 7–21.

20. Anna Teut, *Architektur im Dritten Reich,* Berlin, 1967, 189; cf. J. Petsch, *Baukunst und Stadtplanung im Dritten Reich,* Munich, 1976, 83; Miller Lane, *Architecture and Politics,* 188; Speer, *Erinnerungen,* 68f.

21. *Natural History* 36.101–6; cf. Frontinus, 2.119, where he says Rome's aqueducts are a symbol *magnitudinis Romani imperii.*

22. H. Drerup, "Architektur als Symbol," *Gymnasium* 73 (1966): 184, where Drerup describes Pliny's account as a struggle "zwischen Menschenwerk und Naturgewalt."

23. Lehmann-Haupt, 111.

24. Krier, ed., *Albert Speer,* 213; cf. Hamsher, *Albert Speer,* 77, "my buildings were heavy and menacing, constructed, so to speak, with too much muscle on them."

produce on the Kirghiz tribesmen, whom he intended to bring to the capital from time to time to impress them with its grandeur:[25] "I went through the three storeys of this superb building, within which a feeling of respect almost prevented me from setting foot. The echo of my footsteps under these immense vaults made me imagine that I heard the sturdy voices of those who had built them. *I felt myself lost like an insect in this immensity.* I felt, in spite of my sense of littleness, as if my soul was somehow or other elevated, and I said to myself with a sigh, 'why was I not born a Roman?' "[26]

The new community buildings were not to be randomly sited in towns, but were to have prominent (usually central) positions within the town plan. The clarity, order, and objectivity that Hitler aimed at in the layout of his towns and buildings were to be achieved in conquered territories in the East by founding new colonies, and in Germany itself by reshaping the centers of already established towns and cities.[27] In order to provide towns with centrally located community centers, principles of town planning reminiscent of Greek, but more especially of Roman, methods were revived.

Roman Forum, Fascist Piazza, Nazi Platz

The Roman town plan most typical of cities built as colonies is best exemplified by Timgad (Algeria), founded in A.D. 100 for Trajan's veterans.[28] Here the plan is rigorously rectilinear (Fig. 9). One major axis (*decumanus*) bisects the town from east to west and another (*cardo*) from north to south, but at Timgad this axis culminates where it joins the *decumanus* to form a "T" junction. The entrance to the town's forum is directly opposite this junction, and the town's "community buildings"—temples, shops, curia, basilica— are placed around the edge of the forum. The fora of many Roman towns are so arranged.[29] There is a strong resemblance between this arrangement and the siting of the commander's headquarters in a typical legionary camp at the junction of the *via decumana* (leading from the *porta decumana*) with the *via principalis*. Again it is a question of a "T" junction.[30]

25. Picker, 143f., 190.

26. *Confessions of J. J. Rousseau*, trans. J. Grant, London, 1931, I, 235; the amphitheater at Nimes made little impression on him, since it still contained houses in its arena at the time of his visit; ibid.

27. For Nazi town planning, see Taylor, 250–69 ("The New German City"); Petsch, *Baukunst und Stadtplanung*, 75f.; and especially J. Dülffer, J. Thies, J. Henke, *Hitlers Städte: Baupolitik im Dritten Reich*, Cologne, 1978.

28. C. Saumagne, "Le plan de Timgad," *Revue Tunisienne*, 1933, 35–56, especially 55; it is important to note that not all Roman towns in North Africa share Timgad's precise geometric layout; see R. Thouvenot, "L'urbanisme romain dans le Maroc," *Revista de la*

Universidad de Madrid 118 (1979): 333–36, for irregularities in the plans of Banasa, Volubilis, and other Roman towns in Mauretania. For Djemila's "relaxed orthogonality," see MacDonald, *Architecture of the Roman Empire*, II, 5.

29. R. Martin, "Agora et forum," *Ecole Français à Rome. Mélanges* 84 (1973): 911, where the forum is characterized as "un élément de coordination entre les axes principaux de circulation, leur imposant le rôle de centre attractif des édifices politiques, réligieux administratifs à l'interieur du groupement urbain"; for plans of Cologne, Vienne, Arles, and Djemila, see A. Pelletier, *L'Urbanisme romain sous l'Empire*, Paris, 1982, 33, 42f., 45.

30. For a plan of the camp described by Polybius

Fig. 9. Timgad (Algeria). Forum at
junction of *cardo* and *decumanus*

Ironically, the city of Rome had never enjoyed the benefits of an orthogonal plan. The
congestion of traffic and pedestrians in Rome's often narrow and winding streets has been
vividly recorded by Juvenal in his invective against life in Rome in the first half of the
second century.[31] However, the Fascists were going to rectify this situation, which had
persisted for almost 2,500 years. A group of planners ("La Burbera") under the leadership
of Gustavo Giovannoni published plans in 1929 for the creation of a *cardo* that would
have passed from Piazzale Flaminio in the north to Piazza S. Giovanni in the south, and a
decumanus going from S. Umberto in the east to Termini in the west. Close to the
crossing of these two arterial axes was to be an enormous piazza, the Foro Mussolini,[32]
with buildings in a Romano-Babylonian style. These plans, if carried out, would have

6.27–42, see F. W. Walbank, *A Historical Commentary
on Polybius*, Oxford, 1984, 1, 710. As Walbank points
out (710), Schulten found the remains of a Roman
camp near Numantia, where the praetorium flanked by
a forum and a quaestorium "lie along the cross axis at
right angles to the via principalis."

31. *Satire* 3.236–48; A. Garcia y Bellido, *Urbanistica
de las grandes ciudades del mundo antiguo*, Madrid, 1985,

117–65 ("Roma como problema urbano").

32. Several symmetrical Fascist fora with axially em-
phasized politically important buildings were built or
planned in Rome, e.g., Del Debbio's Foro Mussolini
(1927–32) and Moretti's Concorso per il Palazzo della
Civiltà Italiana; Silvia Danesi L. Patetta, eds., *Il
razionalismo e l'architettura in Italia durante il fascismo*,
Venice, 1976, pls. 271, 282.

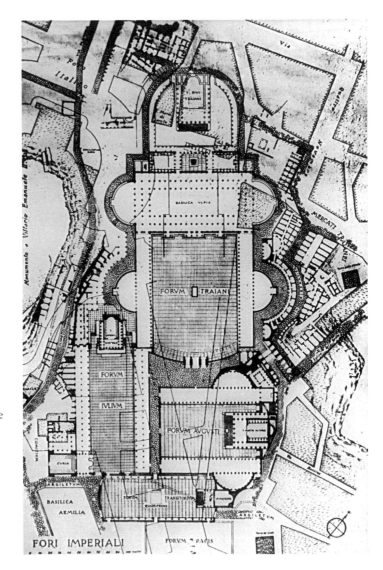

Fig. 10. Plan of the imperial fora, Rome

involved the demolition of large parts of central Rome, so that, not surprisingly, Giovannoni soon earned the nickname "the new Attila." Another group of "Roman" planners, which received less publicity than "La Burbera," also published a plan for a large central axis that would have necessitated large-scale demolitions.[33]

Yet Rome had its enclosed imperial fora (Fig. 10), the most important being those of Julius Caesar, Augustus, and Trajan, each of them dedicated to the glory and cult of one

33. The plans were fortunately never put into effect. L. Piccinato, "Il momento urbanistico alla prima Mostra Nazionale dei Piani Regolatori," *Architettura e Arti Decorative* 9 (1929/30): 195–235, especially 220–27 ("La Burbera") and 231 (the "Roman" group). See also Cederna, *Mussolini urbanista,* 85, 113f., 117 (Giovannoni as a second Attila); Fried, *Planning the Eternal City,* 31.

man, and very different from the open commercial town forum.[34] At the end of the long axis of each of these fora is a temple of special significance to the builder of each forum: Venus Genetrix (Caesar), Mars Ultor (Augustus), Divus Trajanus (Trajan). Trajan's forum is exceptional not only for its large size but also for its layout, with a longitudinal axis that begins at the center of its triumphal entrance gate and then passes through the emperor's equestrian statue, the centers of the transversely positioned Basilica Ulpia, and Trajan's historiated column, before culminating in the temple built by Hadrian but dedicated to Trajan.[35] Each forum was enclosed by a perimeter wall that sealed it off from adjacent buildings and gave it the appearance of a cult enclosure.

The arrangement of an axially emphasized temple at one end of a forum longer than it is broad was not confined to Rome's imperial fora. At the northern end of Pompeii's main forum is the temple of Capitoline Jupiter, and at the southern end are three administrative buildings. The longitudinal axis bisects the temple and the central administrative building, the curia.[36]

The basilica at Pompeii is placed on the southeastern side of the forum, whereas in many towns in the north of Italy and the western provinces (Velleia, Lutetia, Augst, Virunum, Conimbriga),[37] a basilica is placed transversely at one end and "might or might not have a temple in some symmetrical relationship to it"[38] at the other. The strong axial emphasis of buildings of special political and religious significance in both the imperial fora in Rome and in the basilica-forum of the western provinces is typically Roman and was interpreted by Rodenwaldt as a symptom of a centralized bureaucracy.[39] Equally Roman and un-Greek was the axial arrangement of the atrium house, with the tablinum as the culmination point of the dwelling's longitudinal axis, after it passed through the front entrance and the atrium courtyard. This spatial arrangement gave the tablinum pride of place in the hierarchical ordering of the rooms in the Roman *domus*. This was the office of the male head of the *familia* (*paterfamilias*), the master of slaves (*dominus*), and the patron of clients (*patronus*), who consulted him in this room.[40]

34. For the influences that led to the emergence of the imperial forum, see Mansuelli, *Architettura e città,* Bologna, 1970, 238f.

35. P. Zanker, "Das Trajansforum als Monument imperialer Selbstdarstellung," *Archäologischer Anzeiger,* 1970, 499; the only major excavations of this forum have been undertaken by Napoleon and Mussolini (501). Rodenwaldt, *Kunst um Augustus* (1942), 5, commented that the Berlin Olympic Stadium (Reichssportfeld) was more reminiscent of Trajan's Forum than of the sanctuary of Olympia; see further Martin, "Agora et forum," 921–27.

36. J. B. Ward-Perkins *Roman Imperial Architecture,* Harmondsworth, 1981, 159, labels the central building at the southern end of the axis as "City Office"; R. C. Carrington, *Pompeii,* Cambridge, 1936, 159, identifies the central structure as the curia, with the buildings of the *duoviri* and *aediles* flanking it. For the plan of

Pompeii's forum in the fifth century B.C., see Mansuelli, *Architettura e città,* 182–84; towns in the western provinces had a Capitolium, or a sanctuary dedicated to the cult of Rome and the emperor at one end of their fora; Martin, "Agora et forum," 930.

37. Pelletier, 59–63.

38. Ward-Perkins believes this type of forum originated in northern Italy, from where it passed to Gaul and Germany; "From Republic to Empire: Reflections on the Early Provincial Architecture of the Roman West," *Journal of Roman Studies* 60 (1970): 6–13.

39. "Röm. Staatsarchitektur," 560.

40. "Le principe de symétrie axiale qui se retrouve dans la maison à atrium ou les fora impériaux répondait au goût romain. A la différence de la cité grecque décentralisée, la discipline militaire et politique de Rome ordonne les habitations autour de l'endroit où s'exerce le pouvoir du magistrat, le forum situé au

According to Ghirardo and Forster, Fascist Rome was provided with three fora, which were seen as a continuation of the imperial fora of Caesar, Augustus, and Trajan. The Foro Mussolini, built under the direction of the architect Enrico Del Debbio between 1927 and 1938, initially celebrated physical strength and martial arts. At the time of its construction it was seen as the return in Italy of "the gymnasium of the Greeks and Romans, the most perfect expression of the Mediterranean spirit and of the Latin world of the better period."[41] The complex included the Fascist Academy of Physical Education, tennis courts, an Olympic stadium, a lavishly built marble stadium ("Stadio Mussolini"), swimming pools, and other facilities planned to cover a total surface area of 850,000 square meters on ground between the Monti della Farnesina and the Tiber. A new bridge across "the sacred river" was built on the same axis as the monolith bearing the inscription "MUSSOLINI DUX" (still there today). A second axis continued through the entrance arch and culminated in Mussolini's stadium, the most important building in the complex, as its axial emphasis and lavish use of expensive materials showed: sixty four-meter-high statues, four bronze statues, a mosaic pavement of 150 square meters at the entrance to the track, and white Carrara marble step-seats for about 20,000 spectators.[42]

This forum was the nearest Fascist equivalent to the Nazi party's rally grounds in Nuremberg, which, with a total planned surface area of 16.5 square kilometers and a sports stadium with a capacity of 400,000 spectators,[43] was much larger and, as will be seen,[44] built as the assembly center of a world empire. Mussolini's three fora at Rome reveal no such plans. Carlo Magi-Spinetti, writing about Foro Mussolini in 1934, briefly alludes to "Nordic models" for this forum but does not say what they were. He merely says they are to be rejected.[45]

The nature and function of Foro Mussolini changed in 1938, when it was decided to site the Casa Littoria there, the headquarters of the Fascist party. It was pointed out at the time that a political function was essential to the concept of the ancient (Roman)

croisement des axes." R. Chevallier, "Cité et territoire, solutions romains aux problèmes de l'organisation de l'espace," in *Aufstieg und Niedergang der römischen Welt*, 2.1, Berlin, 1974, 691f.

41. ". . . il ginnasio dei greci e dei romani, la più perfetta espressione dello spirito mediterraneo e del mondo latino del periodo migliore"; C. Magi-Spinetti, "Il Foro Mussolini," *Capitolium* 10 (1934): 91. Already in *Mein Kampf* (2.2) Hitler stated that more physical education was needed in the curriculum of German gymnasia, which were a travesty of their Greek model (Was heute Gymnasium heisst, ist ein Hohn auf das griechische Vorbild).

42. Ibid., 97–100.

43. Speer, *Architektur-Arbeiten*, 9, 19.

44. See Chapter III.

45. "E nemmeno facile poteva essere tenersi lontani da modelli nordici, certamente suggestivi, ma appunto per questo da respingersi"; ibid., 91. It was at the beginning of 1934 that Hitler asked Speer to design a stone structure to replace the temporary wooden stands on the Zeppelinfeld in Nuremberg. This was the beginning of Hitler's plans for a "Gigantenforum" for party rallies. Speer's overall plan for the complex was ready in the autumn of 1934. Plans for the huge stadium were not completed until 1936 (Speer, *Architektur-Arbeiten*, 113). It is possible, then, that though the plans for the Nuremberg site could not have influenced the initial plans for Foro Mussolini, they might in 1934 have been known to Del Debbio. The plans of the two fora share few similarities and may well have developed independently of each other. In the absence of precise evidence, the question of reciprocal influences must remain open. A further possibility is that Magi-Spinetti was alluding to March's Reichssportfeld in Berlin (1934–36)—more clearly a sports forum than the Nuremberg rally grounds; see Marconi, "Il foro sportivo germanico a Berlino," *Architettura* 15 (1936): 465–86.

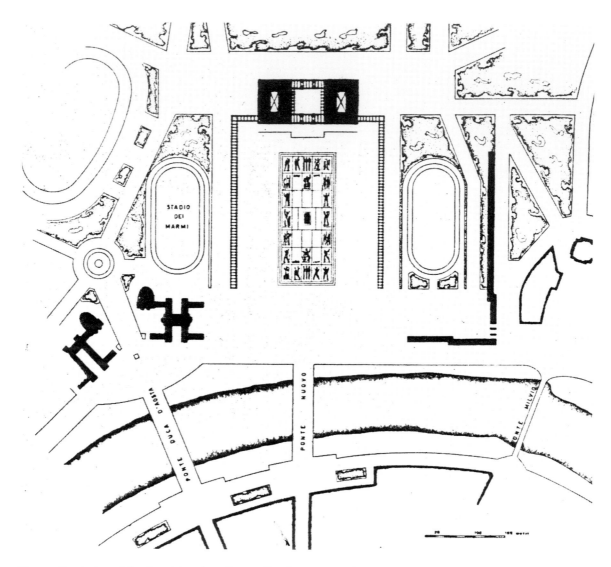

Fig. 11. Rendering of the Foro Mussolini, Rome. Casa Littoria, 1938

forum.[46] The plan of the Casa Littoria (Fig. 11) shows the palazzo at the end of a piazza 160,000 square meters in area, designed to hold 600,000 standing people.[47]

The second Fascist forum in Rome was the "Forum Sapientiae," the new University of Rome, designed as an intellectual and cultural forum by the neo-Roman architect Piacentini and initiated in 1932. This forum (Fig. 12) shows a "T"-shaped space with the most important building, the Rectorate, situated at the middle of the T's bar and at the

46. ". . . voleva essere un vero e proprio programma politico, poichè politica era la funzione dell' antico foro, a chiunque fosse dedicato"; C. Magi-Spinetti, "Nuove

opere al Foro Mussolini," *Capitolium* 13 (1938): 199.

47. V. Civico, "La Casa Littoria," *Capitolium* 13 (1938): 15–17.

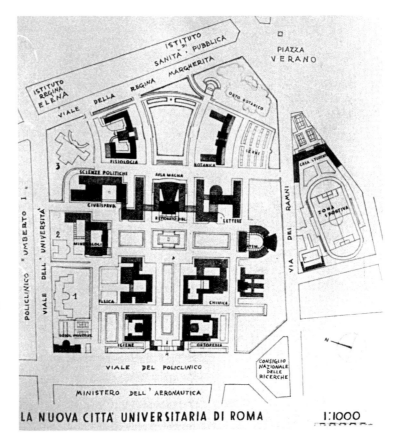

Fig. 12. Plan of "La Sapienza." Rome's new university (1932–35). Plan reminiscent of a basilica with transept

end of the longitudinal axis of the forum, the edge of which is flanked by symmetrically positioned buildings. The entrance to the forum (Fig. 13) was formed by a large austere propylaeum consisting of several large pillars reminiscent of the entrance gate to Trajan's forum. As with Foro Mussolini, where it was said that "Nordic models" were rejected, so too with the Forum Sapientiae: A Fascist commentator, noting that the style of the buildings around the forum was classical, emphasized that it was a "classicism as far from the imitation of the past as it was from the forced virtuosity of the architects beyond the Alps."[48]

The third "forum," EUR (L'Esposizione Universale di Roma), was intended as the new administrative center for Rome and Italy as a whole. It was not a forum in any accepted sense of the word, and it will be considered as a typical example of a Fascist new town

48. ". . . d'un classicismo lontano dall' imitazione del passato quanto dal virtuosismo sforzato degli architetti d'oltr' Alpe"; R. V. Ceccherini, "Dallo studium urbis alla città degli studi," *Capitolium* 9 (1933): 603. At this date Speer's architecture would not have been known in Italy. The writer perhaps refers to Troost's work at Königsplatz. For a full account of the university project, see the special issue of *Architettura*, "La città universitaria di Roma" (1935). It is important to note that Piacentini himself derives the "T"-bar configuration of this forum from the plan of a basilica with a transept; if this derivation can be accepted at face value, the Rectorate corresponds to the altar of a basilica.

Fig. 13. Model of the propylaeum (bottom right) of the Forum Sapientiae (model; *Capitolium*)

inspired by Roman prototypes.[49] The three new centers in their layout aimed to confirm the continuity between the ancient *imperium* and the modern Fascist empire.[50]

The new *cardo/decumanus* and fora planned and partly built in Rome were to be put into effect in the new Fascist towns, the most important of which were established south of Rome in the "Agro Pontino" region, long known for being malarial—an area abandoned by the Volsci after their defeat by the Romans in 328 B.C.[51] One of the main aims of the regime in founding these new cities was to encourage the poor in large cities like Rome to return to the land and become once more heroic *milites agricolae*.[52] The first (1932) and most grandiose of these new cities was the provincial capital, Littoria (now Latina), a name derived from the word *lictor*, the official who carried the *fasces* of a Roman official.[53] The forum of this town was situated at its center, and where its *cardo* and *decumanus* theoretically intersected at the middle of the forum was placed a spherical

49. EUR was based on a plan of a Roman city; see V. Fioravanti, "L'Esposizione Universale di Roma, 1942, crescita di una città" in *Dalla Mostra al Museo*, 93–100.

50. "I modelli delle città di fondazione in epoca fascista," in De Seta, ed., *Storia d'Italia*, Annali 8, Turin, 1985, 651. Foro Mussolini contains a central *mundus*, on the (disputed) meaning of which, see J. Rykwert, *The Idea of a Town: The Anthropology of Urban Form in Rome, Italy, and the Ancient World*, London, 1976, 124–26. F. Coarelli, *Roma*, Bari and Rome, 1983, 47, 58f.; P. Verduchi, "Lavori ai rostri del Foro Romano," *Rendiconti della Pontificia Accademia Romana di*

Archeologia 55/56 (1982/84): 338 n.

51. One of the new towns, Pomezia, was named after a Volscian settlement; C. Andrazzi, "Le palude pontine nella storia," in *La conquista della terra*, 3, 4 April 1932, 41–53; for Italian colonies in Libya, see M.-I. Talamona, "Italienische Agrarsiedlungen in Libyen," in Frank, ed., *Faschistische Architekturen* 139–57.

52. R. Mariani, *Fascismo e "città nuove,"* Milan, 1976, 184.

53. The ancient history of the *fascio* was chronicled by A. M. Colini in his book, *Il fascio littorio ricercato negli antichi monumenti*, Rome, 1933.

Fig. 14. Littoria (Latina). *Mundus* in central piazza

mundus (Fig. 14) which, according to Ghirardo and Forster,[54] "constituted an immediate and palpable reference to the Roman empire." The debt to the colonies of ancient Rome was as obvious in the plan of these Fascist cities as was the political motive for their foundation.[55]

By far the most important of the new towns founded by the Fascist regime was the forum of EUR, where an international exhibition of Italy's past and present scientific and cultural achievements was to be held in 1942, the twentieth anniversary of the Fascist march on Rome. In June 1937 Mussolini appointed a commission of urbanists to draw up a town plan. The group was dominated by the influential Piacentini, whose town plan, characterized by its rigid orthogonal symmetry, was to form the basis of the final plan (Fig. 15). The new town was to have a *cardo*, the Via Imperiale, which at its northern end was to pass beneath a vast triumphal arch, the Porta Imperiale, to be made of aluminum or

54. "Nel punto preciso in cui i due assi ortogonali si intersecano . . . costituisce un immediato e visibilissimo riferimento all' impero romano" ("I modelli delle città di nuova fondazione in epoca fascista," *Annali Storia d'Italia*, ed. C. de Seta, Turin, 1980, 640). For a plan of Littoria, see plan opposite p. 638, and Mariani,

250, fig. 42.

55. In chronological order the towns were Littoria (1932), Sabaudia (1934), Pontinia (1935), Aprilia (1937), and Pomezia (1938); Insolera, Di Majo, *L'EUR e Roma*, Rome and Bari, 1986, 272f.

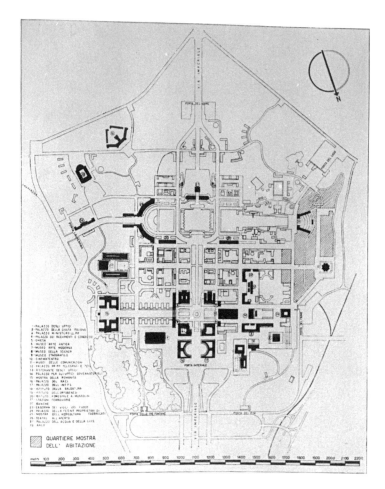

Fig. 15. Plan of EUR

steel and have a span of 300 meters. This triumphal entry arch in concept was inspired by ancient Roman arches such as that of Trajan at the western end of Timgad's *decumanus*. EUR's *decumanus* ran in a straight line from the Church of the Saints Paul and Peter at its western end to what is today the Archivio de lo Stato at its eastern culmination point. Not only the plan but the permanent buildings, state and domestic, were to convey the "senso di Roma" synonymous with the eternal and the universal, and were to be built of durable materials.[56]

The importance of the project was reflected in the nature of the publicity it was given. For example, the journal *Architettura* devoted more than one hundred pages to the project in its issue for 1938.[57] All the texts explaining the drawings and photographs were

56. Insolera, Di Majo, *L'EUR e Roma*, 41, 48, 72; the triumphal entry arch was never built because of its excessive cost. The domestic houses to the south of the church were to be reminiscent of Italian atrium houses; the "casa con giardino interno" was related "alle antichissime tradizioni edilizie delle grandi civiltà remote";

G. Florio, "La mostra dell' abitazione dell'E42," *Capitolium* 14 (1939): 382f. M. Piacentini, "Classicità dell' E42," *Civiltà* 1.1 (1940): 23–32.

57. *Architettura* 17 (1938): 753–905; Bonatz, *Leben und Bauen*, 217, visited Rome in 1943 and saw Piacentini, whom he associates with E42.

published in German and English, as well as in Italian. On 19 September 1933 Hitler told the mayor of Berlin that his city was "unsystematic,"[58] but it was not until 30 January 1937 that Speer was officially put in charge of plans for the reshaping of Berlin, although he had been working on them unofficially in 1936.[59] The order for the reshaping of other German cities was signed by Hitler on 4 October 1937. The plan that Speer coordinated as Inspector General of Construction (GBI) for the center of Berlin (Fig. 16) was based on Roman, not Greek,[60] planning principles, which might or might not have been influenced by Roman-derived town plans in Fascist Italy.[61] Speer's plan was to create a central north-south axis, which was to join the major east-west axis at right angles. On the north side of the junction a massive forum of about 35 hectares was planned,[62] around which were to be situated buildings of the greatest political and physical dimensions: a vast domed Volkshalle on the north side, Hitler's vast new palace and chancellery on the west side and part of the south front, and on the east side the now-dwarfed pre-Nazi Reichstag and the new High Command of the German armed forces (Fig. 17). These buildings placed in strong axial relationship around the forum designed to contain one million people were collectively to represent the *maiestas imperii* and make the new world capital, Germania, outshine its only avowed rival, Rome.

The plan for the center of Berlin differed only in its dimensions from the plans drawn up for the reshaping of smaller German cities and for the establishment of new towns in conquered territories. For example, the plan for Peenemünde,[63] designed by Speer and

58. M. Schmidt, *Albert Speer: The End of a Myth*, London, 1985, 36, 46.

59. R. Wolters, *Albert Speer*, Oldenburg, 1943, 5. L. O. Larsson, *Albert Speer: Le plan de Berlin, 1937–1943*, 39; H. J. Reichhardt, W. Schäche, *Von Berlin nach Germania*, Berlin, 1985, 23.

60. Lehmann-Haupt, 109, points to the orthogonal plans of cities like Priene when discussing Nazi town planning. Bonatz, *Leben und Bauen*, 230–32, praises the orthogonal plan of Priene, which he visited in 1944. But Greek town plans lack the typically Roman central intersection of major axes; F. Castagnoli, *Orthogonal Town Planning in Antiquity*, Cambridge (Mass.), 1971, 129; Priene does have a centrally positioned agora, however; R. Martin, *L'urbanisme dans la Grèce antique*, Paris, 1974, 115. That the Greek orthogonal plan was not necessarily the invention of Hippodamus but the result of gradual development is shown by A. Burns, "Hippodamus and the Planned City," *Historia* 25 (1976): 414–28.

61. Larsson, *Albert Speer*, 229, asserts that the Nazi forum with its community hall and party buildings "est certainement inspiré de l'Italie," but he presents no evidence to show whether German plans were inspired directly by Roman town plans, or indirectly through Fascist plans; cf. Larsson's remarks in Speer, *Architektur-*

Arbeiten, 168f., where he says there is hardly any trace of direct influence of Fascist architects on Nazi architecture. When the plan of Grosse Platz was published in *Architettura*, 18 (1939): 486f., the north-south and east-west axes were labeled *cardo* and *decumanus*, respectively, by L. Lenzi. The Führerpalais was only partly represented on the plan and not identified.

62. Krier, ed., *Albert Speer*, 117.

63. Krier, ed., *Albert Speer*, 192; Larsson, *Albert Speer*, 200, pl. 184. These towns in the East were to accommodate 20,000 inhabitants each, and were intended to form "a vast archipelago of German strongholds" to ensure the subjection and pacification of conquered territories. Their intended function was thus very similar to that of Rome's veteran colonies like Timgad. Peenemünde was, as Krier points out, to be zoned. For ethnic zoning in Italian cities in Africa, e.g., Addis Ababa, see A. Boralevi, "Le 'città dell' impero': Urbanistica Fascista in Etiopia, 1936–1941," in A. Mioni, ed., *Urbanistica fascista*, Milan, 1986, 247–86, where town planning is discussed as "an instrument of repression" (251). The planners were also careful to create a *cardo* and *decumanus* as a link with imperial Rome (260). The zoning created the ideology of "divide and rule," also a link with ancient Rome (261).

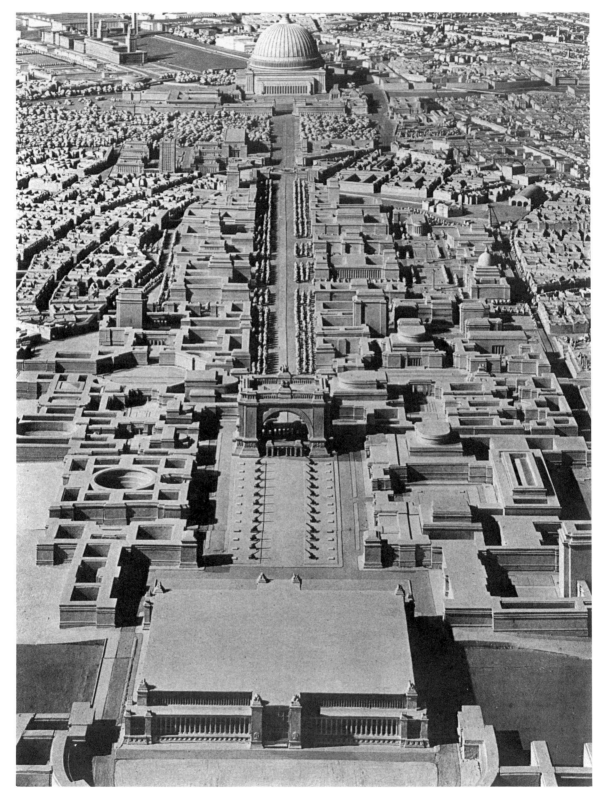

Fig. 16. Albert Speer, Berlin, north-south axis

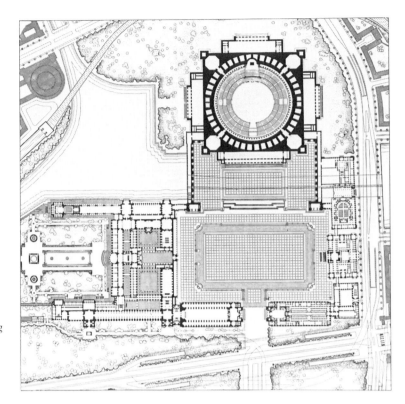

Fig. 17. Albert Speer, plan of the Grosse Platz, Berlin, 1937–40. Left foreground: Reichskanzlei, Führerpalais. Center (rear): Volkshalle. Right (center): Reichstag

Eggerstedt (1940), shows a longitudinal axis bisecting the town and culminating in a square, where it intersects with the last of four transverse axial roads (Fig. 18). This part of the plan is equivalent to the arrangement for the square in Berlin at the intersection of the north-south and east-west axes.[64] The plan devised in 1940 by Herbert Rimpl for the new town of Hermann-Göring-Werke (Fig. 19), which was not as rigidly rectilinear as Peenemünde, nevertheless still had at its center the characteristic intersection of the town's two axial roads, with a forum situated exactly opposite this "T"-shaped junction.[65]

This typically Nazi forum plan, with its rigid symmetry and axially disposed and hierarchically emphasized buildings at the very center of the community, had been associated by Gottfried Semper with the French architect Jean-Nicolas-Louis Durand, whom he criticized for overemphasizing symmetry and uniformity, such as was found in the town plans of Mannheim (Speer's birthplace) and Karlsruhe,[66] which, according to the Nazis, had a "clean overall plan"[67] and which, according to Helen Rosenau,[68] was

64. For Pagano's plan for Portoscuso (1940), see Ghirardo, "Italian Architects," 124; this town, like Peenemünde, was rigidly zoned to separate each social class.

65. Lehmann-Haupt, pl. 6: F.-J. Verspohl, *Stadion-bauten von der Antike bis zur Gegenwart*, Giessen, 1978, 251.

66. Herrmann, 154f. For the Nazi craze for symmetry (shared by the Fascists in Italy), see D. Bartetzko, *Zwischen Zucht und Ekstase: Zur Theatralik von NS-Architektur*, Berlin, 1985, 177, 186, 190.

67. Taylor, *The Word in Stone*, 254.

68. *The Ideal City*, London, 1983, 70f.

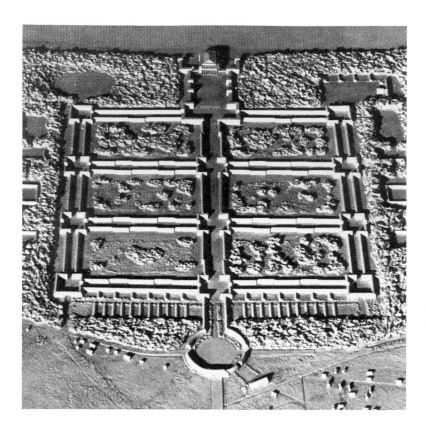

Fig. 18. Albert Speer and Eggerstedt, model of Peenemünde, 1940

Fig. 19. Herbert Rimpl, rendering of the Stadt der Hermann-Göring-Werke, 1940

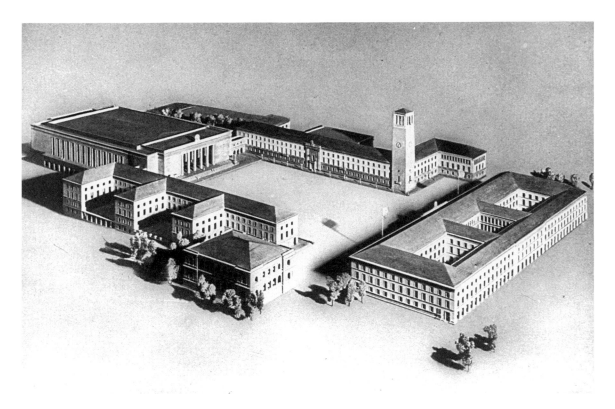

Fig. 20. Hermann Giesler, model of Adolf Hitler Platz, Weimar, 1935–36

influenced by Vitruvius's "utopian" plan.[69] Ghirardo describes how the Fascist planners in Italy tended to situate the main party building (Casa del Fascio) in each new or reshaped town "in the most significant urban location at the intersection of the four main traffic arteries."[70]

The political significance of and interrelationship between axiality and hierarchy in a Nazi forum is well illustrated by an anecdote transmitted by Giesler,[71] who was asked by Hitler to design Adolf Hitler Platz (Fig. 20) in Weimar (1935–36). It was situated in the heart of Weimar on a site personally chosen by Hitler, to rid the city center of its chaotic shapelessness (das Chaotische, das Ungestaltete); its most important building, designed by Giesler to be the culmination point of the forum's longitudinal axis, was to have been the residence of the provincial governor (Reichsstatthalter). However, when Giesler showed this plan to Hitler, the Führer commented that such a placement of the governor's residence would be a "relapse into absolutism" (Rückfall in den Absolutismus). Hitler pointed out to Giesler that the community (Volksgemeinschaft), and not an

69. Described by Vitruvius 1.6, but apparently never put into effect by Roman planners. The design was intended to protect dwellings from the four winds.

70. "Italian Architects and Fascist Politics," 124, talking of Sabaudia.

71. *Ein anderer Hitler,* 119–121.

individual, should be represented by a building placed at the culmination point of the forum's main axis. Accordingly, Giesler altered his plan and replaced the governor's residence with a Volkshalle, outside which was to be placed a statue of Prometheus (by Arno Breker) holding aloft his torch, as described in a poem of Goethe.[72] With the single exception of Königsplatz in Munich, the earliest Nazi forum (see below), all subsequent fora were to have a Volkshalle situated on their long axis, a position corresponding to the placement of a temple of importance (Capitolium/Roma) at the end of the long axis of imperial fora at Rome and of other fora in northern Italy and the western provinces. The pattern was retained even for the huge forum planned for the north end of Berlin's north-south axis. The Kuppelhalle was on the long axis, whereas Hitler's massive palace was on the forum's transverse axis linking the entrance of the Führerpalais with that of the much smaller pre-Nazi Reichstag. However, here, as will be seen, the relationship between the Führerpalais and the Volkshalle was in several respects reminiscent of the relationship between Augustus's house and the temple of Apollo on the Palatine, to which the emperor's residence was linked.[73] In Berlin the individual undisputed ruler of the world (Herr der Welt) was to receive the adulation of his subjects in the temple of the Volksgemeinschaft, or so Hitler thought.

Acropolis Germaniae: The First Nazi Forum

The first Nazi forum in Munich (Fig. 21) was planned in 1931–32 by Hitler and his architect Paul Ludwig Troost (1878–1934), whom Speer says Hitler regarded as the greatest German architect since Schinkel.[74] For several reasons this forum was different from the typologically uniform fora of later date discussed above. To begin with, the site, Königsplatz, had already been planned by Karl von Fischer and F. L. von Sickel in 1812 as a forum for Ludwig I of Bavaria, an ardent admirer of Greek antiquity.[75] When Fischer, the king's architect, died in 1820, Leo von Klenze, whose brother Clemens lectured on ancient history at Berlin University,[76] was put in charge of the project. Von Klenze

72. Giesler, plate opposite p. 128. A statue of Prometheus symbolizing heroic endeavor, holding a spear in one hand and a torch in the other, stands at the entrance to Breker's driveway. It also provides the cover illustration for the newsletter published regularly by the Arno Breker Society International. See *Prometheus*, Summer 1985, no. 16.

73. F. Coarelli, *Roma sepolta*, Rome, 1984, 129. Coarelli suggests this palace/temple complex derived from Hellenistic models like the palace of the Attalids on the acropolis at Pergamum, which was connected to the sanctuary of Athena Nikephoros. Apollo brought Augustus victory at Actium and thus gave him undisputed power. On the full significance of the Berlin

Volkshalle, see page 114 below.

74. "Die Bauten des Führers" (1936), 74f.; Hitler made the remark in his Kulturrede at Nuremberg in 1935.

75. *München und seine Bauten*, herausgegeben vom bayerischen Architekten-und Ingenieur-Verein, Munich, 1912, 195–212; this forum was not unique in nineteenth-century Germany. Semper, for example, designed Zwingerforum in Dresden (1842), which, unlike the Nazi remodeling of Königsplatz, was not to be dominated by any single building; Herrmann, 3.

76. A. Demandt, "Alte Geschichte an der Berliner Universität," in Arenhövel, Schreiber, eds., *Berlin und die Antike*, 75.

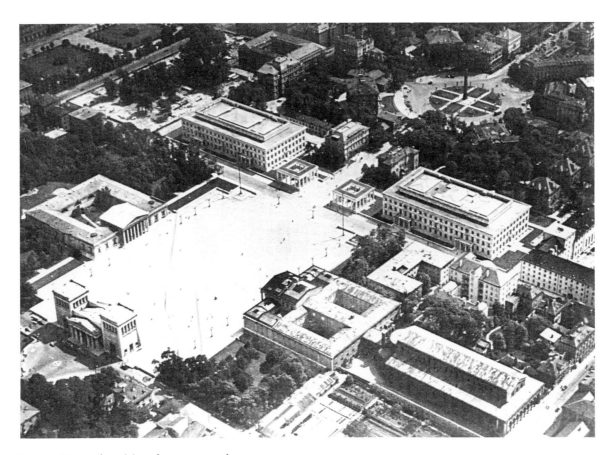

Fig. 21. Königsplatz, Munich, restructured 1933–37

designed the Doric propylaeum (1846–60), intended to commemorate the Greek War of Independence and which gave entrance to the square at its west end, delimited by Luisenstrasse. The square's transverse axis (north-south) culminated at one end in the Glyptothek (1816–30),[77] also by von Klenze, with its central Ionic portico, and at the other in the Neue Staatsgalerie (1838–48), by G. von Ziebland. Plans had been made by Fischer and von Klenze to close off the forum at its east end, which was bordered by Arcisstrasse, but these plans were not put into effect.[78]

The longitudinal axis of the square passed through the center of the propylaeum at the west, and at the east it passed down the middle of Briener Strasse to culminate in the circular-shaped Karolinen Platz.

77. The Glyptothek's model was Durand's design for a museum (1779); W. Szambien, "Durand and the Continuity of Tradition," in R. Middleton, ed., *The Beaux-Arts*, London, 1982, 19–21. For plans and photographs of the Propyläen and Glyptothek, see *München und seine Bauten*, 196, 198f., 201. See also David Watkin and Tilman Mellinghoff, *German Architecture and the Classical Ideal*, Cambridge (Mass.), 1987, 145, 150.

78. K. Arndt, *Das Wort aus Stein*, Göttingen, 1965, 15f.

Troost had already redecorated the interior of the so-called Brown House on Briener Strasse in 1930 after its acquisition by the Nazi party.[79] In the summer of 1931 he prepared drawings for four party buildings that were to be erected at the east end of the forum, symmetrically placed along Arcisstrasse. These buildings were completed under the supervision of his wife, Gerdy Troost, and the head of Troost's atelier, L. Gall, in 1937, when the House of German Art was also officially opened.[80]

Priority was given to the erection of the two "martyrs" temples (Ehrentempel) (Fig. 22) of identical shape, placed just to either side of the square's long axis. The two temples were set forward in front of the two large symmetrically placed buildings in the square's northeast and southeast corners: the Führerbau, Hitler's first official residential block, and the Verwaltungsbau, an administrative office building. Thus the temples, flanked by the two large party buildings, were axially more emphasized than the leader's residence, a principle that, as already seen from Giesler's design for the Weimar forum, was to be maintained in all subsequent Nazi fora. However, the Königsplatz forum was unique in not having a Volkshalle as the culmination point of its main axis.

Troost, who, like his successor, Speer, aimed to "revive an early classical or Doric architecture,"[81] could not have found a more encouraging context for his endeavors than the neoclassical architectural setting of Königsplatz. However, though, like Hitler, he found Bauhaus architecture distasteful, the Ehrentempel he designed for Königsplatz were not uninfluenced by modernist tendencies: In no respect were his temples conventionally Doric. They were square, roofless "atria" supported on each of their sides by rectangular, freestanding fluted pillars without capitals. The pillars supported a heavily molded cornice made of ferroconcrete clad in stone (Deckenkranz). The pillars rested on a podium that was stepped on the inside of the building and led to a cavity where (eight apiece) the iron coffins of the "martyrs" killed in the abortive putsch of 9 November 1923 were placed. Collectively, the two temples were locally labeled the "railway station of Pompeii."[82]

The pillars Troost used in the temples and the entrance porches of the Führerbau and Verwaltungsbau were to become a hallmark of buildings Speer was later to plan for Hitler.

79. Lehmann-Haupt, 113.

80. The Haus der Deutschen Kunst (1933–37) was opened by Hitler on 18 July 1937 with a speech in which he assured his listeners that never was humanity nearer in its external appearance and its frame of mind to the ancient world than it was on that day; Baynes, *Speeches*, 590. The building, with its typically austere frontal colonnade, is a good example of Troost's "stripped" classical style. Here the Nazis promoted exhibitions of sculpture and painting approved by the regime. For Hitler Munich was the capital of German art as well as the Hauptstadt of the Nazi party. Troost's gallery emphasized this. See K. Arnold, "Architektur und Politik," in Speer, *Architektur-Arbeiten*, 116. Rodenwaldt noted with approval Hitler's liking for pillared halls: "Der Wille des Führers hat für die Säulenhallen entschieden.

Sie sind ein unverlierbares Symbol der Wurde für die ideale Bedeutung eines Bauwerks"; "Via dell'Impero," *Zeitschrift für Bauwesens* 23 (1934): 311.

81. Letter of Gerdy Troost to Taylor (67 n. 51) dated 29 November 1969.

82. R. Pfister, "Hitlers Baukunst," *Baumeister* 43 (1946): 27; the House of German Art was also nicknamed the "Railway Station of Athens" (Lehmann-Haupt, 114) and "White Sausage Temple"; G. Hellack, "Architektur und bildende Kunst als Mittel NS Propaganda," *Publizistik* 5 (1960): 90. The latter building was praised in the official Nazi newspaper (*Völkischer Beobachter*) for its avoidance of steel and glass; Teut, ed., *Architektur im Dritten Reich*, 182; cf. Miller Lane, *Architecture and Politics*, 190f.

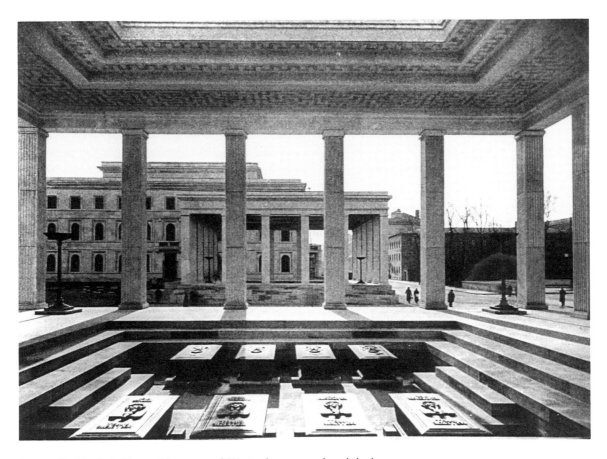

Fig. 22. Paul Ludwig Troost, Ehrentempel Königsplatz, 1934, demolished 1947

Barbara Miller Lane, in her review of Speer's memoirs,[83] remarks that these pillars ("piers") cannot be seen as "neo-classical." She is reluctant to accept the proposition that Speer derived them from the single building by Tessenow that incorporates them, though she tacitly concedes (n. 7) that Troost used them in his Ehrentempel. This is one of the most likely immediate sources. But where did Troost find prior examples of this pillar-type? Miller Lane does not put the question in this manner, since she is mainly concerned in her review with seeking ancient Near Eastern prototypes for Speer's buildings, and she sees this pillar-type as part of this alleged influence. Yet this seems almost certainly to be an incorrect derivation, if, as seems possible, Speer adopted the type from his immediate predecessor. Was Troost, then, influenced by Near Eastern models, more likely to be at odds with the racial theories of his patron than by imperial Roman exemplars? No one so far has argued this.

83. *Journal of the Society of Architectural Historians* 32 (1973): 341–46.

If prototypes or models are to be sought for this canonical feature of Hitler's state buildings, examples can be found in imperial Roman architecture as well as in German architecture of the nineteenth and early twentieth centuries.

The earliest (c. A.D. 65) extant Roman example known to me is found in the peristyle of the House of Julia Felix at Pompeii (Fig. 23). These pillars admittedly have Corinthian capitals, but this in itself is not enough to discount them as possible influences on Troost or Speer, both of whom avoided the use of conventional Greek and Roman capitals on freestanding pillars and columns, as did Giesler and other architects of Nazi state buildings.[84] Another Roman model is provided by the Doric pillars of the *Sala a pilastri dorici* in Hadrian's villa (Fig. 24),[85] which would possibly have been better known than Julia Felix's villa (though of course Speer had visited Pompeii). These pillars, fluted like those in the peristyle of Julia Felix, do not have Corinthian capitals.

However, it is also possible that Troost was influenced in his choice of pillar-type by Schinkel's Kirche in Moabit in Berlin,[86] which incorporated such pillars. They are also part of the architectural vocabulary of Peter Behrens, and are found in simplified form supporting the barrel vault of the music room he designed for the art exhibition in Dresden (1906; Fig. 25).[87] Though he fell out of favor with the Nazis, Behrens was, at the request of the general manager of Allgemeine Elektricitäts-Gesellschaft (AEG), invited by Speer to design an office block for the firm on Berlin's north-south axis. Thanks to Speer's protection, Behrens completed the designs for the building (1937–39), the model of which shows the use of the characteristic Nazi pillar in the ground-floor facade of the building.[88] Paul Bonatz also used such pillars, for example, in his railway station in Stuttgart (1914–22), where two sets of freestanding pillars supported two contiguous gables.[89]

84. An exception has to be made for Dustmann's Museum of Anthropology (Völkerkundemuseum) planned for Berlin's Museuminsel, where there were already neoclassical museums designed by Schinkel and Stüler. Dustmann's gigantic building (275 by 110 meters) incorporated classical elements such as an arcade in the Doric order (Stüler's New Museum incorporated Doric columns and a triglyph frieze) and made use of pillars with stylized Corinthian capitals. These classical elements were, however, "degraded" by the dimensions and proportions of the building to the point of being unrecognizable; W. Schäche, "NS Architektur und Antikenrezeption: Kritik der Neoklassizismus—These am Beispiel der Berliner Museumsplanung," in Arenhövel, Schreiber, eds., *Berlin und die Antike*, 564; for a less negative assessment of the classical vocabulary of the new museum buildings in Berlin, see Larsson, *Albert Speer*, 140–48.

85. S. Aurigemma, *Villa Adriana*, Rome, 1962, 167–69, figs. 172–74. H.-P. Rasp, *Eine Stadt für tausend Jahre*, Munich, 1981, 223, reproduces without critical comment Pirro Legorio's drawing (1559) of Varro's aviary (ornithon), which shows two square unroofed pavilions supported by Ionic columns. Rasp suggests a possible "genetic link" between these pavilions and Troost's temples (224 n. 90), but the conjecture rests on nothing more than visual resemblance.

86. K. F. Schinkel, *Collected Architectural Designs*, New York, 1982, 160.

87. F. Hoeber, *Peter Behrens*, Munich, 1913, 50 and pl. 43; cf. the rectangular pillars in his crematorium in Delftern bei Hagen (pl. 67).

88. A. Windsor, *Peter Behrens, Architect and Designer, 1868–1940*, London, 1981, 172f., who points out that like all the buildings on the north-south axis, this building had to be constructed without the use of steel or reinforced concrete.

89. H. J. Reichhardt, W. Schäche, ed., *Von Berlin nach Germania*, Berlin, 1985, 10, fig. 2.

Fig. 23. Peristyle, House of Julia Felix, Pompeii

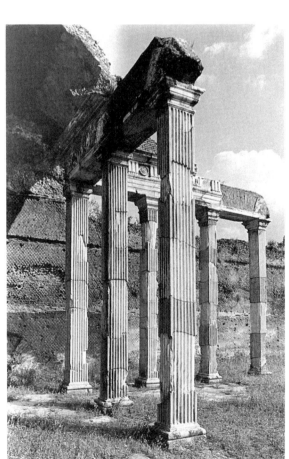

Fig. 24. *Sala a pilastri dorici*, Hadrian's villa, Tivoli

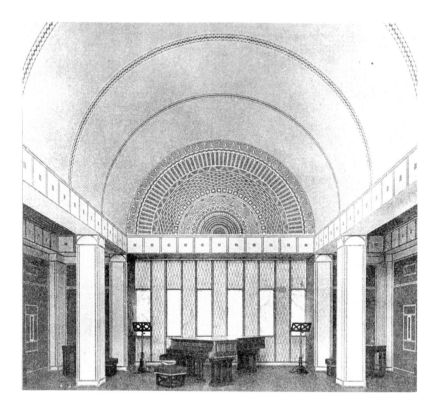

Fig. 25. Peter Behrens,
rendering of the music room,
Dresden exhibition, 1906

A further possibility is that the pillar-type was adopted from or influenced by the repertoire of Italian Fascist architecture: for example, Piacentini's porch for the Rectorate of the University of Rome (built in 1935), which incorporated four such freestanding pillars (Fig. 13) of the kind that appeared in the main stand of Speer's Zeppelinfeld stadium in Nuremberg.[90] The new Italian Fascist architecture was well known in Nazi Germany. Goebbels had been favorably impressed by it,[91] Behrens wrote two short appreciative articles on it,[92] Speer and Piacentini exchanged letters,[93] and Italian art and architecture journals, such as *Palladio, Le Arti, Roma, L'Urbe, Architettura,* and above all *Capitolium* (Fig. 26), circulated freely in Germany.[94]

If, however, Troost was (according to Lehmann-Haupt's caustic comment) "a conventional Philistine of mediocre talent, a classicist who hated modern architecture,"[95] it is

90. For Piacentini's Rectorate, see Ghirardo, "Italian Architects," 117, fig. 8.

91. Taylor, 65 n. 42.

92. *Die Neue Linie,* November 1933, 11–13; ibid., January 1938, 36–38.

93. Mariani, *Fascismo e città,* 239f.

94. Millon, 55. Cf. also G. Buchheit, "Das Fünfte Rom," *Die Neue Saat* 2 (1939): 2–7. The Italian Fascist architecture journals gave very little publicity to Nazi

state architecture. The main exceptions were M. Piacentini, "Premesse e caratteri dell'architettura attuale tedesca," *Architettura* 18 (1939): 467–71, and L. Lenzi, "Architettura del III Reich," ibid., 472–540 (mostly photographs of buildings and models). P. Marconi, W. March, "Il foro sportivo germanico a Berlino," *Architettura* 15 (1936): 465–86.

95. *Art under a Dictatorship,* 113.

Fig. 26. Symbols of *romanità*: Capitoline wolf and *fasces*, cover of *Capitolium*, 1933

CAPITOLIVM

RASSEGNA MENSILE
DEL GOVERNATORATO

ANNO MCMXXXIII

ANNO IX ANNO XII E. F.

perhaps more likely that he derived his pillar-type from ancient Roman rather than from modern models, especially when he was designing buildings that had to harmonize with von Klenze's preexisting buildings in Königsplatz.

The Nazi literature of the period leaves little doubt that this new forum was regarded as a sacred cult center, which was even referred to as "Acropolis Germaniae."[96] The closure of the east end of the forum and the granite slabs with which the entire square was paved gave it a unity it had previously lacked. The new Nazi buildings completely changed the significance, not just the appearance, of Ludwig's forum.

Von Klenze's Propylaeum could no longer be regarded as a piece of architectural romanticism. It now served the same function as its Greek and Roman counterparts, that is, like the fifth-century B.C. propylaeum of the Acropolis in Athens,[97] or the propylaeum that originally gave entrance to the enclosed forecourt of Hadrian's Pantheon.[98] One of

96. A. Heilmeyer, "Die Stadt Adolf Hitlers," *Süddeutsche Monatshefte* 33 (1935): 141. More literature is quoted by Rasp, 23f.

97. H. Berve, G. Grube, *Greek Temples, Theatres and*

Shrines, London, 1963, 379.

98. MacDonald, *The Architecture of the Roman Empire*, 1, diagrams 97–98.

the Nazi additions to the square was a wall that linked the buildings on its long sides,[99] a feature also reminiscent of the enclosed imperial cult fora at Rome. What now gave the enclosure its "sacred" quality (from the Nazi viewpoint) was the presence of the martyrs' shrines, symbolically equivalent, if not architecturally identical, to ancient heroes' shrines (herōa), and around which commemorative ceremonies were held on the anniversary of the 1923 putsch.

In 1935 Hitler said that the martyrs' bodies were not to be buried out of sight in crypts, but should be placed in the open air, to act as eternal sentinels for the German nation.[100] Hitler later insisted on this detail when Giesler planned the Volkshalle for Weimar's forum. He asked his architect to ensure that the two crypts, which were to contain the bodies of Brown Shirts (SA) killed in Thuringia, and which were to be placed at the entrance to the Volkshalle, be lit by open oculi.[101] It is interesting that later still (1940) he asked Giesler to plan his own mausoleum in Munich in such a way that his sarcophagus would be exposed to sun and rain.[102] It is worth noting that in his will of 2 May 1938, written the day before he left Germany for his state visit to Rome, Hitler instructed that his body was to be put in a coffin similar to that of the other martyrs and placed in the Ehrentempel next to the Führerbau.[103]

Troost's temples in Königsplatz were thus regarded as guardposts, a notion reinforced by the presence of SS sentinels who stood guard at the entrance of each temple.[104] A year earlier Hitler had said that the blood of the martyrs was to be the baptismal water (Taufwasser) of the Third Reich.[105] Such imagery perhaps disturbed devout Christians, yet it left no doubt that the cult of Nazi heroes was to replace the worship of Christian martyrs. This objective was demonstrated in another way: No Nazi forum planned for any German city was to incorporate a new church. Indeed, a cathedral (Quedlinburg) was turned into a shrine by the SS, who planned to treat the cathedrals of Brunswick and Strasbourg in the same way; in Munich a church was demolished to make way for new Nazi buildings.[106] Yet overseas the impression was created that the building of new churches was an integral part of the new Nazi building program.[107] Temples for Nazi

99. Rasp, 24.

100. Speech of 10 November 1935 cited by K. Arndt, "Filmdokumente des NS als Quellen für architekturgeschichtliche Forschungen," in G. Moltman, K. Reiner, eds., Zeitgeschichte im Film und Tondokument, Göttingen, 1970, 49f. On the pseudoreligious cults of the Nazis, see H. J. Gamm, Die braune Kult: Das Dritte Reich und seine Ersatzreligion, Hamburg, 1962.

101. Giesler, 121.

102. See pages 116–17.

103. W. Maser, Hitler's Letters and Notes, London, 1974, 151. In his final will (29 April 1945) there was less concern for ritual: "It is our (i.e., Hitler and Eva Braun now married on the eve of her death) will to be burnt at once at the very place I have done the major part of my daily work in the service of my people (i.e., in the grounds of the Berlin Chancellery); Maser, 207.

104. W. Kreis mentions these temples as the inspiration for other types of "heroic" monuments (Ehrenmalen), such as the war memorial for German troops he designed in 1943 for Russia, and above all the Soldatenhalle for Berlin's north-south axis; W. Kreis, "Kriegermale des Ruhmes und der Ehre im Altertum und in unserer Zeit" (March 1943), in Teut, Architektur im Dritten Reich, 222–26.

105. Arndt, 51.

106. Thies, "Nazi Architecture," 60; cf. Dülffer, Thies, Henke, Hitlers Städte, 20.

107. A Nation Builds: Contemporary German Architecture, German Library of Information, New York, n.d., 37–45 ("New Churches").

martyrs were given pride of place, as at Königsplatz or, as at the Weimar forum, martyrs' crypts at the entrance of the Volkshalle were given prominence.

On 6 September 1938 Hitler made his position clear about the attitude of the Nazis toward religion. He said that in its purpose National Socialism had no mystic cult, only the care and leadership of a people defined by a common blood relationship. He continued with the remark that Nazis had no rooms for worship, but only halls for the people (that is, no churches, but Volkshallen)—no open spaces for worship, but spaces for assemblies and parades (Aufmarschplätze). Nazis had no religious retreats, only arenas for sports and playing fields (Stadia), and the characteristic feature of Nazi places of assembly was not the mystical gloom of a cathedral, but the brightness and light of a room or hall that combined beauty with fitness for its purpose.[108] Three days prior to making this statement, which relates precisely to the functions of Nazi state building plans and types, Hitler had stated that worship for Nazis was exclusively the cultivation of the natural (that is, the Dionysiac).[109] It was also in 1938 that Rosenberg made it clear that Nazism and the Christian Church were incompatible.[110] Thus the huge Volkshalle was to dominate Berlin's new forum and north-south axis, whereas at EUR the new Church of the Saints Paul and Peter dominated the new town's *decumanus*. Its dome is the second largest in Rome after that of Saint Peter's, whereas the dome of Saint Peter's would have fitted through the oculus in the dome of the Berlin Volkshalle. No two buildings could better illustrate the differences between Nazi Germany and Fascist Italy with respect to Christian worship.[111] As already seen,[112] Fascist Italy incorporated Rome of the Caesars and of the Popes. Nazi Germany espoused only the values of pagan Rome, where Christians who flouted the cult of the emperor were penalized.[113] The globe on the lantern of Saint Peter's is surmounted by a cross (Fig. 27). The globe of the world, which was to be placed on the lantern of the Berlin Volkshalle, was firmly gripped in the talons of an imperial eagle (Fig. 28), which was also Reichsadler and the attribute of Zeus/Jupiter. The political theme of a globe gripped by an eagle was rendered in bronze by the sculptor Ernst Andreas Rauch for the exhibition of art in the House of German Art in 1940 (Fig. 29).

Not only were churches excluded from the new fora but so was the townhall (Rathaus), since the mayor (Bürgermeister) yielded to the Führer as the representative of local community and nation. This was an essential feature of the leader principle (Führerprinzip).[114]

108. Baynes, *Speeches*, 395f.

109. *Frankfurter Zeitung* (3 September 1938), cited by Baynes, 397. Cf. *Mein Kampf* (1.10): "In a universe where planets revolve about suns, and moons turn about planets, where force alone forever masters weakness, compelling it to be an obedient slave or else crushing it, there can be no special laws for man." (In einer Welt, in der Planeten und Sonnen kreisen, Monden und Planeten ziehen, in der immer nur die Kraft Herrin der Schwäche ist und sie zum gehorsamen Diener zwingt oder zerbricht für den Menschen nicht Sondergesetze gelten können.)

110. "Weltanschauung und Glaubenslehre," *Nationalsozialistische Monatshefte* 9 (1938): 1042–49. For Rosen-

berg as a "fanatical opponent of Christianity," see K. Vondung, *Magie und Manipulation: Ideologischer Kult und politische Religion des Nationalsozialismus*, Göttingen, 1971, 55f.

111. Churches were given prominent positions in the new towns, such as Aprilia; M. Piacentini, "Aprilia," *Architettura* 17 (1938): 403.

112. See page 21.

113. See, for example, Pliny's account of his examination of Christians while he was governor of Bithynia-Pontus, *Ep.* 10.96.

114. Petsch, *Baukunst und Stadtplanung*, 82.

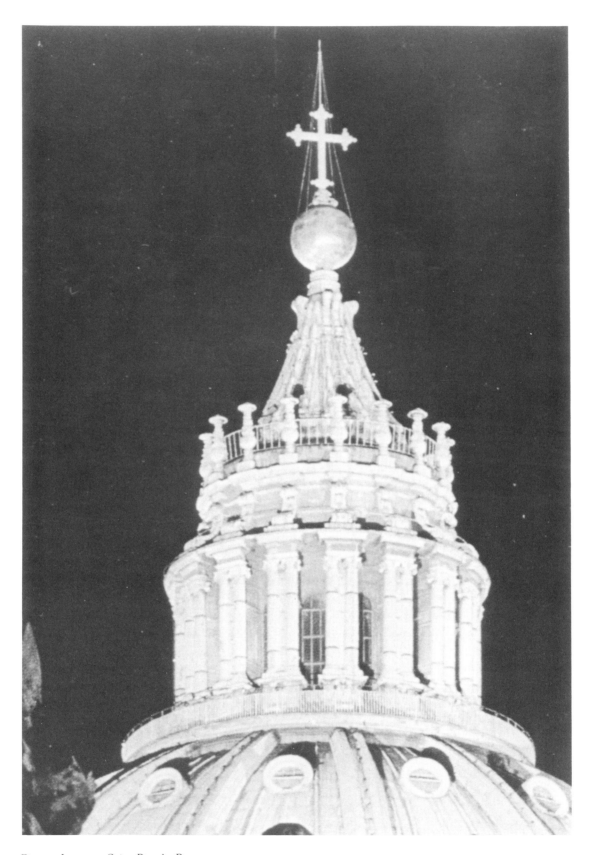

Fig. 27. Lantern, Saint Peter's, Rome

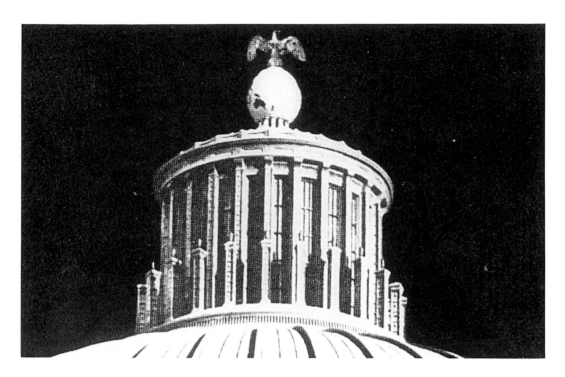

Fig. 28. Model of the lantern, Volkshalle, Berlin

Fig. 29. Eagle and globe by Ernst Andreas Rauch, 1940

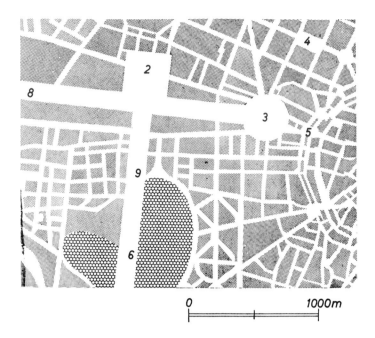

Fig. 30. Junction of east-west and north-south axes, Munich, 1938–40. (2) New opera house; (3) Victory Column of the Nazi party; (4) Königsplatz; (8) East-west axis

The Königsplatz forum differed from later Nazi fora not only in its lack of a (axially emphasized) Volkshalle but also because it was not situated at an intersection of arterial north-south and east-west axes. The new town plan for Munich provided an east-west axis with Giesler's 265-meter-broad domed railway station at its west end and the towering victory monument of the Nazi party at its east end. The north-south axis joined this to form the familiar "T" junction (Fig. 30), but the Königsplatz forum was not situated at this junction. It was situated two blocks north of the east end of the east-west axis. This disjunction of a Nazi forum from its normal site on the main axial intersection was in Munich due to the fact that Königsplatz was planned before Hitler's assumption of power in 1933, and before the new axes were planned from 1938 to 1940.[115] A large square was planned at the axial intersection, but this square was not devoted to the usual Volkshalle and administrative buildings. Instead, it was earmarked for Munich's new opera house, "the largest in the world,"[116] designed by Waldemar Brinkmann and reminiscent of Semper's opera house at Dresden and his Wagner Festival Hall at Isarufer.[117] Restaurants on the east side of this square and a hotel on its west side were to service the opera house on its stepped north side. Fountains and flowers in stone planters were to make this platz "an animated central point" (ein belebter Mittelpunkt) of the new 120-meter-wide east-west axis.[118]

115. Hitler officially put Giesler in charge of the redevelopment of Munich on 21 December 1938; Giesler, 144; for the planning of the east-west and north-south axes, see 152–57.

116. With seats for 3,000 spectators; *Deutsche*

Bauzeitung 46 (1936): 565f.

117. Arndt, *Das Wort*, 22. W. Hansch, *Die Semperoper: Geschichte und Wiederaufbau der Dresdener Staatsoper*, Stuttgart, 1986.

118. Rasp, 87; Giesler, 155.

III

NUREMBERG

THE Nazi party's rally grounds in Nuremberg were frequently referred to as a forum,[1] but the huge complex of assembly halls and open-air stadia cannot be regarded as a forum equivalent in plan or function to the inner-city fora discussed above. The Nuremberg site, measuring approximately 16.5 square kilometers, was far larger in area than any other Nazi ceremonial site and, because of its size, was situated outside the town of Nuremberg.

The vast buildings planned for the site all belonged to what Speer called "Versammlungsarchitektur" (assembly-architecture), essential in Hitler's mind for influencing masses of people and thus, as Speer described it, "a means for stabilizing the mechanism of his domination."[2] They were all related in function to Hitler's interests in mass psychology and how best to influence people en masse in an en face situation (Menschenbeeinflussung im Auge).[3] The beginnings of this type of architecture in Nazi Germany have been traced by Franz-Joachim Verspohl to the Berlin Olympic stadium complex (1933–36; Fig. 31) with its Maifeld equipped with a stand for party officials and a "Leader's pulpit" (Kanzel des Führers), where the masses could be stirred by the party apparatus (Fig. 32).[4] But it was above all in Nuremberg, where every building had a prominent architecturally emphasized raised platform, or *pulvinar*, for the Führer and his entourage, that Nazi assembly-architecture was to reach its full development. Here Hitler presented himself to his *Volk* as leader and living symbol of the German Reich. Flags,

1. Forum der Bewegung: Speer, *Neue Deutsche Baukunst*, 11; das grosse Forum der Partei; W. Lotz, in Teut, *Architektur im Dritten Reich*, 192.

2. Speer, *Architektur-Arbeiten*, 8.

3. Ibid.

4. Verspohl, *Stadionbauten von der Antike bis zur Gegenwart: Regie und Selbsterfahrung der Massen*, Giessen, 1978, 247.

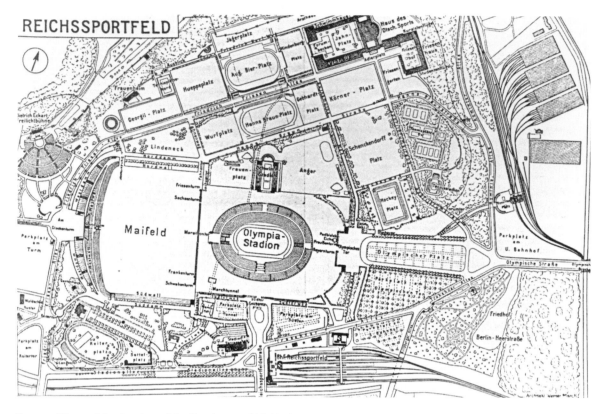

Fig. 31. Werner March, plan of the Reichssportfeld, Berlin, 1933–36

searchlights, stirring music, and rituals such as the "blessing" of standards all helped to engage the emotions of the massed spectators.

To understand the purpose of all the stadia and assembly halls that were built or planned for the Nuremberg site, it is necessary to examine Hitler's aims in establishing the Nazi party rallies (Parteitage), since these objectives have a direct bearing on the design and functions of the buildings themselves. At the Parteitag of 1933 Hitler stated that the aims of these political gatherings were to give the Führer the opportunity to come into personal contact with other leaders of the movement, to reunite the members of the party with their leaders, to strengthen all alike in the confident expectation of victory, and psychologically to inspire the great impulses of the spirit in their determination to pursue the struggle. If these objectives were achieved, those who attended the rallies would go home filled with a new blind trust and a new and unprecedented confidence. The indestructible community between the Führer and his collaborators and the mass of their followers was made possible by the banishment forever of the democratic poison of perpetual disunity and intrigue.

At the Parteitag of 1936 Hitler told the members of his large audience that they had been awakened by his voice, and had followed it year after year, though they had never seen the speaker. In Nuremberg leader and led met together and everyone was filled with

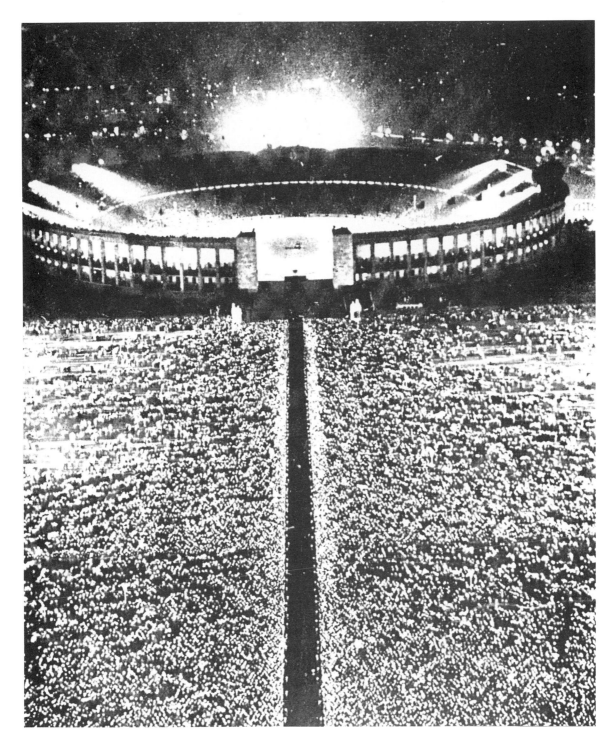

Fig. 32. Maifeld, Rally of 23 September 1937 (Hansen)

wonder at the event: "Not everyone of you sees me, and I do not see everyone of you. But I feel you, and you feel me!"[5]

A notable feature of these rallies was that they were often held at night with spectacular light effects, such as powerful searchlights creating pillars of white light many kilometers long around the perimeter of an assembly ground. The effect of such a contrivance was described as a "Lichtdom," or cathedral of light.[6] The term is most appropriate, since Hitler had already stated in *Mein Kampf* that the Church in its wisdom had studied the psychological appeal made upon worshippers by their surroundings:[7] the use of artificially produced twilight casting its secret spell upon the congregation, as well as incense and burning candles. If the National Socialist speaker were to study the psychology of these effects, it would be beneficial. The lighting effects in Nuremberg, particularly at the Zeppelinfeld stadium, owed nothing to chance.

The "congregationalizing of Nazi souls" in assembly buildings needed a suitable political framework to make it possible.[8] At the heart of Nazi ideology was the "Führerprinzip," according to which all state power was vested in a single individual. On 1 August 1934 Hitler assumed all the powers of Reichspräsident, and this spelled the total destruction of all remaining democratic structures in Germany. Hitler was now the state, and he symbolized the Nazi ideal of the unity of party and state.

The other concept central to Nazi ideology was the "Volksgemeinschaftsprinzip," the notion that the German people constituted a kind of homogeneous national community or fellowship that made unimportant, or even abolished, all social, denominational, and political differences within the nation. This in turn generated the concept of the enemy of the *Volk*, that is, any person (or group) conceived to be hostile to the commonly pursued goals of the nation, for example, the Jews, who were branded enemies of the state and people (Staats- und Volksfeinden). Such people were excluded from participation in the national rituals and festivities that took place within the confines of the community buildings (Volksgemeinschaftsbauten) in Nuremberg, since, as outcasts, their presence would have hindered the creation of the feeling of oneness (Artgleichkeit) between

5. Baynes, *Speeches*, 197f., 200, 204, 207; cf. P. Frédérix, "Hitler manieur des foules," *Revue des Deux Mondes* 20 (1934): 53–70. L. Curtius, who, as director of the German Archaeological Institute in Rome during the Nazi period, noted a similar bond between Mussolini and crowds in the Piazza Venezia: "Nessuna radio può mai sostituire nè l'emozionante spettacolo della reciproca communione di popolo e Duce l'uno di fronte all' altro, nè l'efficacia suggestiva della viva parola indirizzata ed accolta direttamente." He noted similar tendencies in Germany "in parte determinate dall'esempio italiano"; *Mussolini e la Roma antica*, Rome, 1934, 7f. (also published in German; Cologne, 1934). The necessity for Hitler and Mussolini to use fora for public addresses was that, like Augustus and Tiberius, they had abolished democratic elections.

6. Speer, *Architektur-Arbeiten*, 11, 87–92. A special transformer station had to be built at the Zeppelinfeld stadium to provide the electricity needed for "lichtarchitektonischen Effekte"; 14. Mussolini tried to rival these effects when Hitler visited Rome. Bonatz, 150, who saw the "Lichtdom" in the Zeppelinfeld in 1937, called it "impressive but inhuman" (imposant aber unmenschlich). From 1936 the Zeppelinfeld was encircled by 130 searchlights (Flakscheinwerfen); K. Vondung, *Magie und Manipulation: Ideologischer Kult und politische Religion des Nationalsozialismus*, Göttingen, 1971, 82.

7. Page 532.

8. The expression is adapted from Euripides' tragedy the *Bacchae*, (line 75) which illustrates in the timeless context of myth the benefits and dangers of "mass hysteria."

"Führer" and "Geführte" (leader and led), which it was Hitler's aim to create in Nuremberg. Little surprise that a statue of Dionysus was in the library of Hitler's Chancellery in Berlin.[9]

The resemblances between the political function of the Nuremberg stadia as arenas for Hitler's self-dramatization and the role of the Circus Maximus and Flavian Amphitheater in Rome as political arenas for emperors to show themselves off to the people who ruled the world are striking and worth exploring. As in the Nazi stadia, hierarchy was all important in Roman amphitheaters, circuses, and theaters, especially after Augustus passed new legislation regulating seating arrangements in all these places of public entertainment where each group was assigned seats commensurate with its status in the social hierarchy.[10]

The emperor, at the summit of the social pyramid, naturally sat in a prominent position in the Circus and in the Colosseum. The Circus Maximus, which held about 150,000 spectators in the time of Julius Caesar, was provided with a masonry *pulvinar* for the first time by Augustus,[11] who stressed its religious significance (*naos*). Originally statues of gods brought into the Circus were the sole occupants of this raised wooden platform from which they "watched" the games. According to John H. Humphrey,[12] Augustus's *pulvinar* was a "prominent 'box' which fronted onto the arena." Where previously only gods had sat, Augustus (sometimes with Livia and his children) now sat. It is possible that Julius Caesar had sat in the *pulvinar* in his later years.[13]

When Domitian built the *Domus Augustana* on the Palatine, true to his assumed title of "master and god" (*dominus et deus*), he viewed the games either from a box in the palace that overlooked the Circus, or from a box built up against the back of the Circus itself. This much is clear from Pliny's *Panegyricus*,[14] in which he praises Trajan for viewing the games while seated on the same level as the people. It is known that one of Trajan's additions to the Circus, whose seating capacity he enlarged, was a massive new *pulvinar* built into the rear row of seats on the Palatine side of the building.[15] It took the form of a temple with a hexastyle facade and was situated opposite the finishing line in the arena, the most desirable spot in the *cavea*, where the gods and the emperor (who was a divine aspirant) could witness the victory of the triumphant team. Humphrey assumed that Trajan rebuilt Augustus's *pulvinar* in the same part of the Circus as that previously occupied by Augustus's box.[16] From here the emperor could see the people, and they could see him.

9. M. Hirsch, D. Mayer, J. Meinck, eds., *Recht, Verwaltung und Justiz im Nationalsozialismus*, Cologne, 1984, 141–235 (Führerprinzip); 236–75 (Volksgemeinschaftsprinzip). The relation of these two concepts with respect to Nazi state architecture is not discussed in this book, a collection of original documents.

10. Full details in T. Bollinger, *Theatralis Licentia*, Basel, 1961, 1, 19f., 24; J. Kolendo, "Deux amphithéâtres dans une seule ville," *Archeologia* 30 (1979): 54f.; E. Rawson, "Discrimina Ordinum: The Lex Julia Theatralis," *Papers of the British School at Rome* 55 (1987): 83–114.

11. *Res Gestae* 19.

12. *Roman Circuses*, London, 1985, 78.

13. Ibid.

14. *Panegyricus* 51.4–5.

15. Fr.8g of the *Forma Urbis* (Humphrey, 80); the imperial box is clearly represented on Gismondi's model, overlooking the north end of the *spina*.

16. Page 81f.

The political advantages of this arrangement to the emperor were significant. This is clear from the fact that the palace/circus arrangement in Rome was later repeated at other imperial capitals: by Diocletian at Antioch, Maximian at Milan, Galerius at Thessalonica and Sirmium, and Constantine at Trier and Constantinople.[17]

The question as to why so many emperors found it prudent to build palaces adjoining circuses has been addressed by Alan Cameron, who sees this arrangement as part of the process of the elevation of the emperor: "far above the level of ordinary mortals."[18] He concludes:

> The standardization of the palace/circus complex all over the empire is to be seen . . . as a concerted act of imperial policy; designed to foster, not (of course) democratic sentiments, but sentiments of loyalty and adoration towards the person of the emperor . . . the glorification and consolidation of imperial power.[19]

It is in this light that Verspohl sees the Colosseum as a representation of imperial authority (Repräsentation kaiserlicher Machtfülle),[20] though it seated only a third of the spectators contained by the Circus Maximus.

It is interesting that Speer in his *Playboy* interview refers to "a tremendous stadium holding 400,000 people" surrounding Hitler's triumphal arch on Berlin's north-south axis.[21] Giesler, who is highly critical of several of Speer's statements in this interview, rightly questions this detail about the stadium and says it was planned for Nuremberg, not Berlin,[22] "or did Speer wish to erect a second one in Berlin?" This cannot be confirmed from another source, but perhaps Speer had in mind the kind of stadium that is shown centrally located on the main axis of Rimpl's town plan for Hermann-Göring-Werke, an amphitheater pierced at each end of its long axis by the axial road that bisects it (Fig. 19). Or perhaps again he had in mind the plan for Foro Mussolini, where in 1938 the headquarters of the Duce, the Casa Littoria, was sited at the end of a large piazza flanked by two symmetrically positioned stadia (Fig. 11), a historic revival of the imperial Roman palace/stadium complex, or perhaps a reminiscence of the *Domus Augustana*, flanked by the Circus Maximus on one side and the Colosseum on the other.

Giesler further claims that Speer exaggerated the seating capacity of his stadium when he said in the interview that it was to hold 400,000 spectators. Giesler implies when he says that, according to Gregorovius the Circus Maximus accommodated 385,000 spectators,[23] Speer rounded this figure off to show that his stadium was to be bigger than Rome's largest circus.

17. Humphrey, 444–61 (Antioch), 613–20 (Milan), 625–31 (Thessalonica), 606–13 (Sirmium), 602–6 (Trier); for the hippodrome of Constantinople, see R. Guilland, "Les hippodromes de Byzance: L'hippodrome de Sévère et l'hippodrome de Constantin le Grand," *Byzantino-Slavica* 31 (1970): 182f.

18. *Circus Factions*, Oxford, 1976, 181; it is worth remarking that the two main German works on the emperor's elevation (Absonderung) cited by Cameron were published in Germany in 1934 and 1938.

19. Ibid., 182.

20. Verspohl, *Stadionbauten*, 94.

21. Page 80. ". . . oder wollte Speer dasselbe auch noch einmal in Berlin errichten?"

22. Giesler, 322.

23. The reference, not given by Giesler, is F. Gregorovius, *Geschichte der Stadt Rom im Mittelalter*, Stuttgart, 1922, I, 49; this figure is grossly exaggerated. Ac-

Before leaving the general topic of assembly-architecture, it is appropriate to mention the conspicuous failure of one particular type of assembly-building promoted by the Nazi regime to reinforce feelings of group solidarity: the Thingsplatz, or Thingstheater (Fig. 33), an open-air "national" theater similar in design to a Greek theater, consisting of a circular stage area with most of its perimeter surrounded by tiered step-seats.[24] The outdoor setting, often offering spectators a prospect of trees, grass, and bushes, emphasized the "German belief that great drama, that is, drama which deals with eternal problems and conflicts, and not with individual destiny, is but enhanced when performed in an out-of-door setting. The Greek drama and the mystery play were prototypes for the modern open-air performances and its architectural setting. In each case it was a public communal theater as opposed to the private theater performed in an enclosed space."[25]

This propaganda document, produced for consumption in the United States, goes on to state that there were "more than 202 open-air theaters in Germany" and that "the number of spectators in these theaters has been listed as upwards of 1,600,000."[26] These statistics misrepresented the facts. The Nazi experiment in open-air theater, though initially supported by the regime, quickly faltered and failed. More than 400 theaters had been planned for the whole of Germany in 1934, but when Goebbels officially closed down the Thing-movement in 1937, only about 40 theaters had been built.[27] They failed partly because of a lack of suitable scripts to meet the approval of the Nazi cultural hierarchy, and partly because the theaters were situated in rural settings away from city centers, where Hitler could attract much larger audiences to witness his own self-dramatization.

The Dietrich-Eckardt Theater, situated on the periphery of the Reichssportfeld, helped to strike a Greek architectural note in a sports complex that was otherwise Roman in its rigid symmetry and with respect to its main stadium, reminiscent of a Roman amphitheater. Yet after 1937 Germany's "Greek" theaters accommodated only the wind and the rain. The hoped-for creation of "Gemeinschaftsseele" (community spirit) was realized at the Nuremberg rallies and on the parade grounds of the Reich's cities.

The stadium designed by Speer for the Nuremberg site, the Deutsche Stadion (Fig. 34), was, according to Speer himself, inspired not by the Circus Maximus but by the stadium of Herodes Atticus (Fig. 35), which had impressed him so much when he visited Athens in 1935.[28] It was once believed that Herodes built his stadium on the same site as that used by Lycurgus for his stadium in 330–320 B.C. in which the Panathenaic games were to

cording to Humphrey's recent estimate, even after Trajan's expansion of the seating capacity of the Circus Maximus, it is questionable whether it held more than approximately 150,000 (126). Pliny's pre-Trajanic figure is 250,000. The Regionary catalogue gives 385,000 (or 485,000 in the *Notitia*), the figure obviously used by Gregorovius. It is possible that Speer doubled the currently accepted seating capacity of the Circus Maximus (200,000–250,000 spectators). The larger figure is cited twice in *Capitolium* 4 (1928): 60; 12 (1937): 171.

24. Taylor describes them as "basically outdoor

theaters based on the Greek amphitheater [the amphitheater was a uniquely Roman invention], a resemblance which was to recall the alleged racial kinship between modern Germans and classical Greeks"; *The Word in Stone*, 210.

25. *A Nation Builds: Contemporary German Architecture*, 53.

26. Ibid.

27. H. Brenner, *Die Kunstpolitik des Nationalsozialismus*, Hamburg, 1963, 100, 106.

28. *Erinnerungen*, 75.

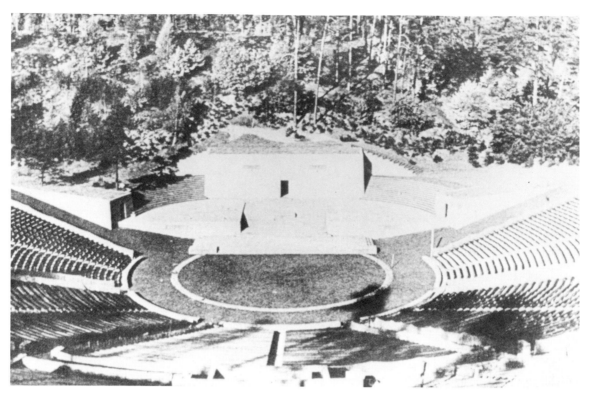

Fig. 33. Werner March, Dietrich-Eckardt-Bühne, Thingstheater, Reichssportfeld, Berlin

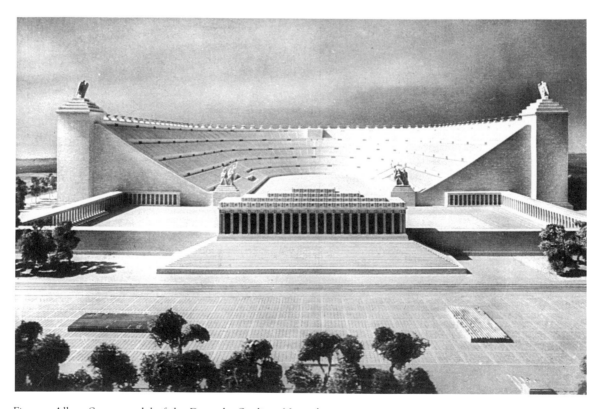

Fig. 34. Albert Speer, model of the Deutsche Stadion, Nuremberg, 1937–42

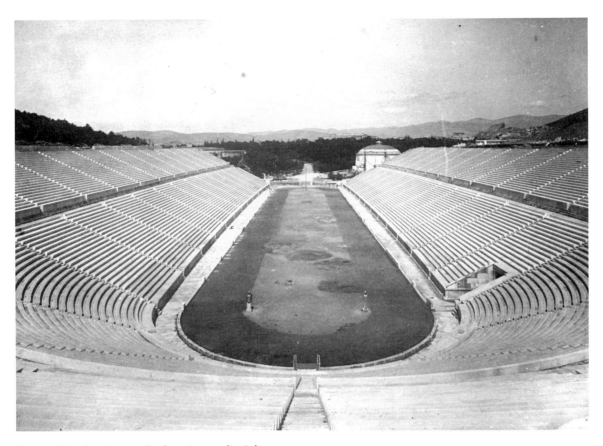

Fig. 35. Herodes Atticus, Stadion (restored), Athens, A.D. 140–143

be celebrated. However, a recent study suggests that Ernst Ziller, the German archaeologist, was right in saying that there was no trace of Lycurgus's stadium beneath Herodes' structure, and that Lycurgus may have built his stadium on the Pnyx.[29] Herodes' stadium (A.D. 140–143) was built at the bottom of a gully with a track in the center flanked by rows of marble-veneered seats tiered up the sides of its two slopes. This stadium was essentially a Roman stadium or circus with semicircular sphendone and slightly curved sides.[30] It had a seating capacity of approximately 50,000 spectators, that is, about 20,000 more than the capacity of Domitian's stadium in the Campus Martius, which was dedicated in A.D. 86 for the celebration of Greek games,[31] and which had been extensively excavated during the Fascist period.[32]

29. D. G. Romano, "The Panathenaic Stadium and Theater of Lykourgos," *American Journal of Archaeology* 89 (1985): 441–54.

30. B. Andreae, *The Art of Rome*, London, 1978, 556; for the history of the site (with full bibliography), see J. Travlos, A *Pictorial Dictionary of Ancient Athens*, London, 1971.

31. A Hönle, A. Henze, *Römische Amphitheater und Stadien*, Feldmeilen, 1981, 169 and pl. 153 (model).

32. A. M. Colini, "Lo Stadio di Domiziano," *Capitolium* 16 (1941): 209–23; idem, *Stadium Domitiani*, Rome, 1943. Speer nowhere alludes to this building in connection with the Deutsche Stadion, though he perhaps was not unaware of it.

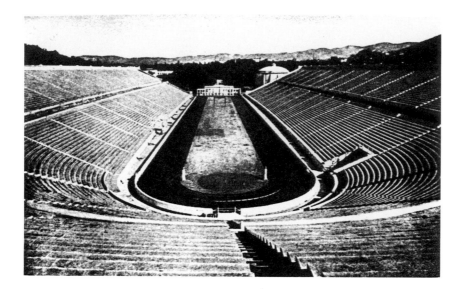

Fig. 36. Herodes Atticus,
Stadion, Corinthian
propylaeum (demolished)

What Speer saw on his visit to Athens in 1935 was the restoration of Herodes' stadium
based on the excavation reports of Ernst Ziller, financed by the Alexandrian entrepreneur
G. Averoff. Part of the restoration was a Corinthian propylaeum (Fig. 36; since re-
moved), which formed a ceremonial entrance at the open end of the track.

Speer's stadium was a gigantic inflation of its Greco-Roman model, from which he
borrowed the horseshoe configuration and the propylaeum, now transformed into a
raised, pillared, temple-like structure (Säulenvorhof) attached to the open end of the
stadium by an internally pillared courtyard.[33] Since the stadium was not set like Herodes'
structure at the bottom of a gully, but on a flat area of land (24 hectares), its five tiers of
seats for 400,000 spectators had to be supported in the usual Roman manner by massive
barrel vaults (Fig. 37). The external facade of pink granite blocks, which would have
risen to a height of about 90 meters, consisted of a series of arches 65 meters high resting
on a podium of dark red granite. The arcade and podium again suggests a Roman, not a
Greek, circus or stadium, which did not traditionally rest on a substructure. In order to
deliver such a vast number of spectators to their seats quickly, express lifts were to be
installed to take spectators 100 at a time to seats on the top three tiers,[34] while escalators
would deliver others to seats on the bottom two tiers.[35] The short transverse axis of the
stadium culminated at each of its ends in a raised *pulvinar* (Ehrentribüne) for the Führer,
special guests, and the press. Once more, Roman practice provided the architectural
precedent.

Speer apparently adopted a horseshoe shape for his building only after rejecting the
oval shape of an amphitheater. The latter plan, he claimed, would have intensified the

33. See R. Wolters, 21, and Krier, ed., *Albert Speer*,
176–85, for illustrations of the courtyard.

34. Petsch, *Baukunst*, 95; the outer measurements of
the building were 540 by 445 m.

35. Speer, *Architektur-Arbeiten*, 18, where he claims
a full stadium could have been emptied in fifteen min-
utes.

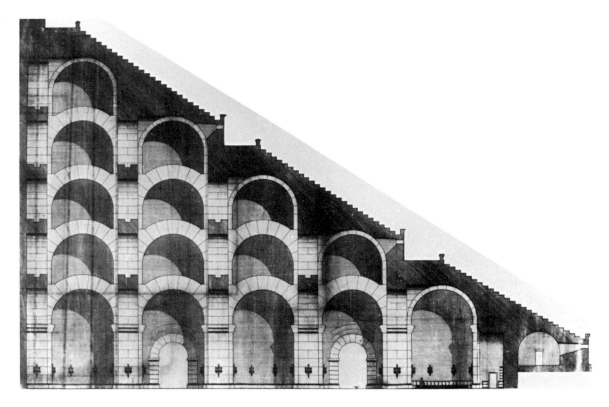

Fig. 37. Albert Speer, Deutsche Stadion, cross section of barrel-vaulted substructure

heat and produced psychological discomfort, a comment he does not elucidate.[36] When Speer remarked on the staggering cost of the building, Hitler, who laid its cornerstone on 9 September 1937, merely retorted that it would cost less than two battleships of the Bismarck class.[37]

Wolfgang Lotz, writing about the stadium in 1937, commented that it would contain twice the number of spectators originally accommodated by the Circus Maximus.[38] Inevitably for the period, he also emphasized the community feeling that such a building would engender between competitors and spectators: "As in ancient Greece, the elite and most experienced men chosen from the mass of the nation will compete against each other here. An entire nation in sympathetic wonder is seated on the tiers. Spectators and competitors merge in one unity."[39] The idea of staging Pan-Germanic athletic games here

36. *Erinnerungen,* 81f.

37. Ibid.; this disregard on Hitler's part for the cost of his buildings was typical ("Geld spielt keine Rolle"); Pfister, "Hitlers Baukunst," 31. Cf. *Mein Kampf* (1.10), where Hitler complains that the Reichstag cost only half the current cost of a battleship.

38. W. Lotz, "Das Deutsche Stadion für Nürnberg,"

Moderne Bauformen 36 (1937): 491.

39. Ibid., 492. "Wie im alten Griechenland stehen hier aus der Masse des Volkes die auserlensten und erprobtesten Männer sich gegenüber. Ein ganzes Volk sitzt, begeisterten Anteil nehmend, auf den Tribünen. Der Zuschauer und der Kämpfer verschmelzen zu einer Einheit."

was perhaps suggested by the Panathenaic games, but Speer's stadium was stylistically more Roman than Greek in inspiration, and with its huge barrel-vaulted substructures and arcaded exterior facade, more like the Circus Maximus than Herodes' stadium. Once more the Nazi building exhibits a mixture of Greek and Roman elements, with Roman predominating.

But Hitler did not want such a stadium to serve merely as a center for German athletic sports. Herodes' restored stadium had been used for the Olympic games of 1896 and the extra Olympic games of 1906 held out of series.[40] In 1936 these games were held in the Reichssportfeld in Berlin, but Hitler insisted that after 1940, when the games were to have been held in Tokyo, all future Olympic games were to be held in the Deutsche Stadion.[41] As Lotz showed in his article of 1937,[42] this stadium was in all its dimensions far larger than the 1936 Olympic stadium in Berlin, which held only 115,000 spectators. It is clear that Hitler anticipated that after winning the war a subjected world would have no choice but to send its athletes to Germany every time the Olympic games were held. Pan-German games were to become global games at which, no doubt, victors would have received their prizes from the Führer, surrounded by the party faithful on the *pulvinar* on the short axis of the cavernous stadium. Thus, this building, like the Volkshalle in Berlin, foreshadowed Hitler's craving for world domination long before this aim was put into words.

One of the smaller buildings on the Nuremberg site was, paradoxically, the Kongresshalle (Fig. 38), designed by Ludwig Ruff in 1934[43] and inspired by the Colosseum (Fig. 39),[44] which Hitler viewed on his visit to Rome in 1938 and of which he saw a restoration in the shape of Gismondi's model in the *Mostra Augustea*.[45] The Congress Hall was not elliptical in plan like its Roman model, but resembled a closed horseshoe reminiscent of a Roman theater, such as that of Marcellus, "liberated" by Mussolini in 1926.[46] Rodenwaldt, in his "Kunst um Augustus,"[47] related the design of the Nuremberg Congress Hall to that of a Roman theater, without referring it to a specific model. It is unlikely that Hitler, who did not visit the Theater of Marcellus in 1938, and who so often in his speeches and table talk referred to the Colosseum as a durable community building,[48]

40. Verspohl, *Stadionbauten*, 163.

41. *Erinnerungen*, 84; Thies, *Weltherrschaft*, 91.

42. Page 493.

43. *Erinnerungen*, 82.

44. Petsch, *Baukunst*, 95; fig. 39 shows Gismondi's model of the Flavian Amphitheater. Two recent writers disagree about the inspirational sources of the Congress Hall: Hilmar Fütterer, *Die Kongresshalle auf dem Reichsparteitagsgelände in Nürnberg*, 17, acknowledges that the Colosseum was a source of inspiration. Enno Dressler, "Die Kongresshalle auf dem ehemaligen Reichsparteitagsgelände in Nürnberg," 67–70, regards comparisons between the Congress Hall and the Colosseum as little more than a reflection of Nazi propaganda. He prefers to instance the Bouleuterion (meeting house of the town council) at Miletus as a more appropriate

model for Ruff's hall than either the Colosseum or a Roman theater. However, Dressler overlooks such obvious points of similarity between the Colosseum and the Congress Hall as their external facades and step-seated auditoria crowned by columns/pillars. The Bouleuterion lacks such features that are common to the Theater of Marcellus and the Flavian Amphitheater.

45. See page 32.

46. F. Fidenzoni, "La liberazione del Teatro Marcello," *Capitolium* 2 (1926): 594–600.

47. Page 3. "Die Nürnberger Kongresshalle stellt motive des römischen Theaters . . ." He had of course just compared the Olympic stadium in Berlin to a Roman amphitheater.

48. See pages 32, 34, and 38.

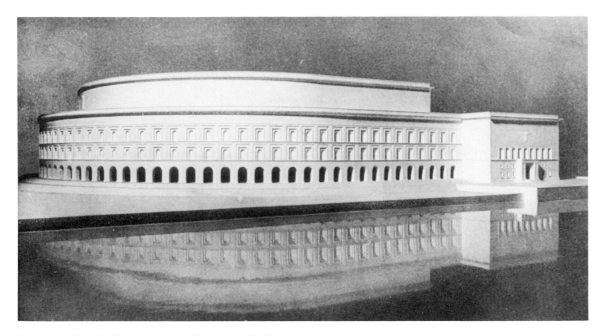

Fig. 38. Ludwig Ruff, model of the Kongresshalle, Nuremberg, 1934–35

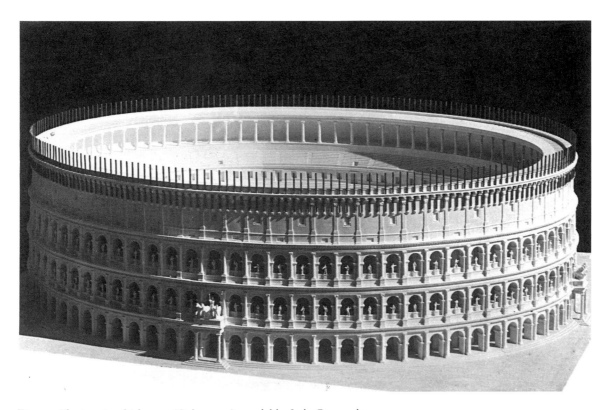

Fig. 39. Flavian Amphitheater (Colosseum), model by Italo Gismondi

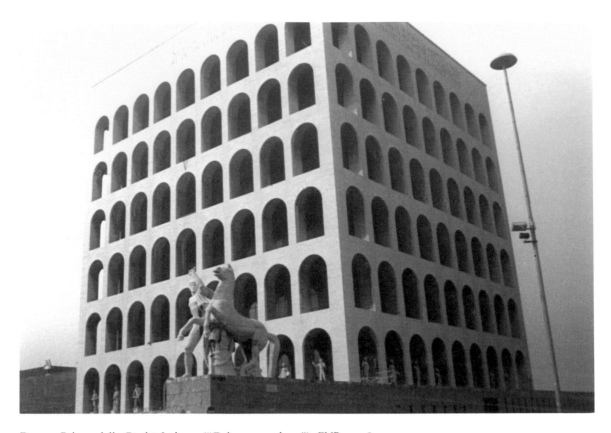

Fig. 40. Palazzo della Civiltà Italiana ("Colosseo quadrato"), EUR, 1938

would have chosen the Augustan theater rather than the Flavian Amphitheater as the prototype for the Congress Hall. The Colosseum also carried the association of eternity that was so much in harmony with Hitler's fantasies about being the founder of a thousand-year Reich.[49] A "Colosseum" on the Nazi party's rally grounds would therefore have been a fitting symbol for the new German regime, just as the "Square Colosseum" ("Colosseo quadrato"), the Palazzo della Civiltà Italiana (1938; Fig. 40)[50] was at EUR for the Fascist regime, where the debt of the modern building to its ancient prototype was more deliberate and obvious, though the building finally selected for the site did not, like one of its competitors,[51] include a colossal statue complete with radiate crown (Fig. 41).

It is also possible that the general configuration of Ruff's building was influenced by the semicircular plan adopted by several Italian architects for their respective projected plans

49. G. Cozzo, *The Colosseum*, Rome, 1971, 93.

50. This building was thought to express the essence of native Italian architecture, since it was constructed of arches. A statue is placed in each arch on the ground floor as a reminder of the statues originally placed in the arches on the first and second levels of the Colosseum; Insolera, Di Majo, *L'EUR e Roma*, 49, 58. The "new"

Rome had as its two most prominent buildings a new "colosseum" and a new "Saint Peter's" as symbols of the continuity of imperial and papal Rome. Both buildings are on elevated sites at the culmination points of two parallel east-west axes.

51. *Architettura* 17 (1938): 863.

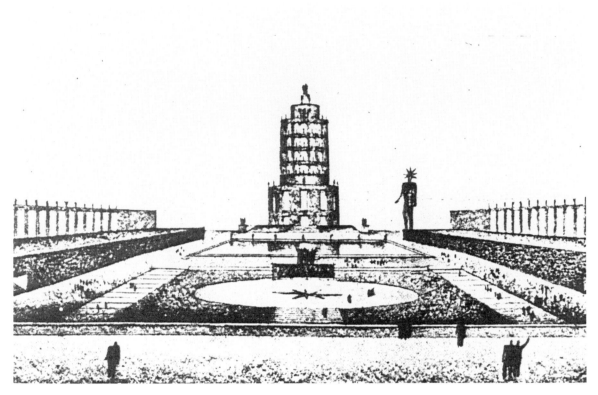

Fig. 41. D. Ortensi, C. Pascoletti, G. Santi, rendering of the Palazzo della Civiltà Italiana, 1938; Colossus with radiate crown

for the Casa Littoria in Rome. The site for the proposed headquarters of the Fascist party was on the Via dell' Impero, adjacent to the Colosseum and opposite the Basilica of Maxentius. Several plans proposed by Italian architects resembled in general ways the plan of a Roman theater, though none is exactly like Ruff's Congress Hall. For example, the plan of Giuseppe Samonà (Fig. 42)[52] conforms to the typical shape of a Roman theater, and there are other examples.[53] It is hardly surprising that so many of the designs proposed for the Casa Littoria should have echoed at least to this extent the design of the nearby Colosseum, with which the new building had to harmonize.[54] Ruff's building was designed in 1934, but even in 1938, when Hitler visited Rome, its construction had not progressed very far, so that Hitler, as already mentioned,[55] could still consider modifications to its plan at this late date.

52. *Architettura: Concorso per il Palazzo del Littorio,* special issue with forty-three projects, Milan, 1934, 10f.

53. Ibid. 28f. (G. Vaccaro); 42 (Del Giudice); 106 (L. Coseriza).

54. Even where there was not an ancient amphitheater for a casa littoria to harmonize with, the theater-type plan could be proposed. See "Concorso per la Casa Littoria di Asti," *Architettura* 13 (1934): 606, 612.

55. See page 80 above. When construction on the site stopped in 1943, only the outer shell of the building and some of the rooms in the closed part of the horseshoe had been built. In 1955 the possibility of turning this existing structure (cost: 82 million Reichsmarks) into a sports stadium was considered, and rejected, as was a proposal to turn the Rundbau (horseshoe section) into quarters to accommodate 7,000

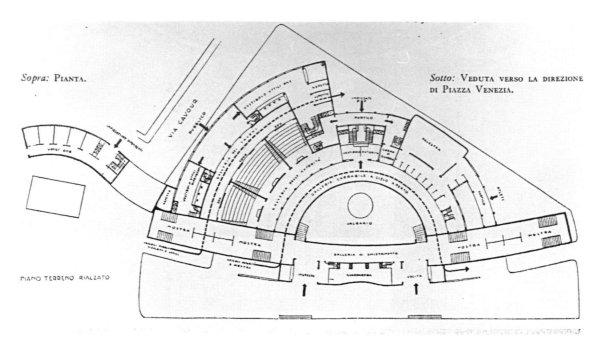

Fig. 42. Giuseppe Samonà, plan of the Casa Littoria, Rome, 1934

The Congress Hall's external facade (Fig. 38) consists of three superimposed rows of arches, of which only those at ground level are open. The top two were windows. Above the third row, and set back from its edge, is a windowless attic story. Between the arches are shallow, completely plain pilasters—simplifications of the engaged columns (Tuscan, Ionic, and Corinthian) between the arches of the Colosseum's facade on its first, second, and third levels, respectively. The interior of the Congress Hall (Fig. 43), which, unlike the exterior facade, was never built, was to have consisted of tiered seats arranged to enclose a horseshoe-shaped arena. The top tier was crowned by a continuous row of rectangular pillars corresponding to the concentric row of Corinthian columns that once encircled the interior of the Colosseum at its attic level.

The Colosseum was roofless but had an awning (*velum*) that on sunny, windless days was stretched over the top of the *cavea* to protect spectators from the summer heat,[56] but not against wind or rain. Ruff's building, on the other hand, was to be covered with a large flat glass roof (160 meters across), a permanent transparent *velum*, the building's only main source of natural light, which because of its weight required the use of steel

beds; *Vorschläge über Verwendungsmöglichkeiten der ehemaligen Kongresshalle*, Hauptamt für Hochbauwesen, Nuremberg, 1955. This building remains to this day unfinished and unused.

56. W. Graefe, *Vela Erunt*, Mainz, 1979, I, 56–61,

gives a new interpretation of the method used to suspend awnings over the Colosseum; note, however, Humphrey, *Roman Circuses*, 101, who says, contrary to Graefe, 126–32, that there is no evidence for the use of *vela* in the Circus Maximus.

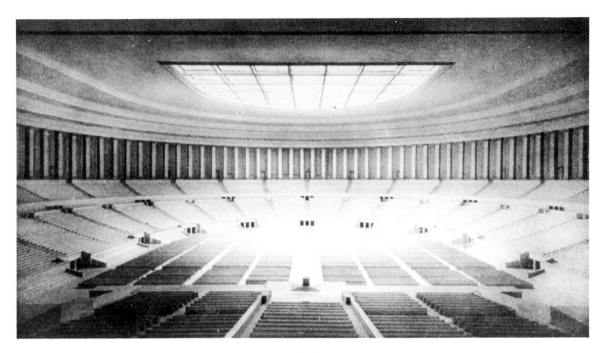

Fig. 43. Ludwig Ruff, model of the interior of the Kongresshalle

girders (always something of an embarrassment to Nazi architects, who were urged to avoid steel and ferroconcrete) to support it.[57] This ensured that spectators would be protected from the more inclement German weather at all times of the year. The Congress Hall was designed to hold about 50,000 spectators,[58] as was its Roman model, although the Nazi counterpart was 1.7 times broader and 1.3 times longer.[59] It therefore is the only one of three buildings in Nuremberg inspired by Roman or Greek models that did not dwarf its ancient prototype.

In 1933 Speer's first major undertaking for the Nazi party was the erection of temporary wooden stands on the Zeppelinfeld at Nuremberg for that year's Parteitag.[60] After Troost's death at the beginning of 1934, Hitler commissioned Speer to draw up plans for a permanent stone structure on the same site, and asked him to devise an overall master plan for the entire rally complex (Gigantenforum).[61] The Zeppelinfeld stadium (Fig. 44) consisted of a large area 290 by 312 meters for 90,000 demonstrators, surrounded on its

57. Taylor, *The Word in Stone*, 173.

58. Petsch, *Baukunst*, 96; Thies, *Weltherrschaft*, 89, gives its capacity as 60,000.

59. Thies, "Nazi Architecture," 62.

60. Speer refers to the stands as "jerry-built bleachers" in his *Playboy* interview, 78.

61. Wolters, 16; Arndt, 113. Speer adopted a Roman, not a Greek, approach to site development: "It

was Speer who urged that the landscape be moulded to fit a bold plan, rather than that the plan be fitted to the scenery," Hamsher, *Albert Speer*, 90; cf. H. Drerup, "Architektur als Symbol," *Gymnasium* 73 (1966): 187; "Als landschaftsbeherrschende Architektur stellt er sich als die in Sichtbarkeit umgesetzte Ingenieurleistung ingesamt dar, die ein Stück Naturbeherrschung war"; cf. 190.

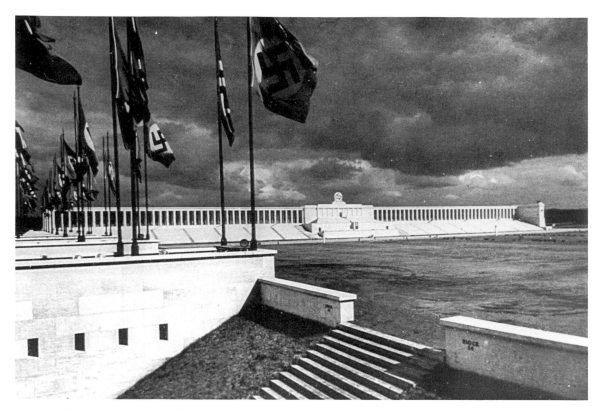

Fig. 44. Albert Speer, Zeppelinfeld Stadion, Haupttribüne, Nuremberg, 1939

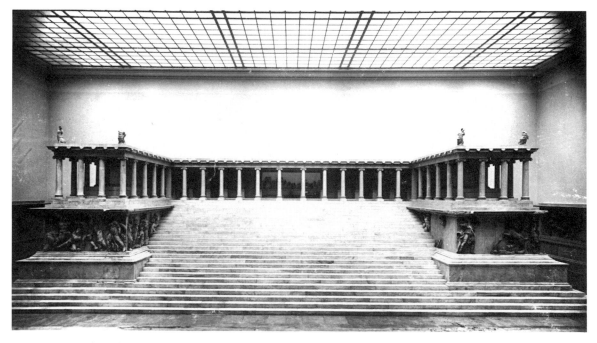

Fig. 45. Great Altar of Pergamum, model of the west front, Pergamon Museum, Berlin

north, south, and west sides by seats on earth banks accommodating 64,000 spectators. Detached from these banks on the east side of the field was the 390-meter long main stand (Haupttribüne) built of yellowish-white travertine from the Juras (Jurakalkstein), which contrasted with the long red swastika flags hung in the intercolumnar spaces of the pillared hall. This stand accommodated 70,000 spectators. Speer himself draws attention to the fact that the length of the Haupttribüne exceeded that of the Baths of Caracalla in Rome.[62] The tiers of seats were discontinued in the center of the stand, as were the rows of pillars at the back of the stand, to accommodate the Führertribüne, a stepped *pulvinar*, raised above the level of the tiers of seats that flanked it. Built into the center of the front wall of the upper step was a Führer-pulpit (Kanzel). The main axis of the field passed through the entrance in the middle of the west stand and culminated in this pulpit, over which a massive swastika encircled in an oak-leaf crown loomed from its position on the roof of the block, which was flanked by pillars and immediately behind the *pulvinar*. The whole building, which today lies stripped of its pillared hall (dynamited in 1967),[63] had a fortress-like appearance imparted by the tall stone towers built into the stand in the north, south, and west sides of the field, and provides a good example of what has been called Nazi *architectura militans*,[64] as would the much larger but uncompleted Märzfeld,[65] where the Wehrmacht was to give displays in an enclosed paved area 611 by 955 meters.[66]

According to Speer himself,[67] the Haupttribüne of the Zeppelinfeld stadium was inspired by the west front of the Great Altar of Pergamum (Fig. 45), a large model of which was (and still is) exhibited in the Pergamon Museum in East Berlin. Despite Speer's comment about the source of his building's inspiration, Miller Lane sees a striking visual resemblance between Speer's Haupttribüne and the tomb of Queen Hatshepsut at Deir-el-bahari,[68] but it is difficult to see the precise relevance of this building to Speer's structure once the relationship of the Pergamum Altar to the Haupttribüne has been explored.[69]

62. ". . . er übertraf die Länge der Caracalla-Thermen in Rom um 180 Meter, also fast das doppelte"; *Erinnerungen*, 68.

63. Krier, ed., *Albert Speer*, 165.

64. Cf. Hinz, *Art in the Third Reich*, 204.

65. So called after the Campus Martius in Rome, used for military exercises until it was covered with monumental buildings in imperial times; it was also in March that Hitler reintroduced compulsory military service (Wehrpflicht).

66. It was from the middle of this enclosure that the 80-m wide, 2-km long processional way issued. The axis formed by this *via triumphalis* ended, again, in Hitler's *pulvinar* in the center of the field's main stand, surmounted by a colossal statue of Victoria by J. Thorak; a photograph of this statue in Thorak's atelier (designed by Speer) is reproduced in Krier, ed., *Albert Speer*, 208.

67. *Erinnerungen*, 68. For German excavations at Pergamum (1876–86) and the building of the Pergamon Museum and the model it housed, see S. Wenk, "Die Arbeit eines deutschen Archäologen an der Mod-

ernisierung des antiken Ideals. T. Wiegand und die Funktion der Antike vom Kaiserreich bis zum deutschen Faschismus," *Ausstellungskatalog*, 41–49. From 1933 to 1936 Wiegand was president of the Archaeological Institute of the German Reich, a position later held by G. Rodenwaldt. Wenk does not discuss the connections between the Pergamum altar and Speer's Zeppelinfeld stadium.

68. *Journal of the Society of Architectural Historians* 32 (1973): 343, figs. 4, 5. In her article "Architects in Power: Politics and Ideology in the Work of Ernst May and Albert Speer," *Journal of Interdisciplinary History* 17 (1986): 305, Miller Lane says Speer's "protestations of admiration for Greek architecture must have been conditioned by some notion of what he thought he ought to say, as a Nazi, and by a belief that this was what Hitler would like to hear." However, the Zeppelinfeld stadium is clear proof that Speer's admiration for Greek architecture was not merely lip service.

69. Which Miller Lane nowhere mentions in her discussion.

Speer made the following main modifications when adapting the design of the west front of the altar to suit the specific functional requirements of his own building. First, he stretched the monumental staircase of the altar front to provide tiers of step-seats for spectators; second, he replaced the flanking porticoes at either end of the staircase with massive pylons devoid of colonnades, but still rising to the same height as that of the pillared hall that crowned the stand; third, the Ionic columns of the Hellenistic building were transformed into plain rectangular pillars; fourth, the pillars and the tiers of seats at the center of the building were interrupted to insert a raised *pulvinar* for Hitler and his entourage. The massive relief sculptures of the altar have no counterpart in Speer's building. The only decorative features are the usual Nazi icons: a swastika in an oak-leaf crown attached to the front of each pylon topped by a bronze brazier (Feuerschale)[70] and a huge swastika surmounting the roof of the stand's central pavilion. The flat roof of the flanking porticoes of the Hellenistic structure supported statuary,[71] which is absent from Speer's stand. However, in his *Neue Deutsche Baukunst*, Speer published a plate[72] showing a statue by Breker entitled "der Künder," which he says was "für den Tribünenbau des Zeppelinfeld." Yet its exact position, actual or intended, is not revealed by any other photographs.

The ceiling between the two rows of pillars on top of the stand consisted of a single row of coffers decorated with a swastika key-pattern (Figs. 46 and 47). This was the only decorative feature of the Haupttribüne linking it to Troost's House of German Art in Munich, which contained a similar ceiling behind its frontal colonnade.[73]

The massive terminal pylons of the stand have been compared by Adolf Max Vogt to the towers incorporated by Etienne Louis Boullée into a city wall in his drawing "Intérieur de ville" (c. 1780).[74] The comparison is fruitful in that it emphasizes the *architectura militans* aspect of the Zeppelinfeld (and Märzfeld) stadium, though perhaps the comparison is more applicable to the stone towers built into the earth banks on the north, south, and west sides of the field. Yet it is doubtful whether Speer derived his pylons from Boullée; indeed, it is difficult to determine whether Speer was acquainted with the work of Boullée (and Ledoux) at the time he was designing Hitler's buildings. These architects are not mentioned in his publications before the appearance of his memoirs (1969),[75] long after the buildings were designed, and when interest in French revolutionary architecture was reviving.[76] Boullée's buildings, which, like most of Speer's, remained on

70. A standard decorative feature of Nazi state buildings and already present in Munich's Königsplatz; Speer, *Baukunst*, 51; Wolters, *Speer*, 23; Krier, ed., *Albert Speer*, 172.

71. E. Schmidt, *The Great Altar of Pergamum*, London, 1961, pl. 4. For a general account of the building activities of the Attalids, see E. V. Hansen, *The Attalids of Pergamon*, Ithaca, 1971, 234–98 (with large bibliography); and E. Rohde, *Pergamon: Burgberg und Altar*, Munich, 1982.

72. Page 27.

73. Illustrated by Taylor, *The Word in Stone*, pl. 79.

The swastika mosaic in the House of German Art is still in place.

74. "Revolutions-Architektur und Nazi-Klassizimus," in M. Gosebruch, L. Dittman, eds., *Argo-Festschrift für K. Badt*, Cologne, 1970, 358.

75. Both French architects are mentioned in passing connection with Speer's Berlin Volkshalle; *Erinnerungen*, 169.

76. J.-M. Pérouse de Montclos, *Etienne Louis Boullée, 1728–1799: Theoretician of Revolutionary Architecture*, New York, 1974, 44, 133 n. 49, questions whether Speer knew Boullée's work prior to his incarceration in

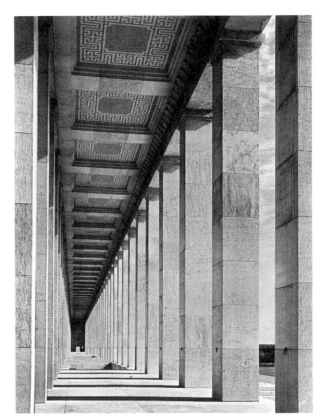

Fig. 46. Albert Speer, Zeppelinfeld Stadion, ambulatory of Haupttribüne

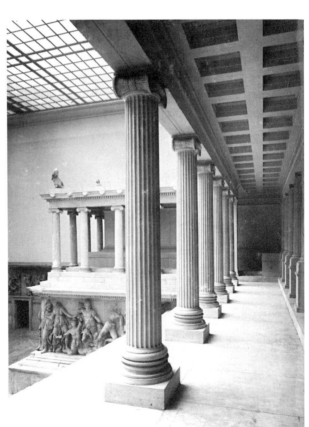

Fig. 47. Pergamum Altar, model of the west front, Ionic colonnade

paper, were massively proportioned, and this fact alone immediately invited comparison with Speer's structures. But whereas the colossal dimensions of Boullée's buildings were inspired by contemporary discoveries in astronomy and physics,[77] the dimensions of Speer's buildings had far more to do with the representation of political power and Hitler's belief that there was a connection between vast buildings and mass psychology. Yet Vogt has recently criticized Boullée's brutal representation of state functions in his buildings.[78]

Apart from sharing massive proportions, the buildings of Boullée and Speer are often reminiscent of Roman models or architectural elements.[79] But it still remains to be convincingly demonstrated that Speer was acquainted with Boullée's work between 1933 and 1941, and that specific areas of Speer's work were influenced by Boullée. The fact that both architects built on a massive scale (for different reasons) and that their styles are often reminiscent of Roman imperial architecture is not enough to demonstrate direct influence. It would perhaps be more prudent to suggest that if French revolutionary architecture was an influence on Speer's state architecture, it was transmitted to him through the work of Gilly, whom he undoubtedly admired,[80] and who was after his stay in France deeply influenced by revolutionary architecture.[81]

Accordingly, the Haupttribüne of the Zeppelinfeld was not an enlarged, literal quotation of the west front of the Pergamum Altar. The configuration of the whole stand is still recognizably indebted to the form of its model, even after changes necessitated by the different function of Speer's building have been taken into consideration. The architectural style and ornamentation of the Hellenistic model was transformed by Speer into the idiom already established by Troost's buildings in Munich, especially the House of German Art. As Elaine Hochmann has stated, one should not look for classical motifs in Speer's state buildings so much as recognize that Speer's liking for the "Doric" may be seen in his "interest in the use of modular units, as well as clear ordered arrangements of simple, geometric masses."[82]

The symbolism of Speer's Hellenistic model also deserves some consideration, since it almost certainly was not randomly chosen, and has rather more significance in the context of Nazi ideology than the tomb of Queen Hatshepsut. The Great Altar was one of

Spandau prison and suggests his knowledge could be "an afterthought prompted by Boullée's present-day celebrity."

77. Thies, *Architekt der Weltherrschaft*, 67f.; Vogt, 359f., points to the discoveries of Descartes, Leibnitz, and Newton.

78. "Orwell's Nineteen-Eighty-Four and E. L. Boullée's Drafts of 1784," *Journal of the Society of Architectural Historians* 43 (1983): 63: "Here the state seems brutally to flaunt its defensive power and appears as resistant as if it were pitched not only against the attack of armed masses but against the threat of the universe itself. . . . Here the features of power and defensive aggrandizement are so exaggerated that George Orwell's *1984* suggests itself logically enough."

79. "Most of Boullée's projects can be traced back to a Roman monument." Pérouse de Montclos, *Etienne Louis Boullée*, 29.

80. See I, note 137.

81. It is interesting that when Giesler comments on Speer's Berlin Volkshalle, he says (327) that it was the sort of building a Boullée or a Gilly or a Schinkel might have built, if they had combined their ideas with the technology of the twentieth century.

82. Letter to the editor, *Journal of the Society of Architectural Historians* 33 (1974): 272; reprinted along with many other reviews of Speer's memoirs in A. Reif, ed., *Albert Speer: Kontroversen um ein deutsches Phänomen*, Munich, 1978, 353.

the architectural wonders of the ancient world, largely because of its exceptional size (especially that of its relief sculpture). Hitler habitually derived satisfaction from seeing world-famous monuments being surpassed in size by German equivalents. The Deutsche Stadion in Nuremberg provides only one example of this. There were many others.[83] Architectural elephantiasis alone does not explain the full significance of the choice of model. The Great Altar, built by Eumenes II about 180 B.C., commemorated the military victories won by his father, Attalus I, and was dedicated to Athena Nikephoros (and to Zeus), the goddess of war, in her capacity of "bringer of victory." These associations were completely congruent with the context provided by the Nuremberg rally-ground complex, the heart of which was the huge Märzfeld dedicated to the Roman god of war and the Roman goddess Victoria, a colossal statue of whom towered above Hitler's *pulvinar* in the center of the ground's main stand. Also, Athena was very much part of Nazi iconography and racial ideology, the Greeks being considered the ancestors of the Germans.[84] These associations give more point to Vogt's remark that the main stand of the Zeppelinfeld was the "first altar of the movement"[85] and to Georg Hellack's observation that "here the cult of power and the glorification of the Führer attained a religious consecration . . . and the altar of this political shrine was the seat of the Führer on a prominent platform of the Haupttribüne."[86]

Again, it is possible to discern similar symbols with similar functions in Nazi Germany and Fascist Italy, where the "altar" of Mussolini as founder of "La Terza Roma" was the reconstructed and resited altar of Rome's second founder, Augustus, the Ara Pacis. This refurbished monument was finally[87] placed at the edge of the Tiber and in front of the "liberated" mausoleum of Augustus.[88] This architectural complex was designed as a cult site with its own piazzale (Piazza Augusto Imperatore), where on special occasions the

83. The Berlin Volkshalle dwarfed its model, the Pantheon (and Saint Peter's and the Capitol in Washington, D.C.); Hitler's triumphal arch in Berlin would dwarf the Arc de Triomphe; Hamburg was to have a skyscraper and a suspension bridge over the Elbe larger than the Empire State Building in New York and the Golden Gate over the San Francisco bay, etc.; see D. Schubert ". . . ein neues Hamburg entsteht . . . ," in Frank, ed., *Faschistische Architekturen*, 299–318.

84. See page 13.

85. "Revolutions-Architektur," 358.

86. "Hier wurde der Kult der Macht und der Verherrlichung des Führers bis zur religiösen Weihe gesteigert . . . und der Altar dieser politischen Weihestätte war der Platz des Führers auf einem vorgeschobenen Podest der Haupttribüne"; G. Hellach, "Architektur und Bildende Kunst als Mittel NS Propaganda," *Publizistik* 5 (1960); 87.

87. An early plan was to resite the altar on the Capitol: C. Cecchelli, "L'Ara della Pace sul Campidoglio," *Capitolium* 1 (1925): 65–71. The altar

was finally reassembled near the Tiber and inaugurated on 23 September 1938, the intended final day of the *Mostra Augustea* (23 September 1937 to 23 September 1938). For the altar's history between 1926 and 1938, see G. E. Rizzo, "Per la ricostruzione dell' Ara Pacis Augustae," *Capitolium* 2 (1926): 457–73; G. Lugli, "In attesa dello scavo dell' Ara Pacis Augustae," *Capitolium* 11 (1935): 365–83; G. Moretti, "Lo scavo e la ricostruzione dell' Ara Pacis Augustae," *Capitolium* 13 (1938): 479–90. In May 1938 Hitler viewed the altar's relief sculptures while they were still housed in Diocletian's baths; see page 30 and Figure 5.

88. A. M. Colini, "Il Mausoleo di Augusto," *Capitolium* 4 (1928): 11–22; B. Giovanni, "I concerti romani e l'Augusteo," *Capitolium* 10 (1934): 361–84; G. Gatti, "Il Mausoleo di Augusto," *Capitolium* 10 (1934): 457–64; A. Muñoz, "Sistemazione del Mausoleo di Augusto," *Capitolium* 13 (1938): 491–508; G. Gatti, "Nuove osservazioni sul Mausoleo di Augusto," *L'Urbe* 3 (1938): 1–17. The reconstruction of the Ara Pacis was reported in the *Dresdener Anzeiger* of 4 August 1937.

people could gather "in religious silence" to listen to the words of the "Founder of the new Italian empire" while standing beside the "sacred urn" of the "founder of the ancient empire."[89]

Hitler, founder of the Third Reich, admirer of imperial Rome, yet aware that the ancient Germans were never romanized and were traditionally regarded by the Romans as enemies of the Pax Romana,[90] erected as a cult site for the Nazi party a victory altar borrowed from the alleged racial ancestors of the Germans—the Greeks. His dilemma was that because of his admiration for the Classical cultures of the ancient Mediterranean, he could not isolate and politicize German antiquity, as Mussolini had done with respect to Roman antiquity. He therefore had to import political symbols into Germany and justify their presence on the grounds of a spurious racial ancestry, the myth that the Greeks and the Romans (excluding the Etruscans)[91] were the ancestors of the Germans.

89. A. Muñoz, "Sistemazione," *Capitolium* 13 (1938): 508: "Un religioso silenzio regna nella isolata ed alta platea, ove su quella che fu la sacra urna del fondatore dell' impero antico, il popolo potrà raccogliersi ad ascoltare la parola del Fondatore del nuovo impero italiano." See also Kostof, "The Emperor and the Duce," and I, note 3.

90. This was a conclusion of the book by M. Bendiscioli et al., *Romanesimo e Germanesimo*, Brescia,

1933. Tacitus in his monograph, *Germania*, tended to contrast the unsophisticated lifestyle of the tribal Germans with the oversophisticated urban lifestyle of Romans softened by luxurious living. Hitler in his speech given in the Palazzo Venezia on 7 May 1938 alluded to the strife that had existed for centuries between Germans and Italians; see page 32.

91. For A. Rosenberg's views of the Etruscans, see page 20 above; M. Cagnetta, *Antichisti,* 147 n. 4.

IV

ALBERT SPEER'S THEORY OF RUIN VALUE

T HE Zeppelinfeld stadium not only provided Hitler with the party's first "victory altar" but was the first of Speer's state buildings to be erected according to his so-called theory of ruin value (Theorie vom Ruinenwert), which basically was an extension of Semper's views about "natural" materials and the avoidance of iron girders.[1]

The relevant passage in Speer's memoirs is worth citing in full, since it again reveals an important facet of Hitler's thoughts about Nazi state architecture in relation to Roman imperial architecture:

> Hitler liked to say that the purpose of his building was to transmit his time and its spirit to posterity. Ultimately, all that remained to remind men of the great epochs of history was their monumental architecture, he remarked. What then remained of the emperors of the Roman empire? What would still give evidence of them today, if not their buildings. . . . So, today the buildings of the Roman empire could enable Mussolini to refer to the heroic spirit of Rome when he wanted to

1. See W. Herrmann, *Gottfried Semper*, London, 1981, 174–83 ("Semper's Position on Iron as a Building Material"). Semper in *Der Stil* taught the "proper monumental material is ashlar," 183. According to Giesler (202), Hitler disparaged American skyscrapers as examples of "architectural esperanto." Their style was as international as were the materials out of which they were constructed: steel, ferroconcrete, and glass. Italian Fascist architects were not hostile to skyscrapers on

stylistic grounds. They seemed more concerned about the practical problems of fire risk and the provision of necessary utilities; see L. Vietti, "Grattacieli," *Architettura* 11 (1932): 189–201; on New York's skyscrapers, especially the Empire State Building, cf. also M. Sarfatti, "Grattacielo," *Architettura* 16 (1937): 333–44; G. Pagano, "L'America dei grattacieli," *Domus* 122 (1938): 2.

inspire his people with the idea of a modern imperium. Our buildings must also speak to the conscience of future generations of Germans. With this argument Hitler also underscored the value of a durable kind of construction.[2]

Hitler accordingly approved Speer's recommendation that, in order to provide a "bridge of tradition" to future generations, modern "anonymous" materials such as steel girders and ferroconcrete should be avoided in the construction of monumental party buildings, since such materials would not produce aesthetically acceptable ruins like those of Roman buildings. Natural stone, preferably German and granite, was to be used wherever possible. Thus the most politically significant buildings of the Reich would, to some extent even after falling into ruins after thousands of years, "resemble their Roman models."[3]

Speer expressed his views on the matter in the Four Year Plan of 1937 in his contribution "Stone not Iron," in which he published a photograph of the Parthenon with the subscript: "The stone buildings of antiquity demonstrate in their condition today the permanence of natural building materials." Later, after saying modern buildings rarely last more than fifty years, he continues: "The ages-old stone buildings of the Egyptians and the Romans [What of the Greeks?] still stand today as powerful architectural proofs of the past of great nations, buildings which are often ruins only because man's lust for destruction has made them such."[4] Hitler approved Speer's "law of ruin value" (Ruinengesetz) after Speer had shown him a sketch of the Haupttribüne as an ivy-covered ruin. The drawing pleased Hitler but scandalized his entourage.[5]

Angela Schönberger has argued that the adoption of the theory of ruin value was little more than opportunistic propaganda to conceal the fact that more and more steel and concrete was being absorbed by the growing needs of war industries and military projects.[6]

2. "Hitler liebte zu erklären, dass er baue, um seine Zeit und ihren Geist der Nachwelt zu überliefern. Letzlich würden an die grossen Epochen der Geschichte doch nur noch deren monumentale Bauwerke erinnern, meinte er. Was sei denn vor den Imperatoren des römischen Weltreiches geblieben? Was würde für sie heute noch zeugen, wenn nicht ihre Bauten? . . . So würden es heute die Bauten des römischen Imperiums Mussolini ermöglichen, an den heroischen Geist Roms anzuknupfen, wenn er seine Idee eines modernen Imperiums seinem Volk popular machen wolle. Auch einem Deutschland der kommenden Jahrhunderte müssten unsere Bauwerke ins Gewissen reden. Mit dieser Begründung unterstrich Hitler auch den Wert einer dauerhaften Ausführung"; Erinnerungen, 68.

3. ". . . etwa den römischen Vorbildern gleichen würden"; Erinnerungen, 69.

4. ". . . stehen heute noch die jahrtausendealte Steinbauten der Ägypter und Römer als gewaltige Bauzeugen der Vergangenheit grosser Völker da,

Bauwerke, die nur deshalb vielfach Ruinen sind, weil menschliche Zerstörungswut sich darüber gemacht hat"; Speer, "Stein statt Eisen," Vierjahresplan 1 (1937): 136.

5. Erinnerungen, 69; two paintings of ruins in the Roman forum by H. Robert (1733–1808) hung in the Cabinet room of Speer's new Chancellery in Berlin (1939) symbolized the theory of ruin value. The paintings can be seen in A. Speer, ed., Die Neue Reichskanzlei, Munich, 1940, 84. The theory was still being vigorously supported in 1943, when construction work ceased on the Nuremberg site; F. Tamms, Die Kunst im Dritten Reich 8 (1943): 60. Architectural "ruin fantasies" by architects (of their own buildings) were not unparalleled in Germany; see, for example, H. Jussow's drawing of Schloss Wilhelmshöhe (n. Kassel) as a ruin: Watkin, Mellinghoff, German Architecture and the Classical Ideal, 48f.

6. Die Neue Reichskanzlei von Albert Speer, Berlin, 1981, 165–67.

The use of natural stone would release quantities of strategic materials for more urgent needs. Persuasive though Schönberger's thesis is, it must be pointed out that already in *Mein Kampf* (1.10) Hitler had stressed the need for increased expenditure on public buildings that in terms of durability and aesthetic appeal would match the *opera publica* of the ancient world. In fact, few Nazi community buildings were constructed entirely from natural stone, or from stone quarried in Germany or Austria. In his article "Stein statt Eisen" Speer published a photograph of the Parthenon as an example of what he was urging German architects to imitate in terms of materials. The choice was not fortuitous, since the Parthenon was constructed entirely from marble blocks. Yet the Roman imperial buildings to which he and Hitler so frequently refer were for the most part constructed of brick-faced concrete, veneered on its internal surfaces with various types of marble. The Baths of Caracalla, the Pantheon, the Circus Maximus, the *Domus Aurea,* and Hadrian's mausoleum are just a few of the buildings Speer and Hitler allude to that were not built of solid stone. The only exception was the Colosseum, the facade of which was constructed from solid travertine, though brick-faced concrete was used in its interior. Ferroconcrete was used in the Deckenkranz of the temples in Königsplatz, but it was concealed by stone cladding,[7] as were the massive quantities of concrete used at the Nuremberg site.[8] The huge dome of the Berlin Volkshalle was to consist of steel girders from which a coffered ceiling was to be suspended. This was done on Hitler's own orders, even though Speer himself wanted to construct the dome out of granite, and its foundations were to be made of massive reinforced concrete blocks of 20,000 cubic square meters each.[9] The Romans also used vast quantities of concrete as foundation pads for their monumental imperial buildings, for example, the eight-meter-thick pad beneath the *cavea* of the Colosseum.[10] Nor could the quarries of the Reich supply enough granite to build Hitler's monuments. Consequently, vast quantities of granite and marble were ordered from quarries in Sweden, Finland, Denmark, France, and Italy.[11]

After the total collapse of the Third Reich in 1945, one of Speer's major state buildings, the new Chancellery, in Berlin did not become an aesthetic ruin but was treated like the monuments of ancient Rome, after its political collapse. For example, the builders of the Colosseum had demolished parts of the *Domus Aurea* to use as infill for the basement story of the amphitheater. It was a convenient way for the new Flavian dynasty to start the demolition of the politically unacceptable palace of the last member of the Julio-Claudians. The Flavian Amphitheater did not suffer the same fate as the Golden House, but when it was no longer used for gladiatorial combats and wild beast hunts, it fell into decay, and for centuries provided builders with a travertine quarry right in the center of Rome. This was especially true after the damaging earthquake of 1349, which shook down large tracts of the building's outer walls. Thus, for example, Pope Nicholas V

7. See page 58.
8. Petsch, 93.
9. Krier, ed., *Albert Speer,* 77.
10. M. E. Blake, *Roman Construction in Italy from* *Tiberius through the Flavians,* Washington, D.C., 1959, 94; G. Lugli, *The Flavian Amphitheatre,* Rome, 1960, 28f.

11. Thies, *Architektur der Weltherrschaft,* 100.

removed 2,522 cartloads of stone between 1451 and 1452 for the construction of Saint Peter's and the city walls. When the Russians in 1947 demolished the hated "Machtzentrum" of the Führer, the marble that had once decorated the representative rooms of the palace was reused to build a Russian war memorial in East Berlin's Treptow Park and to construct the Thalmann-Platz metro station.

V

Berlin/Germania

WHEN Hitler became Chancellor in 1933, he inherited a Reichskanzlei that he characterized as "fit for a soap company,"[1] and unsuitable for a man who aspired to being "master of the world" (Herr der Welt). The old Chancellery (1736–39) had once been the palace of Graf Schulenberg-Radziwill, before it became Bismarck's official residence, and the Reichskanzlei in 1875. Additions were made by Johann Siedler (1928–30), and still more were made in 1934, when Hitler became Reichspräsident on the death of Hindenberg, and thus gained supreme command of the armed forces (Reichswehr).[2] In 1935 Speer added a balcony to Siedler's building for the Führer's public appearances. Hitler did not like to stand behind the windows but preferred to be seen from all sides.[3] The "Führerbalkon" was an essential feature of all Hitler's official residences: the Führerbau (Munich), Neue Reichskanzlei, and the monstrous Führerpalais planned for Grosse Platz at the north end of Berlin's north-south axis. All these balconies were essential stages for Hitler's self-dramatization (Selbstinszenierung).[4]

However, even these additions did not satisfy Hitler's mania for the architectural grandeur he felt was appropriate to his status and that of his nation. Accordingly, Speer was officially commissioned on 11 January 1938 to have a new Chancellery ready for

1. *Erinnerungen,* 116.

2. For the early history of the building, see Schönberger, *Die Neue Reichskanzlei,* 15–36.

3. K. Arndt, "Architektur und Politik," in Speer, *Architektur-Arbeiten,* 126.

4. Mussolini required balconies for the same reasons: the balcony outside his huge office in the Palazzo Venezia, from which he delivered more than sixty discourses to crowds in the Piazza Venezia; Insolera, Perego, *Archeologia e città,* 73–75. He also used the balcony at the Palazzo Chigi. A balcony was also part of the main Fascist building in Piazza Augusto Imperatore. Above the balcony was a depiction (*inter alia*) of the first founders of Rome, Romulus and Remus, and below the

Hitler's occupation by 10 January 1939.[5] Speer recollects that Hitler asked him to con-
struct an architectural stage set of imperial majesty, and to provide large rooms and halls
to intimidate lesser potentates (kleineren Potentaten).[6] Speer, with an unrestricted (and
undisclosed) budget, produced exactly what Hitler desired, in the same way as Rabirius
had produced on the Palatine an imperial residence designed for a ruler who styled himself
as "master and god" (dominus et deus). As William L. MacDonald aptly puts it, the
emperor asked his architect "to create a tangible rhetoric of power, a panegyric in
architecture of the emperor's claim to omniscience. . . . nothing was overlooked that by
association would evoke feelings of reverence for the palace and imply a numinous
presence there."[7]

Speer's palace (Fig. 48) was not based on any specific Roman model, though some
secondary literature about the Reichskanzlei associates it with Nero's megalomania as
reflected in his Domus Aurea.[8] The new palace did, however, conform to the imperial
Roman belief that a residence must match the auctoritas of its occupant,[9] a belief made
increasingly evident by Augustus's successors, who were not satisfied with the modest
house of the princeps on the Palatine.[10] The definitive palace was the Domus Augustana,
the official wing of which contained the most impressive rooms of the complex, above all
the vaulted audience hall (aula regia) (Fig. 49), where the emperor received diplomats
and other functionaries.[11] The emperor sat enthroned on a raised platform in an apse at
the south end of the hall. The apse was emphasized by its site on the longitudinal axis of
the aula which passed through the middle of the peristyle and state dining room, both of
which were arranged serially behind the audience hall. Visitors entered the aula at its
north end and walked over the marble-veneered floor, and past the walls decorated with
alternating marble columns and aediculae, beneath the room's vaulted ceiling, in full view
of the emperor enthroned at the south end. The arrangement was calculated to awe and
intimidate visitors.

balcony a long Latin inscription recording that Musso-
lini restored the Mausoleum of Augustus and the Ara
Pacis.

5. Schönberger, 38, shows that plans for the new
building had already been completed by the middle of
1937. Between 1935 and 1937 many houses in Voss-
strasse had been bought and demolished to make way for
the new Chancellery. Thus when it was publicly stated
that the building had been planned and built in under a
year, it was presented as a miracle of Nazi efficiency
("Vorstellung von übermenschlicher Dynamik"; Schön-
berger, 52). Only supermen could achieve such feats.

6. Erinnerungen, 116.

7. The Architecture of the Roman Empire, New Haven,
1982, 73; cf. H. P. Isler, "Die Residenz der römischen
Kaiser auf dem Palatin, Antike Welt 9 (1978): 16, who
sees Domitian's palace as an essential part of Domitian's
"Selbstdarstellungspolitik."

8. E. Schultz, "Ein Gunstling des Schicksals," in
Reif, ed., Albert Speer, 269f.

9. Vitruvius, 6.5.1–3, where he says people of com-
mon station (communi fortuna) have no need for splen-
did vestibules, tablina, and atria because they are clients
of the rich and not patrons (1). On the other hand,
high-status Romans need regal vestibules, and spacious
atria and peristyles, with woods and avenues ad decorem
maiestatis perfectae.

10. See page 39. For the origin of the aula regia, see
A. Boethius, "The Reception Halls of the Roman
Emperors," British School at Athens, Annual 46 (1951):
27f.

11. See B. Tamm, Auditorium and Palatium, Lund,
1963, 206–16. For the later development of the aula
regia/palatina in the medieval period, see E. Baldwin
Smith, Architectural Symbolism of Imperial Rome and the
Middle Ages, Princeton, 1956, 36, 59–62.

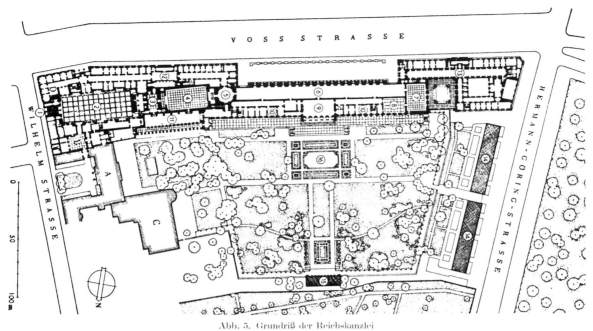

Abb. 5. Grundriß der Reichskanzlei

1. Portal am Wilhelmsplatz; 2. Ehrenhof; 3. Vorhalle; 4. Mosaiksaal; 5. Runder Saal; 6. Marmorgalerie; 7. Empfangssaal; 8. Reichskabinettsaal;
9. Arbeitszimmer Hitlers; 10. Büros der Adjutanten; 11. Speisesaal, im Obergeschoß Bibliothek; 12. Verwaltungsbau Voßstraße 4. Kanzlei des Führers;
13. Verwaltungsbau Voßstraße 6, Reichskanzlei; 14. Wohnhäuser der Begleitmannschaften; 15. Gewächshaus; 16. Wasserbecken
A. Alte Reichskanzlei (ehemals Palais Radziwill); B. Erweiterungsbau von 1930; C. Erweiterungsbau von 1934; D. ehemaliges Borsig-Palais
(aus: H. WOLF, Die Neue Reichskanzlei, Kanter-Verlag Königsberg, o. J.)

Fig. 48. Albert Speer, plan of the new Chancellery, Berlin

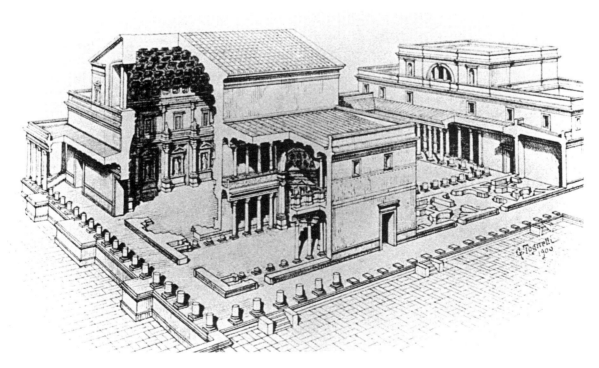

Fig. 49. Rabirius, *aula regia* of the *Domus Augustana*, Rome

The rationale of the new Chancellery harmonized with that of Roman imperial precedent. Nor was an example lacking within the borders of Germany, since at Trier the Constantinian Aula Regia (basilica) would have been known through the publications of Speer's professor of art history at Berlin, Daniel Krencker.[12] The towers at the four corners of this building originally supported cupolas that E. Baldwin Smith describes as "symbols of imperial domination *urbis et orbis*,"[13] a symbol that, as will be seen, was not missing from the enfilade of rooms on the Chancellery's diplomatic walk.

As usual with Hitler's buildings, symmetry and axial emphasis for hierarchical purposes were rigidly applied in the new Chancellery. The longitudinal axis (east-west) of the building began at the center of the huge bronze doors that gave onto the open Ehrenhof, and culminated in the reception room at the end of the marble gallery, the central part of the whole building. The north-south axis passed through the center of the marble gallery, bisected Hitler's study, passed through the ornamental-garden fountain, and culminated in the palmery at the end of the enclosed garden.[14] Hitler's study was thus axially emphasized in the same way as his *pulvinars* in the Märzfeld and Zeppelinfeld stadia in Nuremberg. His study on the north-south axis received the same axial emphasis as the tablinum of a *dominus/patronus* in a typical Campanian atrium-type house where the main axis passed through the fauces, the atrium, and culminated in the tablinum, or, after the addition of peristyles, continued through the tablinum and then through the peristyle's centrally placed fountain to culminate at the end of the peristyle garden.[15] It is also worth noting, with Karl Arndt,[16] that the marble gallery of the new Chancellery, with Hitler's centrally positioned study, is a reminiscence of the Hall of Mirrors at Versailles, with the King's Room (Chambre du Roi) at the center of its east side. Here too the east-west axis of the palace begins in this room and passes through the middle of the extensive gardens and fountains behind the main palace buildings.

The direct entry into the Ehrenhof, an enclosed paved courtyard with three niches and engaged columns set symmetrically in each of its lateral walls, is also reminiscent of the direct entry into the peristyle of the official wing of Domitian's palace, an arrangement adopted by C. F. Busse in his plans for an ancient villa (1827).[17] The *Domus Augustana*

12. See page 36; see also Krencker, *Das römische Trier*, Berlin, 1923; K. Köthe, "Die Trier Basilika," *Trierer Zeitschrift* 12 (1937): 151–79.

13. Baldwin Smith, *Architectural Symbolism*, 79.

14. R. Timm, who was responsible for the design of the new Chancellery's garden, adopted the symmetrical layout similar to that of a large Roman peristyle garden with its usual centrally placed fountain. The traditional Japanese garden with its avoidance of axiality and symmetry was regarded by the Nazis as formless and chaotic: "Die japanische Gartenkunst scheut Entschiedenheit, Symmetrie, Wiederholung, und versinkt der japanische Garten Formlosigkeit. Das deutsche Kunstwerk ist dagegen kraftvolle Vollendung und Wirklichkeit; C. Wilezek, "Über die Stuttgarter Reichsgartenschau"

(1939), *Gartenkunst* 2 (1940), in V. Heinrich-Hampf, "Über Gartenidylle und Gartenarchitektur im Dritten Reich," in Frank, ed., *Faschistische Architekturen*, 271.

15. For an excellent study of axiality in the Campanian atrium house, see F. Jung, "Gebaute Bilder," *Antike Kunst* 27 (1984): 74, 77f., 83 f.; see also L. Bek, *Towards Paradise on Earth*, Odense, 1980, 164–203. Again, this use of axiality in domestic architecture is Roman rather than Greek.

16. "Architektur und Politik," in Speer, *Architektur-Arbeiten*, 127 and pl. 12.

17. R. Bothe, "Antikenrezeption in Bauten und Entwurfen Berliner Architekten zwischen 1790 und 1870," in Arenhövel, Schreiber, eds., *Berlin und die Antike*, II, 316 and pl. 641.

had been known to German architects since 1805, when Guattani published his *Roma descritta ed illustrata*.[18] Once the visitor had passed through the Ehrenhof, ascended the steps of the portico flanked by Breker's two massive bronze statues, the Wehrmacht and the party (now innocently renamed "Swordbearer" and "Torchbearer," respectively),[19] and traversed the almost homely vestibule decorated with flowers, the next room, the Mosaic Hall, lit only from a flat glass roof (Oberlicht) and containing no furniture or carpet, created yet another rapid change of mood. The windowless walls of this large disorienting space (46.20 by 19 meters) were encrusted with mosaic panels (8.45 by 2.70 meters) by Hermann Kaspar (Fig. 50). Mosaic work, first introduced to Germany by the Romans, and admired by Schinkel on his visit to Pompeii in 1824,[20] was encouraged by the Nazis as a suitable form of decoration to portray propaganda on state buildings.[21] Mussolini had also revived the use of mosaic in Italy, where, for example, it was used extensively to decorate such open spaces as Foro Mussolini in Rome.[22] Contemporary German mosaic artists were encouraged to emulate the artistry of the Capitoline "Taubenmosaik" and the Alexander mosaic from the House of the Faun in Pompeii.[23]

Each mosaic wall panel in the Mosaiksaal was framed by bands of oak-leaf crowns (*coronae civicae*), which in Roman times had been traditionally awarded to those who saved the life of a citizen in battle. The Roman people as a whole awarded such a crown to Augustus for saving the entire citizen body from the chaos caused by years of civil strife.[24] On public buildings the Nazi swastika was often represented encircled by a crown of oak leaves. The oak was also highly regarded by the ancient Germans,[25] and oak forests were to be planted on the Nuremberg rally grounds to fill the spaces between the buildings.[26] Beneath each panel were two crossed *thyrsi*, fennel rods tipped with pine cones tradition-ally carried by devotees of Dionysus, and here perhaps emphasizing the Nazi "Greek

18. Ibid. The "classical harmony" (Ausgeglichen-heit) of the peristyle (Innenhof) was noted by Giesler in his essay ("Symbol des Grossdeutschen Reiches") for Speer's collection of essays on the Chancellery in his *Die Neue Reichskanzlei*, Munich, 1940, 12, in which he also comments on the building as a symbol of "Autorität" (14); cf. O. Thomae, *Die Propaganda-Maschinerie*, 146–48.

19. B. J. Zavrel, *Arno Breker: His Life and Art*, New York 1985, pls. 9–10; V. G. Probst, *Der Bildhauer Arno Breker*, Bonn, 1978, pls. 31, 33.

20. "Schinkel schrieb 1824 aus Pompeji: 'In der Stadt sind in jedem Hause interessante Malareien und Mosaikfussboden.' " Bothe, 324.

21. H. Wühr, "Mosaik der Gegenwart," *Kunst im Dritten Reich* 2 (1938): 216–17; Thomae, *Die Propa-ganda-Maschinerie*, 430. See also page 4 above.

22. For illustrations, see Verspohl, *Stadionbauten*, 224–27. The mosaics in the open were mainly made out of black and white marble *tesserae* in imitation of Roman monochrome mosaic work, e.g., the mosaics around the

mundus of the Foro Mussolini and the mosaic at the entrance of the track in Stadio Mussolini. In the cov-ered swimming pool at Foro Mussolini the mosaics on the walls are polychrome, and portray athletes in a style reminiscent of the athlete mosaic from the Baths of Caracalla. The mosaics at Foro Mussolini are deteriorat-ing because people rollerskate and play football on them. A recent report assesses damage to the "patrimonio archeologico" as 20 percent of the 5,000 m² of mosaic work; *Il Messaggero*, 11 March 1988. A monograph on Fascist and Nazi mosaic work is needed. For the Roman models that inspired Fascist artists, see G. Calza, "L'Espansione e la vita di Roma antica sulla spiaggia ostiense," *Capitolium* 12 (1937): 332f., 335–37.

23. Wühr, 218.

24. *Res Gestae* 34 (see Brunt's comments *ad loc.*); the legend *ob cives servatos* also appeared on his coins.

25. R. Much, *Die Germania des Tacitus*, Heidelberg, 1937, see index *s.v.* Eiche.

26. Krier, ed., *Albert Speer*, 163.

Fig. 50. Hermann Kaspar, wall
mosaic in Mosaiksaal, new
Chancellery, Berlin 1939

connection," as well as representing the Nazi glorification of nature. The main motif of
each panel was a pair of eagles perched on a horizontal pole and separated by a lighted
torch, a favorite Nazi emblem of "heroic" endeavor,[27] grasped in the talons of one of the
eagles. The birds do not grasp swastikas,[28] as is so often the case in Nazi iconography, so

27. Cf. the statue of Prometheus by Breker for the
Weimar forum (page 56 above); Breker's statue of the
party at the porticoed entrance to the Chancellery;
crossed torches also provided a decorative motif for the
exterior of the building for the High Command of the

Wehrmacht on Berlin's Grosse Platz; Krier, ed., *Albert
Speer*, 88, 96.
28. Swastikas are a feature of the mosaic bands that
divided up the red marble floor into squares.

they may here be interpreted as both a German national symbol (Reichsadler) and a standard attribute of Zeus/Jupiter, father of Dionysus and patriarchal ruler of Olympus.[29] Sprigs of laurel and burning torches shown at the top and bottom of each panel signify, respectively, victory and endeavor. Schönberger states that the symbols in these mosaics served a largely decorative function,[30] but it is difficult to agree with this view. The mosaics, the only eye-catching objects in an otherwise unfurnished, undecorated, uncarpeted hall, were surely intended to form a coherent iconographic program to impress "the lesser potentates" with symbols of Hitler's power and Germany's ancient pagan past.

It was not only the varying shapes, rectilinear and curvilinear, of the representative rooms but also their decorations (mosaics, sculptures, tapestries, paintings) that cumulatively were to give visitors what Speer described as a "taste of the power and grandeur of the German Reich."[31] At each end of the Mosaiksaal were two massive portals described by Speer's biographer and friend Rudolf Wolters as being of Roman format.[32] Breker also recorded his admiration for the room, which was "permeated with the fire of political power" and was "clear and classical . . . that is, in harmony with itself."[33] The fire Breker alludes to is not purely metaphorical, since large quantities of red marble veneered the walls and floors of the official rooms. Again this is a Roman feature of interior decoration that Fascist architects in Italy did not ignore. Marble was regarded as being hierarchically the most important of natural materials, and was therefore selected for extensive use in important party buildings. As Ghirardo reports the words of Giuseppe Terragni: "For a representative building only marble walls can be used."[34] Indeed, a painting by E. Mercker, "Marble for the Reich Chancellery," showing a quarry, was one of several Nazi representations of this theme of nature dominated and exploited by the new regime.[35]

From the oblong Mosaiksaal the visitor passed into the circular Runde Saal, again windowless, but lit by a domed glass roof. It perhaps produced the same feelings of surprise as a visitor feels on passing for the first time from the rectangular porch and intermediate block into the rotunda of the Pantheon,[36] a building that, as will be seen, seems to have had a very strong influence on Hitler, even before he visited it for the first time in 1938.

The domed hall led directly into the marble gallery (Marmorgalerie), the largest of the representative rooms (146 by 12 meters), which ran the entire length of the Chancellery's middle tract. Large floor-to-ceiling windows perforated the outer wall and five large doors

29. Nazi ideology stressed Paternitätsprinzip as it did the Führerprinzip; a woman's task was to subordinate herself to the needs of the husband, family, and the state; Hinz, Art in the Third Reich, 149f.

30. Die Neue Reichskanzlei, 92.

31. Speer, Erinnerungen, 117.

32. ". . . von römisch grossem Format sind die steinernen Turnischen"; "Werk und Schöpfer," in Speer, Reichskanzlei, 52.

33. ". . . von machtpolitischem Feuer durchglüht . . . klar und klassisch ist . . . das heisst: in Harmonie zu sich selbst"; "Zum Bau der neuen Reichskanzlei," in Speer, Reichskanzlei, 59.

34. Ghirardo, "Italian Architects and Fascist Politics," 118. Vast quantities of white Carrara marble were used by Del Debbio in his buildings at Foro Mussolini. The bulk of it was concentrated in the most important building on the site, the Stadio Mussolini, where 8,400 tons were used for the step-seats and sixty monumental statues. The step-seats of the Colosseum were also once veneered with white marble; C. Magi-Spinetti, "Foro Mussolini," Capitolium, 10 (1934): 85.

35. Hinz, Art in the Third Reich, 111; colorplate between pages 80 and 81.

36. A similar impression is created by the combination of the Poicile and circular Teatro Marittimo in Hadrian's Villa.

set at equal intervals punctuated the inner wall, which was veneered with light yellow marble and contrasted with the dark red marble floor. The door in the mathematical center of the inner wall, directly placed on the building's north-south axis, was unmistakably important. Two SS guards stood to either side of it, and above it on a bronze scroll were the initials AH, one letter superimposed on the other in the way Albrecht Dürer used to represent his initials.[37] This was the study of "the master of the world,"[38] who "conceived great thoughts here."[39]

On the walls immediately outside Hitler's door were hung large tapestries illustrating the victories of Alexander the Great. These seventeenth-century tapestries, "borrowed" from the Kunsthistorisches Museum in Vienna, apparently irritated Hitler because they were not of uniform size.[40] In 1939 it was decided to remove and replace them with tapestries of uniform dimensions (4.15 by 8.10 meters), designed by Werner Peiner.[41] These illustrated famous German victories.[42] Tapestry, a "regal" art form, was revived by the Nazis, just as they revived mosaic work, to aid the process of promulgating propaganda in *opera publica*.[43] It was surely no accident that the Alexander tapestries were placed outside Hitler's Arbeitszimmer. Alexander had been recognized by the Nazis as a "Nordic national leader" (nordischer Volksführer), a concept still echoed by Ernst Kornemann in 1943,[44] even though Fritz Schachermeyer a year later accused Alexander of biological sacrilege (Chaos des Blutes) by trying to persuade his Macedonians to marry oriental wives.[45] Victor Ehrenberg, in an essay written on Alexander in 1941, made it clear that in his opinion comparisons between Alexander and Hitler were unfounded: "In aiming at world domination he [Alexander] did not merely serve his own ambitions. He always served the larger idea, that of an empire which was to unite the peoples of the earth without forcing any one of them into slavery." In a postscript added to the essay in 1944 when Ehrenberg was in England, he further commented: "There is no justification for comparing the great Alexander with the would-be great Führer. . . . Whatever the future of Europe it will not be built on the ruins left by a criminal and amateurish megalomaniac."[46] Yet until Peiner's tapestries replaced them, the Alexander tapestries

37. Schönberger, *Neue Reichskanzlei*, 112; the method currently used by Arno Breker to represent his monogram.

38. "Wenn man die Reichskanzlei betritt, soll man das Gefühl haben, den Herrn der Welt zu besuchen"; Speer, *Tagebücher*, 84.

39. W. Lotz, in Speer, *Reichskanzlei*, 79.

40. Schönberger, *Neue Reichskanzlei*, 94, 147.

41. H. Hoffman, "Die Neue Reichskanzlei," *Moderne Bauformen* 38 (1938): 525. Although the Alexander tapestries were probably not in the Reichskanzlei when the Russians seized it in 1945, the Kunsthistorisches Museum has never recovered them.

42. For color illustrations of Peiner's sketches for these tapestries, see Hinz, *Art in the Third Reich*, plates opposite p. 81; cf. 158f. The victories depicted were: "Die Schlacht im Teutoburger Wald," "König Heinrich I in der Ungarnschlacht," "Die Belagerung der Ma-

rienburg," "Die Türkenschlacht vor Wien," "Friedrich der Grosse bei Kunersdorf," and "Die Schlacht bei Leipzig"; R. Müller-Mehlis, *Die Kunst im Dritten Reich*, Munich, 1976, 49, who says five of these tapestries were ready in 1945. Cf. also Thomae, *Die Propaganda-Maschinerie*, 360f.

43. B. Kroll, "Der neue deutsche Gobelin," *Kunst im Dritten Reich* 12 (1938): 372.

44. A Demandt, "Politische Aspekte im Alexanderbild der Neuzeit," *Archiv für Kulturgeschichte* 54 (1972): 335, 349.

45. See I, note 67. Badian, "Some Recent Interpretations of Alexander," 281f. Badian points out that Schachermeyer later repudiated his *Indogermanen und Orient*, Stuttgart, 1944.

46. *Aspects of the Ancient World*, Oxford, 1946, 172, 178. It is fair to point out that Ehrenberg's view of Alexander is at least arguable.

Fig. 51. Hermann Kaspar, marquetry inlays in Hitler's desk, Arbeitszimmer, new Chancellery, Berlin

were further symbols of Weltherrschaft and provided validations of Hitler's aspirations.

Two other sets of tapestries taken from Vienna were hung in the Chancellery: eight illustrating the legend of Dido and Aeneas and five on the legend on Decius Mus.[47] Both legendary figures symbolized dedicated patriotism: Mus on the field of battle and Aeneas through the founding of a nation destined to become rulers of the world. Aeneas was also a link with Augustus, the second founder of his country, and its savior.[48]

One of the Aeneas tapestries was hung in Hitler's study, but it is not clear where the remaining seven were situated.[49] The marble veneering that was evident in all the representative rooms on the "diplomatic walk" was also present in Hitler's study with its dark red walls and floor, which was almost entirely covered with a reddish-brown carpet decorated with swastikas. Greek and Roman mythological figures were prominent in much of the decoration of this totalitarian nerve center. The front of Hitler's desk incorporated three marquetry panels (Fig. 51) by Kaspar, representing from left to right the heads of Athena, Mars, and Medusa. According to Speer, Hitler particularly relished the depiction of the sword half drawn from its scabbard shown in the central panel: "Good, good, . . . when the diplomats sitting at the front of my desk see this, they will learn the meaning of dread."[50] The head of Medusa (Gorgoneion) was frequently shown

47. Schönberger, *Neue Reichskanzlei,* 147. The legend of Decius Mus was also revived in Fascist Italy; see C. Carabba, *Il fascismo a fumetti,* Rimini, 1973, 46.

48. See above for Rodenwaldt's views on this topic.

49. A second hung in the Gesellschaftshalle; Schönberger, 100, who is not concerned with the symbolism of the tapestries.

50. "Gut, gut. . . . Wenn dass die Diplomaten sehen, die vor mir an diesem Tisch sitzen, werden sie das Fürchten lernen"; Speer, *Erinnerungen,* 128.

on the breastplates of Roman emperors as an apotropaeon to "petrify" the enemy and generally ward off misfortune.[51] Athena's helmeted head is shown against two crossed *thyrsi*, a motif that had already been used in Kaspar's mosaics on the walls of the Mosaiksaal. Athena and Dionysus were represented in the Chancellery's library, situated above the ground-floor dining room.[52] The visitor seated in front of Hitler was thus confronted by three figures associated with military aggression.

Above each of the two doors in the end walls of Hitler's study were allegorical representations of four virtues—Wisdom, Prudence, Fortitude, and Justice—to remind "the emperor" of his obligations to his subjects and realm. The visitor would hardly have been reassured by the faces of Prudence and Fortitude, which resembled the face of the Führer. Four paintings in this room also deserve mention. One depicted the return of Hermann (Arminius) after his defeat of three of Augustus's legions in the Teutoburgerwald, another the funeral of young Pallas, a third, Hector's parting from Andromache, and a fourth, Herakles and Omphale,[53] which appears here somewhat incongruously, since the painting deals with the humiliation of a Greek hero by a Lydian woman—a double affront to Nazi ideology, which asserted the superiority of the male (Paternitätsprinzip) and the racial inferiority of Asiatics. But there were also portraits of German national heroes: Hermann, Frederick the Great, Bismarck, and Hindenberg served to suggest that Hitler was part of an illustrious German group of dedicated patriotic leaders and field commanders. All these decorative elements combined to give the unmistakable impression that here was the center of power (Machtzentrum) of the Reich, where the visitor was supposed to feel an excess of awe and fear. The idea of *proskynesis* and Byzantine court rituals are not entirely inappropriate associations with the iconography of the dictator's throne room.[54]

Even before Hitler moved into this costly underutilized palace, he had already made plans for a colossal Führerpalais, covering a total area of two million square meters on the west side of the great forum (Grosse Platz) at the north end of the new north-south axis (Fig. 17).[55] The new palace was to have been ready for Hitler in 1950, when the Chancellery was to have become Rudolf Hess's residence,[56] a mere 16,300 square meters.[57] If the new palace represented a massive advance in Hitler's megalomania (the new diplomatic walk was more than half a kilometer), it also marked an equally significant increase in the Führer's paranoia. The Chancellery was relatively accessible,[58] whereas the new palace was to have a windowless facade, pierced only at its center by a cavernous

51. Andreae, *Art of Rome*, pls. 441, 541–42, where the head is winged, as in the inlay on Hitler's desk. Hitler would probably have known the painting of Medusa by one of his favorite painters, Franz von Stuck; C. de Jaeger, *The Linz File*, London, 1981, 25.

52. Schönberger, 109, Dionysus (and Prometheus) was also represented at the Reichssportfeld in Berlin; E. König, ed., *Arno Breker*, Paris, 1943, 1 and Pls. 11–13.

53. Schönberger, 109.

54. E. Schulz, "Ein Gunstling," in Reif, ed., *Albert Speer*, 270: "Einmal enge Geschlossenheit, dann endlose Länge, die fast die Proskynese, den bizantinischen

Kniefall, herausfordete oder seelisch vorbereitete, brachten diesen Stil in die Nähe einer Ideologie der Macht."

55. Speer says Hitler's first sketches of this palace dated from 5 November 1936; he made more sketches in 1937 and 1940; Speer, *Erinnerungen*, 537 n. 9.

56. K. Arndt, in Speer, *Architektur-Arbeiten*, 126.

57. W. Lotz, "Die Errichtung," in Speer, *Reichskanzlei*, 36.

58. Miller Lane, Review of Speer's *Inside the Third Reich*, *Journal of the Society of Architectural Historians* 32 (1973): 343.

arched portal fitted with a bulletproof steel door, like all the other buildings in this forum.[59] Withdrawal from the people was accompanied by fear of the people. Domitian, as portrayed by Suetonius and Pliny, showed similar traits when he retired to his "Palatium." The walls of the peristyle of the *Domus Augustana* were lined with reflecting stone so that the emperor might see whatever was happening behind him.[60] Pliny also suggests in his panegyric of Trajan how Domitian had removed himself from the people by watching the *circenses* in the Circus Maximus from his palace, where he lurked like an animal in its lair.[61]

The surface area occupied by the new palace was not, as usual, fortuitous. It was not only to be the largest palace of its kind in the world, but more specifically, it was to be twice the size of Nero's *Domus Aurea* (eleven million square feet).[62] Giesler, ever watchful of his rival's claims, accuses Speer of inflating the dimensions of the palace in order to transfer his own megalomania onto Hitler and thus impress on his American readers Hitler's profligacy (Verruchtheit). According to Giesler's examination of one of Speer's working plans, the total area of palace and grounds was not two million square meters, but 254,000 square meters (built-over area: 106,000 square meters). Thus Hitler's palace was only a quarter of the size of the *Domus Aurea*.[63] However, the main state rooms of the building extended for one thousand meters;[64] the alleged distance of the colonnade of the *Domus Aurea* according to Suetonius was one mile.[65]

The central axis of the palace extended through the garden fountain and pools, as in the Reichskanzlei garden.[66] To either side of the central suite of rooms were two open peristyles with double colonnades, which Speer in 1948 referred to as "Pompeian ideas of two-storeyed pillared halls."[67] The building's bilateral symmetry, typical of imperial Roman *thermae*, magnifies and echoes that of the Reichstag building, which lay at the east end of the forum's transverse east-west axis. The vast palace at its west end, a stronghold of absolutism, seems a blatant challenge to the much smaller pre-Nazi (Wilhelmine)

59. Speer, *Erinnerungen*, 173; cf. idem, 175, where Speer laments that this and other buildings on the forum had no Doric features.

60. *Domitian* 14.4; ". . . parietes phengite lapide distinxit e cuius splendore per imagines quidquid a tergo fieret provideret."

61. *Panegyricus* 47.5–48.5; 51.4–5.

62. Speer, *Playboy* Interview, 80; *Erinnerungen*, 171.

63. *Ein anderer Hitler*, 322f; no one else, it seems, has as yet questioned Speer's dimensions, which are accepted by Larsson, *Albert Speer*, 81; Krier, ed., *Albert Speer*, 85, who published a colorplate of the facade (model) of the palace, gives its dimensions as 40 m high and 240 m long, "the exact dimensions of the main elevation of the Reggia at Caserta."

64. Krier, ed., *Albert Speer*, 85.

65. Suetonius, *Nero* 31; ". . . porticus triplices miliarias haberet; Neros 'Goldenes Haus' hatte einen Kilometer im Geviert"; Giesler, 323. The total size of its estate is controversial; see J. Ward-Perkins, "Nero's

Golden House," *Antiquity* 30 (1963): 212; M. P. O. Morford, "The Distortion of the Domus Aurea Tradition," *Eranos* 66 (1968): 159–62.

66. On the axial arrangements of ornamental Roman peristyle gardens where a canal or pond (usually with a fountain) was on the main axis, see P. Grimal, *Les jardins romains*, Paris, 1983, 71, 72f., 83, 176; E. B. MacDougall, W. F. Jashemski, eds., *Ancient Roman Gardens*, Dumbarton Oaks, 1981, 29–48 (peristyle gardens). The gardens of the House of Diomedes and the House of Octavius Quartius at Pompeii are good examples of symmetrically arranged gardens, as is the garden of the Roman "palace" at Fishbourne (Sussex). The tradition was already evident in such imperial residences in Germany as "Sanssouci," built by Frederick the Great in Potsdam. Hitler clearly liked as much Ordnung in his gardens as he had inside his residences; see now V. Heinrich-Hampf, in Frank, ed., *Faschistische Architekturen*, 271–81.

67. *Tagebücher*, 166f.

democratic debating chamber at its east end. Because the Reichstag's dimensions were so much smaller than those of the other buildings surrounding the huge forum, Speer tried to persuade Hitler to demolish the building, but Hitler refused. According to photostats of notes taken by two of Hitler's adjutants on 15 March 1941,[68] Hitler said he might appear vindictive if he demolished the building, which, he suggested, might one day be venerated because Nazis had fought in it. But he might also have wished to preserve the building to show how much Germany had grown from small beginnings to world empire under his leadership.[69] In imperial Rome the equivalent tangible symbols of Rome's rise from small beginnings to mastery of the world was the *casa Romuli*,[70] preserved by the emperors out of duty to the past (*pietatis causa*). This archaic hut of timber and clay, which Seneca the Elder saw as a symbol of Rome's humble beginnings,[71] contrasted with the vast new palace of Domitian.

68. Now in the possession of Lehmann-Haupt, *Art under a Dictatorship*, 57f.

69. E. Canetti, "Hitler nach Speer," in Reif, ed., *Albert Speer*, 295.

70. On the southwest corner of the Palatine, where Augustus's residence was situated; F. Coarelli, *Guida archeologica di Roma*, Rome, 1980, 135. It survived after several restorations into the fourth century A.D.; G. Lugli, *Roma antica. Il centro monumentale*, Rome, 1946, 455. A Balland, "La Casa Romuli au Palatin et au Capitole," *Revue des Etudes Latines* 62 (1984): 57–80.

71. *Controversiae* 1.6.4.

VI

HITLER AND HADRIAN'S PANTHEON

Just as Augustus's house on the Palatine was connected to the temple of Apollo,[1] so Hitler's palace was connected by a cryptoporticus to the Volkshalle, which filled the entire north side of the forum. This truly enormous building, the full significance of which has not as yet been completely appreciated, was, according to Speer,[2] inspired by Hadrian's Pantheon, which Hitler visited privately on 7 May 1938.[3] But Hitler's interest in and admiration for the Pantheon predated this visit, since his sketch of the Volkshalle dates from about 1925.[4] Giesler records a conversation he had with Hitler in the winter of 1939/40, when Hitler was recalling his "römische Impressionen": "From the time I experienced this building—no description, picture or photograph did it justice—I became interested in its history. . . . For a short while I stood in this space [the rotunda]—what majesty!—I gazed at the large open oculus, and saw the universe and sensed what had given this space the name Pantheon—God and the world are one."[5]

Hitler's impressions of the Roman Pantheon were revived when on 24 June 1940 he made a tour of selected buildings in Paris (with Speer, Giesler, and Breker), including the

1. See II, note 73.

2. *Erinnerungen*, 167.

3. See page 30. The Pantheon was an important symbol for Mussolini as well, but his plan to bulldoze a wide road from the Piazza Colonna to the Pantheon was never realized. The temple was restored during the Fascist period; C. Montani "Il Pantheon e i suoi recenti restauri," *Capitolium* 8 (1932): 417–26. Montani noted that the building represented the "grandezza dell'Impero Romano" (417). B. C. Gustavo, "Il Pantheon," *Capi-

tolium 14 (1939): 240–49. The Pantheon, as a mausoleum, inspired a war memorial at Syracuse: (anon.), "Il Pantheon dei Caduti Siracusani," *Architettura* 16 (1937): 563–70.

4. Giesler, 325; W. Maser, *Hitler's Letters and Notes*, London, 1974, 120.

5. "Seitdem ich diesen Raum erlebt habe, keine Beschreibung, Zeichnung oder Photographie wird ihm gerecht—hat mich seine Geschichte interessiert. . . . Eine kurze Weile stand ich allein in diesem Raum—

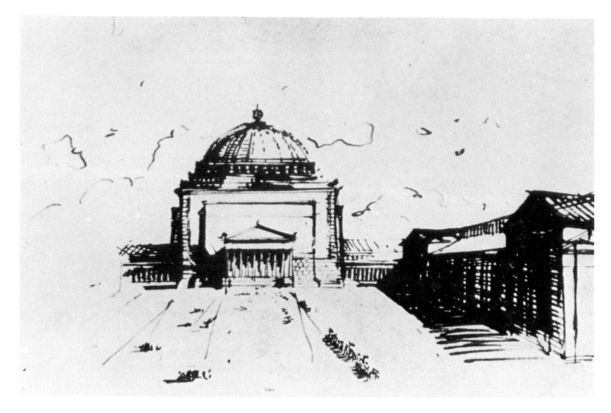

Fig. 52. Adolf Hitler, sketch of Volkshalle, about 1925

Panthéon, which seems to have disappointed him. His disappointment is independently recorded by Giesler[6] and Breker.[7]

The sketch of the Volkshalle given by Hitler to Speer (Fig. 52) shows a traditional gabled pronaos supported by ten columns, a shallow rectangular intermediate block, and behind it the domed main building. Giesler notes that the pronaos of the temple in Hitler's sketch is reminiscent of Hadrian's Pantheon (Fig. 53) and of the style of Gilly or Schinkel.[8] However, there was little about Speer's elaboration of the sketch that might be termed Doric, except perhaps for the triglyphs in the entablature,[9] supported by the geminated red granite columns with their egyptianizing palm-leaf capitals (Fig. 54), previously employed by Speer in the portico outside Hitler's study on the garden side of the new Chancellery.

welche Majestät!—ich schaute zum grossen, offenen Lichtauge, ich sah das Weltall und erfühlte, was diesem Raum den Namen gab: Pantheon—Gott und die Welt sind eins"; Giesler, 30f.; a recollection of his visit of 7 May 1938, when he did not enter the building "allein."

 6. Giesler, 391.

 7. *Hitler et moi*, Paris, 1970, 106: "D'une façon surprenante l'édifice n'éveilla pas en H. la réaction que nous attendions. L'intérieur malgré ses proportions remarquables et énormes, ne sembla pas non plus dégeler son indifférence."

 8. Giesler, 326.

 9. Larsson, *Albert Speer: Le plan de Berlin*, 79.

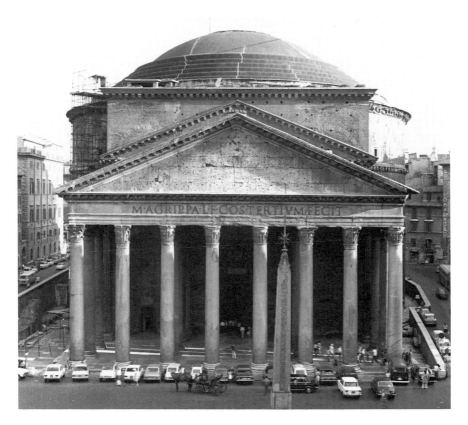

Fig. 53. Hadrian's Pantheon, Rome

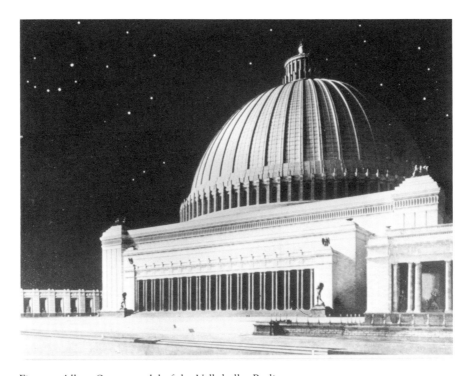

Fig. 54. Albert Speer, model of the Volkshalle, Berlin, 1937–40

Speer's "Monsterbau" was to be the capital's most important and impressive building in terms of its size and symbolism. Visually it was to have been the architectural centerpiece of Berlin as world capital (Germania). Its dimensions were so huge that it would have dwarfed every other structure in Berlin, including those on the north-south axis itself. The oculus of the building's dome, 46 meters in diameter, would have accommodated the entire rotunda of Hadrian's Pantheon, as well as the dome of Saint Peter's. The dome of the Volkshalle was to rise from a massive granite podium 315 by 315 meters and 74 meters high, to a total inclusive height of 290 meters. The diameter of the dome, 250 meters, was to be exceeded, much to Speer's annoyance, by the diameter of Giesler's new domed railway station at the east end of Munich's east-west axis. It was to be 15 meters greater in diameter than Speer's Volkshalle.[10]

The Pantheon had of course exercised considerable influence on architects in Berlin and Potsdam from the middle-eighteenth century: the oval marble hall in Sanssouci (1746–74) and the French Church (1752), also at Potsdam, but above all the Hedwigskirche in Berlin. Work began on the site of this church in 1747, but because of financial and other problems was not completed until the nineteenth century.[11] Frederick the Great planned the cathedral in 1746 as an equivalent to its Roman model, a temple dedicated to all the gods. The new cathedral in Berlin was orginally conceived of by the emperor as a place where all religions could be practiced, but this idea was not put into effect.[12] Hitler and Speer must both have known the Hedwigskirche, but it is nowhere mentioned in connection with the Berlin Volkshalle. Nor is it at all likely that Hitler would have looked to a later Pantheon-like building as a model, when he admired the original building so much.

The resemblance of the Volkshalle to the Pantheon is far more obvious when their interiors are compared (Figs. 55 and 56). The large niche (50 meters high by 28 meters wide) at the north end of the Volkshalle was to be surfaced with gold mosaic and to enclose an eagle 24 meters high, beneath which was situated Hitler's tribunal. From here he (and subsequent leaders) would address 180,000 listeners, some standing in the central round arena, others seated in three concentric tiers of seats crowned by one hundred marble pillars (24 meters high), which rose to meet the base of the coffered ceiling suspended from steel girders sheathed on the exterior with copper.[13]

The three concentric tiers of seats enclosing a circular arena 140 meters in diameter

10. According to Giesler (177), when Speer heard of the dimensions of the railway station's dome, he exclaimed: "Impossible—for my hall in Berlin is 250 m in diameter. You must keep to less than that in Munich— 245 m—as you originally planned" (unmöglich,—denn meine Halle in Berlin hat 250 m Spannweite. Du musst in München darunter bleiben, auf 245 m, wie du es bisher geplant hast!).

11. T. Eggeling, "Friderizianishe Antikenrezeption am Beispiel der Hedwigskirche und der Oper," in Arenhövel, Schreiber, eds., Berlin und die Antike, 113;

see also Berlin und seine Bauten, 196; Watkin, Mellinghoff, German Architecture and the Classical Ideal, 24. Destroyed by bombs in 1943, rebuilt 1952–53.

12. Eggeling, 114; it is worth noting that Bonatz's Stadthalle (1911–14) in Hannover owes obvious debts to the Pantheon. Speer would have known this building. For an illustration of the interior, see Franco Borsi, The Monumental Era: European Architecture and Design, 1929–1939, New York, 1987, 29.

13. Speer, Erinnerungen, 168.

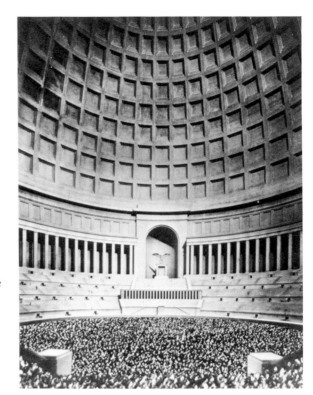

Fig. 55. Albert Speer, interior of the Volkshalle

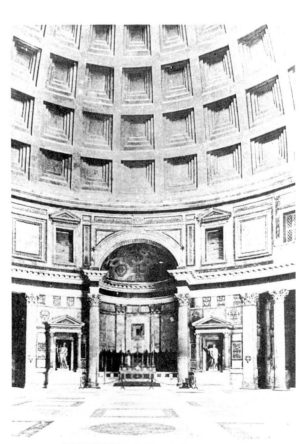

Fig. 56. Interior of Hadrian's Pantheon

owe nothing to the Pantheon but resemble the seating arrangements in Ruff's Congress Hall at Nuremberg, which was modeled on the Colosseum.[14] Other features of the Volkshalle's interior are clearly indebted to Hadrian's Pantheon: the coffered dome, the pillared zone, which here is continuous, except where it flanks the huge niche on the north side. The second zone in the Pantheon, consisting of blind windows with intervening pilasters, is represented in Speer's building by a zone above the pillars consisting of uniform, oblong shallow recesses. The coffered dome "rests" on this zone.

The design and size, as well as aspects of the external decoration of this Volkshalle, are all exceptional and call for explanations that do not apply to community halls planned for Nazi fora in other German cities.

The temple-like nature of the domed building was noted by Speer,[15] who surmised that the building was ultimately intended for the worship of Hitler and his successors, that is, it was to be a dynastic temple/palace complex of the kind Augustus built on the Palatine, where his "modest" house was connected to the temple of Apollo.[16] According to Filippo Coarelli,[17] this palace/temple complex of Rome's second founder was derived from Hellenistic models, like that at Pergamum, where the palace of the Attalids on the acropolis was connected with the sanctuary of Athena Nikephoros, the deity to whom the Attalids attributed their military successes. Agrippa's Pantheon was also probably originally intended as an "Augusteum,"[18] a temple of a type known in the Hellenistic East for the worship of a ruler in his own lifetime. Augustus wisely compromised, so Agrippa erected a temple to all the gods. The building of a vast mausoleum by Augustus is also seen by Coarelli as part of the emperor's borrowing of dynastic architectural forms from the East,[19] most probably from Hellenistic Egypt, which Augustus visited in 30 B.C. The two obelisks that flanked the entrance to Augustus's mausoleum, and the recent discovery of egyptianizing architectural elements on the structure, suggest to Coarelli that Augustus was inspired by Hellenistic monuments in Ptolemaic Alexandria. Perhaps this explains Speer's use of egyptianizing palm-leaf capitals in the colonnade of the Volkshalle, though no statement by Speer or Hitler is on record to confirm such an association.

Hitler's aspirations to world domination, already evident from architectural and decorative features of the new Chancellery, are even more clearly expressed here. External symbols suggest that the domed hall was where Hitler as cosmocrator (Herr der Welt) would appear before his Herrenvolk: On top of the dome's lantern (Fig. 28) was an eagle grasping in its claws not the usual swastika but the globe of the Earth (Erdball) (Fig. 29). This combination of eagle and ball was well known in imperial Roman iconography, for example, the restored statue of Claudius holding a ball and eagle in his right hand (Fig.

14. See page 80.

15. *Erinnerungen*, 167.

16. See page 56.

17. F. Coarelli, *Roma sepolta*, Rome, 1984, 129. As Coarelli gives no literature on the topic, see G. Kawerau, T. Wiegand, *Die Paläste der Hochburg*, Berlin, 1930 (Die Altertümer von Pergamon, V.1); E. Böhr-

inger, F. Krauss, *Das Temenos für den Herrscherkult*, Berlin, 1932 (1X); O. Deubner, "Pergamon und Rom," *Marburger Jahrbuch für Kunstwissenschaft* 15 (1949/50): 95ff.

18. Dio Cassius, 63.27.2–4. J.-M. Roddaz, *Marcus Agrippa*, Rome, 1984, 272–77.

19. Ibid.; see also page 91 above.

Fig. 57. Statue of the Emperor Claudius
(restored) holding an orb and eagle

57).[20] The vast dome on which it rested, as with Hadrian's Pantheon,[21] symbolically
represented the vault of the sky spanning Hitler's world empire. The globe on the dome's
lantern was enhanced and emphasized by two monumental sculptures by Breker (each 15
meters high), which flanked the north facade of the building: at its west end Atlas
supporting the heavens (Fig. 54), at its east end Tellus supporting the Earth. Both

20. Italian Fascist architects also had used the symbol
of the globe and the eagle, e.g., the pavilion of A.
Limonelli at the Exhibition of Tripoli, which was
flanked by pillars topped by eagles on globes; *Architettura
e Arti Decorative* 10 (1929/30): 262. The eagle/globe
motif seems to have been specifically associated with
Divus Augustus; see A. S. Robertson, *Roman Imperial*

Coins in the Hunter Coin Cabinet, I, 61, nos. 14–15. The
motif is not found on Republican coins. I am indebted
to Dr. Robert Hannah for this information.
 21. W. L. MacDonald, *The Architecture of the Roman
Empire,* I, 118–21, for symbolic interpretations of Ha-
drian's Pantheon.

mythological figures were, according to Speer, chosen by Hitler himself.[22] Despite the evidence of these overt and largely traditional imperialistic symbols of domination over *urbs* and *orbis*,[23] Giesler says that Speer was wrong to represent the Volkshalle as a symbol of Weltherrschaft.[24] However, Giesler's remark that Hitler never made plans for world domination, and that to suggest as much is not only nonsense (Unsinn) but "Speer-rubbish" (Speerlicher Quatsch), hardly counts as a reasoned refutation of the symbolism of the Volkshalle, which does appear to be a prophetic symbol of Hitler's ultimate ambition.

If Hitler planned a dynastic palace/temple complex, did he also, like Augustus and Hadrian, plan to build a "founder's" mausoleum? Here Giesler, not Speer, gives a full answer to this question. On his tour of Paris in June 1940 Hitler visited Les Invalides, where he stood silently gazing upon Napoleon's tomb. This suggested to him a plan for his own mausoleum: a monumental sarcophagus beneath a dome with an oculus, as in Hadrian's Pantheon. In the autumn of 1940 Hitler said more to Giesler about the Pantheon and the mausoleum he had asked Giesler to build: "Imagine to yourself, Giesler, if Napoleon's sarcophagus were placed beneath a large oculus, like that of the Pantheon."[25] He goes on to express an almost mystical delight in the thought that the sarcophagus would be exposed to darkness and light, rain and snow, and thus be linked directly to the universe.

It is worth recalling here that the idea of placing coffins in buildings open to the sky had already been put into effect on 9 November 1935 at the Königsplatz Ehrentempel, where Nazi martyrs encased in iron coffins were placed in Troost's open temples.[26] It seems from a passing remark Giesler made that at one time Hitler considered the possibility of having his own sarcophagus placed in one of the Königsplatz temples, but this idea was rejected along with many others (pyramids, cypress-planted mausolea like those of Augustus and Hadrian, and so forth).[27] Hitler's final choice was a mausoleum the design of which was based on that of the Pantheon, not in its original function as a temple but in its later function as a tomb of the famous: Raphael, the kings Victor Emmanuel II and Umberto I.

22. Speer, *Erinnerungen*, 168.

23. For a discussion of the symbolic significance of domes and orbs in "imperial" architecture, see H. P. L'Orange, *Studies on the Iconography of Cosmic Kingship in the Ancient World*, Oslo, 1953, especially 28–34 (Domus Aurea); not that Hitler in any way presented himself as a sun king, as Louis XIV did at Versailles. For criticisms of L'Orange's interpretations, see A. Boethius, "Nero's Golden House," *Eranos* 44 (1946): 442–59; J. M. C. Toynbee, *Journal of Roman Studies* 38 (1948): 160f.; M. P. Charlesworth, ibid. 40 (1950): 71f. E. Baldwin Smith, *Architectural Symbolism of Imperial Rome and the Middle Ages*, Princeton, 1956, 52–73; 130–51.

24. "Hitler believed that as centuries passed, his huge domed assembly hall would acquire great holy significance and become a hallowed shrine as important to National Socialism as St. Peter's in Rome is to Roman Catholicism. Such cultism was at the root of the entire plan." *Playboy* Interview, 80; on this, see Giesler, 327f., who predictably prefers the building sketched by Hitler to the plans produced by Speer.

25. Giesler, 31.

26. See page 64. Also compare the open-air Things-platz.

27. Giesler, 25; for Hitler's will of 2 May 1938, in which he instructed that his coffin was to be placed in one of the Ehrentempel, see page 64 above.

The mausoleum was to be connected to the Halle der Partei at Munich by a bridge over Gebelsbergerstrasse (Fig. 58), to become a party-political cult center in the city regarded by Hitler as the home of the Nazi party. The dimensions of the mausoleum were (surprisingly) slightly smaller than those of its Roman model: 40 meters in diameter and height,[28] as opposed to 43.30 meters in the Pantheon.[29] The interior was also to be simplified to avoid showy decoration and anything "enigmatic" (ohne Prunk, absolute Einfachheit, nichts sollte . . . rätselhaft sein). The top of the interior rotunda wall was to culminate in a metope-triglyph-frieze, whose austere order (straffe Ordnung) was to be continued in the coffers and ribs of the dome. The oculus in the center of the dome was to be one meter wider in diameter than that of the Pantheon (8.92 meters) to admit more light onto

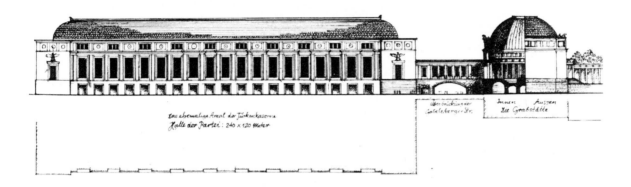

Die „Halle der Partei"

Fig. 58. Hermann Giesler, plan of Hitler's mausoleum, Munich, 1940–41

Hitler's sarcophagus, placed immediately under it on the floor of the rotunda. The modest dimensions of the structure and its lack of rich decoration are at first sight puzzling in the light of Hitler's predilection for gigantic dimensions, but in this case the focal point of the building was the Führer's sarcophagus, which was not to be dwarfed by dimensions out of all proportion to the size of the sarcophagus itself. Likewise, rich interior decoration would have distracted the attention of "pilgrims." Giesler's scale model of the building apparently pleased Hitler, but the model and plans, kept by Hitler in the Reichskanzlei,

28. Giesler, 31. 29. MacDonald, *Architecture*, 203.

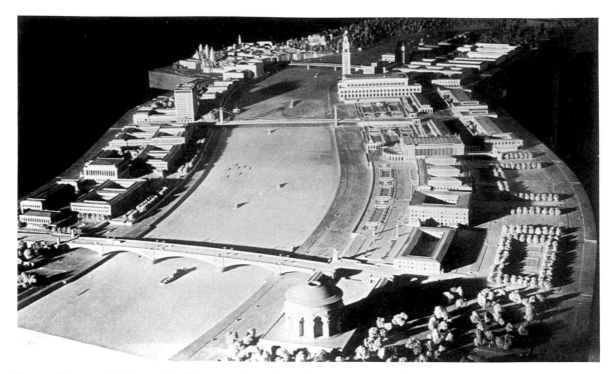

Fig. 59. Hermann Giesler, model of the mausoleum for Hitler's parents (center foreground), Linz, 1940–41

are now probably in the hands of the Russians, or have been destroyed.[30] It was perhaps because Hitler was so pleased with the design of his own mausoleum that in late autumn 1940 he asked Giesler to design a mausoleum for his parents in Linz. Giesler gives no details of the structure, but it is clear from the photograph of his model (Fig. 59) that once more Hadrian's Pantheon was the model.

30. Giesler, 35.

VII

THERMAE OF THE REICH

In *Mein Kampf* (1.10) Hitler had referred to the public baths of imperial Rome as examples of ancient Gemeinschaftsbauten, and during his visit to Rome in 1938 he viewed the Baths of Caracalla and those of Diocletian.[1] It is therefore not surprising that a massive bathing establishment was planned for Berlin's north-south axis, at its south-east end, close to the new railway station and partly adjacent to the east side of Hitler's gigantic triumphal arch. The architect commissioned to plan the bath complex was Cäsar Pinnau, who had collaborated earlier with Speer in designing parts of the interior of the new Chancellery.[2] This contact led to further commissions, which included the designing of the Thermen in 1941–42.[3]

According to Pinnau, Hitler wished Berlin to have a large modern bathing establishment, which the capital had previously lacked. In accordance with the model of ancient classical *thermae*, they were to include a large indoor pool in a vaulted hall 150 by 50 meters and an outdoor pool 100 by 22 meters, along with sport and exercise facilities, saunas, and steam and mud baths.[4] Pinnau was not influenced by the design of any single

1. See page 32.

2. J. C. Fest, *Cäsar Pinnau Architekt*, Hamburg, 1982, 89–93.

3. Pinnau's plans have never been fully published or even summarily discussed. Publication so far includes the reproduction of part of a colored drawing of a cross section of the baths on the cover of L. O. Larsson's *Albert Speer*, Brussels, 1983; fully reproduced with other plans, but no discussion in Fest, *Cäsar Pinnau*, 100–103. I wish to thank the architect for providing me with basic

information about his sources of inspiration for the baths and the dimensions of its various parts, as well as for previously unpublished photographs of the structure.

4. Personal letter of 6 August 1985. For an excellent discussion of public baths in Germany up to the first decade of the twentieth century, see B. K. Ladd, "Public Baths and Civic Improvement in Nineteenth-Century German Cities," *Journal of Urban History* 14 (1988): 372–93.

Roman *thermae* such as that of Caracalla, or the imperial baths at Trier, but by the general character of classical bath buildings. The requirements of a bath building in modern Germany were rather different from those that obtained in ancient Rome, apart from considerations of climate. Pinnau replaced the usual sequence of central main rooms (*frigidarium, tepidarium, caldarium*) with a large modern swimming-pool equivalent to the *frigidarium*, according to Pinnau, and an outdoor swimming pool (= *natatio* and *palaestra*). The remaining public utilities, sweat-baths (= *sudatorium*), medicinal baths, sports rooms, and dressing rooms (= *apodyteria*) were grouped around the large indoor pool. These plans were never worked out in detail. Although Pinnau had visited the ruins of *thermae* in Rome during his student days, he did not revisit them later in connection with his plans for the Thermen. However, he did consult Krencker's *Trierer Kaiserthermen* (1929), Palladio's *Le Terme dei Romani* (1785), and Wasmuth's *Lexicon der Baukunst*, vol. 4 (1932).[5]

The ground plan of Pinnau's baths (Fig. 60) does reveal several features that are reminiscent of the plan typical of imperial Roman bath buildings. For example, the crossing of longitudinal and transverse axes in the Baths of Caracalla (Fig. 61) and those of Diocletian appears in the center of the vaulted *frigidarium*. Exactly the same axial disposition is found in the central vaulted hall that housed the indoor swimming pool in Pinnau's baths, and that Pinnau himself sees as the *frigidarium* of his complex. Furthermore, this central hall had a vaulted ceiling consisting of three parallel barrel vaults (Fig. 62), of which the central one was on the main axis, an arrangement found in the *frigidaria* of the Baths of Caracalla (Fig. 61), Diocletian, and at the imperial baths of Trier and Carthage.[6] The rear of the east wall of Pinnau's "frigidarium," with its rectangular exit flanked by two semicircular niches, echoes the configuration found in the Baths of Caracalla and Diocletian, where the *natatio* joins the rear wall of the *frigidarium*. The correspondence in detail is clear and is further confirmed by the fact that Pinnau regards his open-air swimming pool as a *natatio*.

There is of course no equivalent in Pinnau's plan to the *tepidarium* and *caldarium* on the main axis of his building. Where the *tepidarium* and *caldarium* might have been expected in the plan of Roman *thermae*, Pinnau situated a large garden peristyle with a fountain at its center. The steam baths and ancillary medicinal baths were situated elsewhere on the plan. The bilateral or "mirror" symmetry typical of the plan of Roman imperial *thermae* is also clearly evident in Pinnau's plan, particularly in the central block of the complex, where at the northern and southern extremities of the *frigidarium*'s transverse axis are open colonnaded courtyards equivalent to the open pillared *palaestrae* in which the transverse axes of Caracalla's and Diocletian's baths culminate.

A further ancient reminiscence found in Pinnau's *frigidarium* is the use of columns (with palm-leaf capitals) as a decorative feature to fill the spaces between each of the three ground-floor arches. Above each of the four freestanding columns in each arch was a statue. A model of the Kaiserthermen at Trier in the Landesmuseum shows exactly this

5. Personal letter of 29 August 1985.

6. See E. Brödner, *Die römischen Thermen und das antike Badewesen*, Darmstadt, 1983, 226, 231, 236, 247.

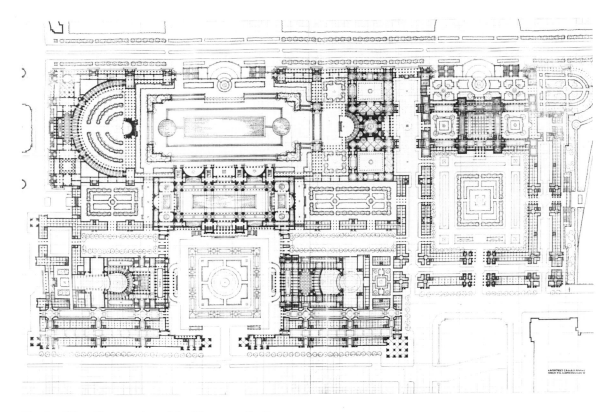

Fig. 60. Cäsar Pinnau, plan of the Thermen, Berlin, 1940–41

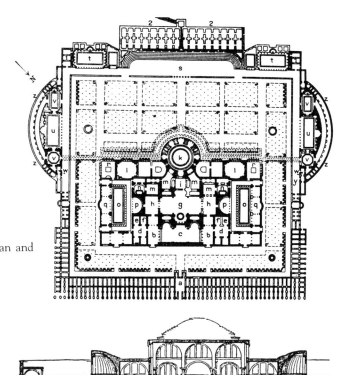

Fig. 61. Baths of Caracalla, Rome, plan and cross section of *frigidarium* (g)

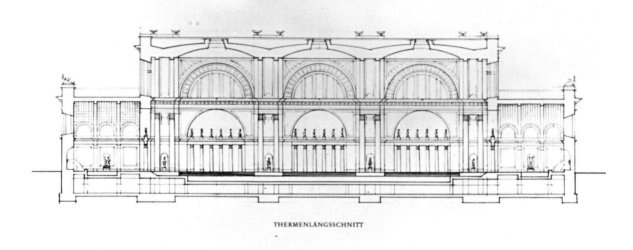

THERMENLÄNGSSCHNITT

Fig. 62. Cäsar Pinnau, Thermen, cross section of central block

arrangement with statues on pedestals above each of four freestanding columns, which extend to half the height of the arch leading from the east side of the *caldarium*.[7]

There are no details available about the sculptures that would have been used in Pinnau's Thermen, but they were an important part of the decoration in Roman imperial *thermae*.[8] With their richly appointed public rooms they gave the poor a momentary impression that they were living like the rich.[9] As Erika Brödner rightly remarks, the huge sums of money spent by emperors on *thermae* were to their own political advantage, since such structures had a psychological influence on the masses of people who thronged them. Trophies, sculptures, and inscriptions reminded clients that they enjoyed the facilities of the bathing establishment thanks to the power and generosity of their ruler.[10]

However, it is hardly likely that Hitler looked upon public bathing establishments as a branch of "assembly-architecture" (Versammlungsarchitektur) exemplified by his stadia and halls in Nuremberg and elsewhere. It is more likely that Pinnau's Thermen was

7. Brödner, pl. 73.

8. H. Manderscheid, Die Skulpturenausstattung der kaiserzeitlichen Thermenanlagen, Berlin, 1981; see now on the sculpture in the Baths of Caracalla, M. Marvin, "Freestanding Sculptures from the Baths of Caracalla," *American Journal of Archaeology* 87 (1983): 347–84.

9. Scobie, "Slums," 431; Marvin, 347.

10. Page 229f.; Brödner cites the inscription from Diocletian's baths, *CIL* 6.1130, which informed bathers who was responsible for building and dedicating the baths. Cf. N. Hannestad, *Roman Art and Imperial Policy,* Jutland, 1986, 10.

commissioned as nothing more than a public utility worthy of the capital.[11] Its style was unmistakably Roman and, like all the other major buildings on Berlin's north-south axis, it would have enhanced the *maiestas* of the Reich and the dictator's authority.

Although Pinnau quite specifically stated his sources of inspiration, it is worth knowing that his Thermen had much earlier precedents in Fascist Rome, where "romanità" and "grandezza imperiale" were looked for in modern *opera publica*. In view of this, it is no surprise to find a revival of interest in the building of public baths in the imperial Roman style. A review of the main Fascist examples will help to indicate that Pinnau's Thermen are not an isolated phenomenon; they are part of the Nazi and Fascist program to erect community buildings that not only provide large numbers of people with opportunities for recreation in hygienic conditions but also were symbols of the political systems that provided them.

In the very first issue of *Capitolium*, Francesco Cenciarini recalls the "majestic" baths of ancient Rome and notes that no modern counterparts have yet been erected in the capital.[12] The necessity for such baths is not so pressing, the writer continues, because modern Italian houses now included properly equipped bathrooms. However, there was a need for recreation centers where people could swim, exercise, and avail themselves of hydrotherapy and heliotherapy. Two projects for such a center, built in the Roman imperial style, were ready for implementation. One by Vincenzo Fasolo, a "centro sanitario e sportivo," was to be built near the Piazza del Risorgimento. It would be among the most grandiose bath buildings in Europe, surpassing those of Cologne, Breslau, Frankfurt, and Budapest.[13] The main covered pool (60 by 20 meters) was spanned by an elaborately coffered vault (Fig. 63) typical of imperial *thermae*. *Palaestrae* were also included in the complex for physical exercise "to reconnect the new type of baths to the ancient traditions."[14]

The second "progetto termale," designed by Alessandro Limongelli, was inspired by "traditional forms of the golden age of Rome,"[15] and was to be sited in the area of Monte Mario. This project also included swimming pools, *palaestrae*, and other facilities for physical exercise. Neither project was built, but both were forerunners of baths that were erected on different sites.

Four years after the publication of these projects, a letter was sent to the editor of *Capitolium* pointing out "a gap which especially today at a time when the cult of *romanità*

11. Berlin was inadequately provided with such facilities. The main bath (Admiralgarten Bad) was built in 1873–74 by Kyllmann and Heyden. It included vaulted "Roman" and "Russian" baths, with separate rooms for first- and second-class customers. The walls of the first-class rooms were veneered with Carrara marble, whereas second-class rooms were lined with zinc; *Berlin und seine Bauten*, 361–67. A large Thermen was also planned for Munich's east-west axis, designed by H. Tillmanns in 1939; for a sketch and model, see H.-P. Rasp, *Eine Stadt für tausend Jahre*, Munich, 1981, 151–52.

12. "Per le nuove terme," *Capitolium* 1 (1925): 89–92.

13. Ibid., 90. A modern bath building at Dresden designed by P. Wolf was admiringly described by "Ga. Mi." in *Architettura* 12 (1933): 762–66. The building owed nothing to Roman tradition. The author remarks that the building is "un po'dura pel nostro sentimento meridionale."

14. Ibid., 91.

15. Ibid., 92.

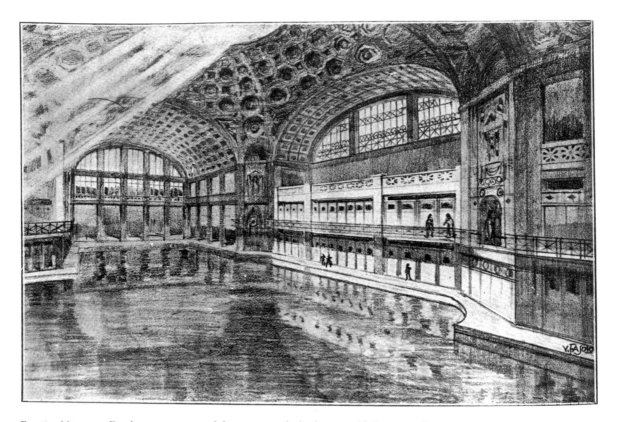

Fig. 63. Vincenzo Fasolo, prospective of the interior of a bathing establishment in Rome, 1925

is being renewed, ought to be filled. It is necessary to endow Rome with a large bath building of the kind which rose majestically and served a very useful purpose in the imperial period."[16] M. Rizzo responded by publishing a photograph of a modern Italian bathroom equipped with bath, washbasin, and flush-toilet, and at the same time referred to the projects of Fasolo and Limongelli. He concluded by pointing out the existence of modern bathing facilities in the Via Buonaroti and Viale del Re.[17]

The Fascist authorities were clearly not in a hurry to build modern *thermae* in Rome, but on the coast at Ostia, the Società Elettroferroviaria Italiana had commissioned Giovanni B. Milani to build a "stabilimento balneare" on the marina at Ostia.[18] The plan (Fig. 64), as well as the style of one part of the complex, was original, if not eccentric, revealing a central block built of masonry situated on the shore at the edge of the marina. This block was connected by a ferroconcrete causeway to a domed rotunda, also of

16. "Stabilimenti termali," *Capitolium* 5 (1929); 642–44; "una lacuna che oggi specialmente, nel rinnovellato culto della romanità, dovrebbe essere colmata. E'necessario dotare Roma d'un grande edificio termale sul tipo di quelli che sorsero maestosi ed utilissimi nell' epoca imperiale" (642).

17. Ibid., 644.

18. G. Giovannoni, "Lo stabilimento balneare 'Roma' alla marina di Ostia," *Architettura e Arti Decorative* 6 (1926/27): 495–510.

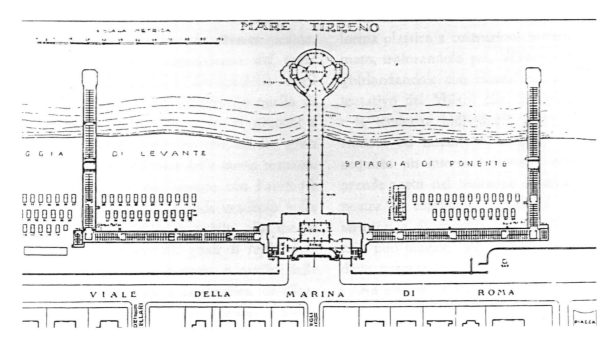

Fig. 64. Giovanni B. Milani, plan of the beach complexes at Ostia, 1926

ferroconcrete, built on a platform above the sea. All these structures on the central axis were reminiscent of the central suite of rooms in imperial *thermae*. The rotunda (24 meters in diameter), despite its bizarre stylistic mixture of Roman rotunda with Gothic flying buttress (Fig. 65), was an echo of the domed *caldarium* of the Baths of Caracalla. The central block consisted of three groin-vaulted chambers in the usual Roman style (Fig. 66). The main transverse axis of these three vaulted rooms formed the long central "Vestibolo Principale," which corresponds to the *frigidarium* of the Baths of Caracalla, and the semicircus at the edge of the Viale della Marina corresponds to the semicircus in front of the reservoir-block of the Baths of Caracalla (Fig. 61). The bilateral symmetry of imperial *thermae* is also present. The rows of shops in the outer enclosure of the Baths of Caracalla are here represented by rows of changing rooms placed back to back. These parts of the building were built of timber. The rooms on the central axis housed gymnasia, restaurants, a barber's establishment, a laundry, and toilets. The design is whimsical, since there is not a single pool in the whole structure designed to provide those who wanted to swim in the sea, or sit on the beach, with ancillary facilities.

Gustavo Giovannoni praises the building's *romanità*, ignoring the hybrid nature of its rotunda, and compares it favorably with New York's Pennsylvania Railroad Station, "an artificial copy" of Roman imperial *thermae*.[19]

19. Ibid., 508.

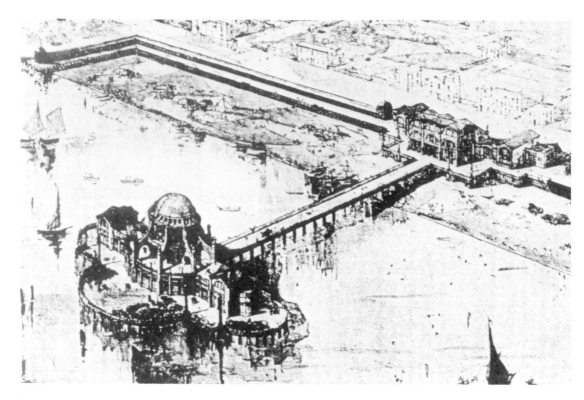

Fig. 65. Giovanni B. Milani, drawing of the central block and causeway of "stabilimento marino"

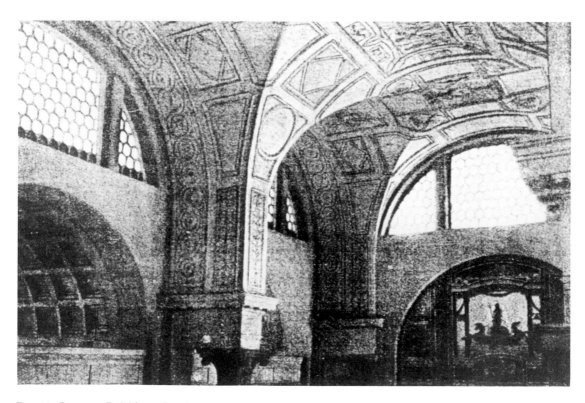

Fig. 66. Giovanni B. Milani, detail of the interior of the central block of "stabilimento marino"

In Rome, Del Debbio, who designed the main buildings at Foro Mussolini, published a short note in 1930 urging a need for a return to the physical culture of Greek and Roman times:[20] "It is known that Greece was truly outstanding in this sphere, and the Romans no less so. . . . the pleasant distraction we today derive from conversation over coffee was for the Romans derived from the sight of beauty and physical strength, which they could enjoy daily at the public bath. How far we are today from that conception of life, hygiene, and beauty."[21]

In 1937 Del Debbio's wish to have baths at Foro Mussolini was realized, but the Palazzo delle Terme bore little resemblance to the traditional Roman *thermae*. Externally the architecture resembled in simplified form Del Debbio's neighboring Accademia Fascista di Educazione Fisica. The interior also had little in common with Roman prototypes (no coffered barrel-vaulted ceilings).[22] Only the black and white mosaics surrounding the main pool (50 by 18 meters) and the polychrome mosaics on the walls of the pool room were deliberate attempts to evoke *romanità*.[23] The white marble step-seats (for 2,000 spectators) flanking the main pool were also not a feature of Roman *thermae* but a link with Del Debbio's Stadio Mussolini. The most sumptuously decorated room in the complex was the Palestra del Duce on the first floor. It was provided with mosaics by Gino Severini and held two statues of gilded bronze. Other service rooms were provided, including a large salone (60 by 15 meters), all of which made it possible to give state dinners there, such as the one given for Hess and other Nazis on the evening of 6 May 1938.[24] The addition of the Palazzo delle Terme enabled Magi-Spinetti to emphasize that Foro Mussolini was not just for the benefit of the Fascist party, "but, like *thermae*, also for the use of the public. In this . . . the Foro Mussolini belongs to Roman tradition."[25] Thus, unlike Pinnau's Thermen in Berlin, which would have been built next to the new railway station and not associated with the most important buildings around Grosse Platz, the Fascist *Terme* in Rome were incorporated into the most significant political forum in the capital. This forum also gained in political significance when the Casa Littoria was built there.

20. "Per l'incremento dell' educazione fisica nell' Urbe," *Capitolium* 6 (1930): 389–92.

21. "Si sa che la Grecia in questi manifestazioni fu veramente eccelsa e Roma non minore. . . . La piacevole distrazione che per noi oggi può essere la conversazione al caffè, per i Romani era invece spettacolo di bellezza e forza fisica che potevano giornalmente godere al bagno pubblico. Quanto lontano siamo noi oggi da questa concezione di vita di igiene e di bellezza" (390).

22. C. Magi-Spinetti, "Nuove opere al Foro Mussolini," *Capitolium* 13 (1938): 197–205.

23. "G. Rosso il quale riprende con spirito moderno antichi motivi decorativi a due colori, come per esempio quelli delle Terme di Caracalla e di Ostia" (204); cf. *Architettura* 19 (1940): 583–94.

24. See page 28.

25. ". . . ma, como le terme, anche il pubblico può usarne. In questo . . . il Foro Mussolini riallaccia alla tradizione romana" (201).

VIII

LABOR AND PLUNDER

THE number of skilled and unskilled workers required to erect Hitler's increasingly gigantic buildings created a labor problem. When he assumed power in 1933, there were still many unemployed workers in Germany,[1] some of whom were given work on public building schemes that Hitler thought would stimulate a sluggish German economy and at the same time provide him with popular propaganda ("Hitler creates jobs": Hitler schafft Arbeit). The majority of the unemployed were quickly absorbed by the armaments factories and not by the construction industry, as Nazi propaganda suggested.[2]

However, the unemployed did not always thank Hitler for their employment. German workers employed on the building of the autobahns repeatedly went on strike from 1934 onward because of their atrocious working conditions, which led to graffiti such as "Adolf Hitler's roads are built with the blood of German workers." The Gestapo was ruthlessly used for strike-breaking, and recalcitrant workers were sent to concentration camps on the assumption that they were Communists.[3]

As preparations for war, and later, as the demands of war absorbed increasingly larger quantities of steel, concrete, and manpower, the state building program slowed down to the point where in 1943 all work virtually came to a halt at the Nuremberg rally grounds.[4]

Speer's "theory of ruin value" addressed the problem of trying to save concrete and

1. More than six million; K. Lämer, *Autobahnbau in Deutschland 1933 bis 1945*, Berlin, 1975, 52; by September 1937 the number had dropped to 469,053, when the number of workers employed on "strategic" road building peaked at 130,000; idem, 55.

2. "Die faschistischen Arbeitsbeschaffungsprogramme waren . . . nicht anderes als der grossangelegte Versuch . . . die Aufrüstung Deutschlands voranzutreiben"; Lärmer, 54.

3. Lärmer, 76–81.

4. Schönberger, *Neue Reichskanzlei*, 164–66.

steel, but it created a new problem. Since state buildings were to be erected according to ancient principles of statics and built from natural stone, huge quantities of quarried stone were required.[5] Since quarries within the Reich could not meet the demand, large amounts of granite and marble were ordered from Scandinavia, France, and Italy.[6] New quarries within Germany and Austria were established by the SS, who set up concentration camps such as Mauthausen, Flossenbürg, Neuengamme, Natzweiler, and Gross-Rosen,[7] where inmates were forced to quarry stone for Hitler's buildings. The inmates were to be given minimal, low-cost diets, in which Himmler took a special interest. On 23 March 1942 he asked Oswald Pohl "to gradually develop a diet which, like that of Roman soldiers or Egyptian slaves, contains all the vitamins and is simple and cheap."[8]

The grim conditions under which slave laborers worked in a rocket factory housed in caves beneath the Harz Mountains did not fail to remind Speer of his visit to Syracuse:

> Oddly enough, I thought of the Greek prisoners of war who dug out the caves of Syracuse 2000 years ago. Just a few years earlier, I had visited the caves with Magda Goebbels and the sculptors Arno Breker and Joseph Thorak. I had shuddered at the heritage of cruel centuries. Now I saw bleaker scenes than my imagination had pictured in Syracuse.[9]

Plans were also made to import three million Slavs ("Untermenschen") into Germany to work for twenty years on the Reich's building sites.[10] Already by May 1941 more than three million people were being forced to work in Germany, and of these a third were prisoners of war and the rest people forcibly removed from conquered territories.[11]

5. Petsch, *Baukunst*, 107

6. Thies, *Weltherrschaft*, 100.

7. Thies, *Weltherrschaft*, 101; G. Kunert, "Ein Fachmann," in Reif, ed., *Albert Speer*, 363; Speer, *Infiltration*, New York, 1981, 41f. Giuseppe Pagano, the architect who had designed buildings for the new University of Rome and who quarreled with Piacentini over the style of the state buildings at EUR, resigned from the Fascist party in 1942, became a partisan commander, and was imprisoned in Brescia (1944), then in Milan. The Germans then transferred him to Mauthausen, where he died on 22 April 1945. The choice of Mauthausen was perhaps no accident on the part of the German authorities. A distinguished architect was forced to quarry stone for German projects; C. De Seta, ed. *Giuseppe Pagano*, 1976, LXX; Insolera, Di Majo, *L'EUR e Roma*, Rome and Bari, 1986, 57. Speer arranged a ten-year supply of construction materials from Mauthausen on 30 June 1938. He visited the camp on 29 March 1943 in connection with the employment of prisoners in the manufacture of V2 rockets in bombproof caves. On 13 and 18 January 1943 Hitler had approved the use of decimation as a punishment in the case of sabotage

blamed on prisoners; H. Marsalek, *Mauthausen*, Milan, 1977, 17f., 20. Decimation, the selection of every tenth person for execution, had long been used by the Romans in military contexts; G. R. Watson, *The Roman Soldier*, London, 1969, 119–21.

8. Speer, *Infiltration*, 36; cf. J. M. Steiner, "The SS Yesterday and Today," in J. E. Dimsdale, ed., *Survivors, Victims and Perpetrators: Essays on the Nazi Holocaust*, Washington, D.C., 1980, 414. The diet of Roman soldiers in imperial times at least, was not particularly cheap or simple; see R. W. Davies, "The Daily Life of the Roman Soldier," in *Aufstieg und Niedergang der römischen Welt*, 2.1, Berlin, 1974, 381f.; Himmler perhaps was thinking of the hardtack (*buccellatum*) a Roman legionary carried while on the march—an iron ration a soldier with no corn could live on for three days; Watson, *The Roman Soldier*, London, 1969, 58.

9. Ibid., 211; *Playboy* Interview, 92; Marsalek, *Mauthausen*, 19f.

10. J. Thies, "Nazi Architecture," in D. Welch, ed., *Nazi Propaganda*, London, 1983, 58.

11. E. L. Homze, *Foreign Labor in Nazi Germany*, Princeton, 1967, 68f.

This use of forced (slave) labor, as well as the massive expenditure of funds on buildings commissioned by an autocrat under no constraint to disclose or justify such expenditure, invites comparison with Roman methods of paying for and erecting *opera publica*.

Rome's vast state buildings, admired and envied by Hitler, could be built only because Roman imperialism over a period of centuries generated the wealth and made available the manpower to pay for and erect the structures that enhanced the *maiestas* and spread the propaganda of the emperor. In Rome public buildings were customarily paid for out of plunder (*manubiae*) derived from foreign wars. For example, Trajan's vast forum was financed from booty derived from his Dacian wars.[12] Julius Caesar's grandiose building plans, partly put into effect after his death by Augustus, were made possible thanks to the plunder he had gained from his wars in Gaul. The acquisition of works of art for the embellishment of private and public buildings was also frequently based on plunder. Here one can point to the aftermath of the sack of Corinth by Mummius in 146 B.C., when shiploads of art treasures were sent to Rome.[13] So too Hitler "collected" works of art from all conquered territories for eventual exhibition in the vast gallery that was to have been built in Linz.[14] The use of forced labor on building sites both in Rome and in the provinces was a normal Roman practice.[15]

Thus it seems clear that Hitler's grandiose plans for the architectural embellishment of Berlin and Germany's regional capitals could only have been achieved by using the same methods as those employed by the Romans: forcible acquisition of funds and forced labor.[16]

12. P. Zanker, "Das Trajansforum im Rom," *Archäologischer Anzeiger,* 1970, 506; G. B. Giglioni, *Lavori pubblici e occupazione nell' antichità classica,* Bologna, 1974, 77.

13. Velleius Paterculus 1.13.4. The plundering of artworks by the Romans began with the sacking of Etruscan towns such as Veii (396 B.C., Livy 5.22.3–8). Marcellus's sack of Syracuse (211 B.C.) triggered a craze for collecting Greek art in Rome (Livy 25.40.1–3). Cf. Plutarch, *Aemilius Paullus* 32–33. "From the time Rome became an imperial city until today she has been a parasite-city", M. I. Finley, *The Ancient Economy,* London, 1985, 125; cf. 130, 190. For an attempt to whitewash the practice, see Silius Italicus, 14.665–88; Ovid, *Ars Amatoria* 3.113f., states that "golden Rome . . . owns the vast wealth of the conquered world."

14. de Jaeger, *The Linz File,* for the Linz museum project, see 52–56. The Führermuseum in Linz was to house the greatest art collection in the world. Armor, rare books and manuscripts, sculpture, furniture, tapestries, and coins were all to be housed in separate buildings. A special looting organization, Sonderauftrag Linz, with headquarters in Munich, supervised opera-

tions. The shelter beneath the Führerbau in Munich was one of the storage dumps for part of this loot; D. Roxan, K. Wanstall, *The Jackdaw of Linz,* London, 1964, 9, 22f. Napoleon was also a robber of art treasures; see P. Wescher, *Kunstraub unter Napoleon,* Berlin, 1976, 11–25, for a brief history of art looting prior to Napoleon.

15. P. A. Brunt, "Free Labour and Public Works at Rome," *Journal of Roman Studies* 70 (1980): 82, says forced labor was used in the provinces but not in Rome; see, however, Pliny, *NH* 36.24.108, where reference is made to the use of forced citizen labor for the construction of the Cloaca Maxima. See also L. Casson, *Ancient Trade and Society,* Detroit, 1984, 120–23. For forced labor in Roman mines and quarries, see F. Millar, "Condemnation to Hard Labour in the Roman Empire," *Papers of the British School at Rome* 52 (1984): 124–47. G. Pagano, in C. de Seta, ed., *Giuseppe Pagano,* 94.

16. ". . . the giant metropolis [Berlin/Germania] he envisaged could only serve as the heart of a conquered and enslaved empire." Speer, *Playboy* Interview, 80; criticized as nonsense by Giesler, 328.

IX

THE CULT OF VICTORY

BOTH the Nazis and the Romans employed architecture of colossal dimensions to overawe and intimidate. Both cultures were preoccupied with architectural monuments that celebrated or glorified a victory ideology: triumphal arches (the largest in the world on Berlin's north-south axis), columns, trophies,[1] and a cult of pageantry associated with the subjugation of others. Nothing pleased the inhabitants of Rome more than the pomp of a triumph celebrated by a victorious general or emperor over a nation foolish enough not to welcome the Romans.[2] Depictions of the goddess Victoria are exceedingly common in official Roman art.[3] It was a colossal statue of this deity that had pride of place in the Nuremberg rally site above Hitler's *pulvinar* in the Märzfeld stadium.[4] The axial 80-meter wide triumphal way in Nuremberg culminated in this victory-crowned *pulvinar*. The *via triumphalis* in the center of Berlin was spanned by a massive triumphal arch designed by Hitler himself in 1925 (170 by 119 meters and 117 meters high).[5] As Speer wryly remarked, when it was safe to do so: "The Romans built arches of triumph to

1. G. C. Picard, *Les trophées romains*, Paris, 1957.

2. H. S. Versnel, *Triumphus*, Leiden, 1970; L. B. Warren, "Roman Triumphs and Etruscan Kings," *Journal of Roman Studies* 60 (1970): 49–66. E. Kuenzl, *Der römische Triumph: Siegesfeiern im antiken Rom*, Munich, 1988.

3. J. Gagé, "La théologie de la Victoire impériale," *Revue Historique* 171 (1933): 1–34; J. R. Fears, "The Theology of Victory at Rome," in *Aufstieg und Niedergang der römischen Welt*, 2.17.2, Berlin, 1981, 3–141; for a colossal statue of Victory in the Baths of

Caracalla, see Marvin, "Sculptures," figs. 21–22. The domination of nature and peoples subjugated by Rome was represented throughout the Roman Empire in amphitheaters by means of beast hunts (*venationes*) and gladiatorial combats (*munera*). M. Clavel Lévêque, *L'empire en jeux; Espace symbolique et pratique sociale dans le monde romain*, Paris, 1984, 78–86; 93–100.

4. See page 87 above; K. Arndt, "Architektur als Politik," in Speer, *Architektur-Arbeiten*, 122.

5. Thies, *Weltherrschaft*, 97. According to Bonatz, *Leben und Bauen*, 108f., Hitler's sketch of this arch dates

celebrate the big victories won by the Roman empire, while Hitler built them to celebrate victories he had not yet won."[6]

The square between the south side of Hitler's arch and the north side of the railway station was to be decorated with military spoils captured in the Russian campaign. These were to include heavy tanks mounted on granite pedestals.[7] Here Hitler was following in the tradition of Berlin's Siegesdenkmal, the central column of which was decorated with the barrels of captured field guns. Being a victory column, it was one of the few monuments in Berlin Hitler liked. He moved it from its position outside the Reichstag to the Tiergarten to be one of the focal points of the new east-west axis.[8]

The Nazis also planned and built many military trophies and memorials (Mähnmaler) on the eastern borders of the Reich.[9] In the same way, the Romans had built celebratory trophies on the borders of their empire to commemorate victories and warn off would-be attackers. One of the most prominent memorial buildings intended to commemorate Germany's past and anticipated military glory was Wilhelm Kreis's Soldatenhalle, planned for the Runde Platz on the north-south axis.[10] This was to be yet another cult center to promote the regime's glorification of war, patriotic self-sacrifice, and *virtutes militares*. The main architectural features of this building were overtly Roman.[11] A groin-vaulted crypt beneath the main barrel-vaulted hall was intended as a "pantheon" of generals exhibited here in effigy. It also functioned as a heróon, since the bones of Frederick the Great were to be placed in the building.

Flags and insignia also played an important part in Nazi (and Fascist) ceremonial and in the decoration of buildings. The eagle-topped standards carried by the SA at Nuremberg rallies were reminiscent of Roman legionary standards, the uniformity of which Hitler admired.[12] Mussolini had gone further. With the permission of the Italian king, the Roman eagles were restored to the standards of the Italian army, thus establishing a direct link with the Roman past.[13] A striking feature of Nazi ceremonies in general was its highly evident sense of ritual and pageantry, also a prominent characteristic of Roman public life, with its propensity for public dramatizations of official functions. The most lavish of these, the triumph, was, as Anthony Marshall observes, "enormously relished by the massed spectators." The Romans were also aware that state insignia such as the *fasces*,

from 1921. He also remarks that when Hitler saw the Arc de Triomphe in 1940, he commented that it was quite attractive but too small (ganz schön, aber zu klein). He further adds that the arch was to incorporate a 600-m long frieze 11m high, and compares these dimensions with the 92-cm-high frieze of the Parthenon.

6. F. Dal Co, S. Polano, "Interview with Albert Speer, October 1977," *Oppositions* 12 (1978): 43.

7. K. Arndt, in Speer, *Architektur-Arbeiten*, 132.

8. *Berlin und seine Bauten*, 102, for an account of the monument; Petsch, *Baukunst*, 104, and Larsson, 35, for the transfer of the column by Hitler.

9. For example, the Totenburg Bitolj and other monuments erected by the Volksbund deutsche Kriegsgräberfürsorge, and the Dnieper monument, which resembles Trajan's trophy at Adamklisi; G. Troost, *Das Bauen*, 42–45; W. W. Taylor, *The Word in Stone*, pl. 60; C. Picard, *Les trophées romains*, 391–406, for the Adamklisi trophy.

10. Speer, *Baukunst*, 52–54.

11. Petsch, *Baukunst*, 112; Larsson, *Albert Speer*, 89–94.

12. *Table Talk*, 149f.

13. "Aquila romana sui vessilli dell' esercito," *Roma* 6 (1938): 469. Mussolini also kept on his desk in the Palazzo Venezia a small ceramic eagle and a statuette of Victory: Insolera, Perego, *Archeologia e città*, 70.

which Mussolini revived as a political icon, had a "fearful glamour" that would cow and awe others into fearful obedience.[14] Terror was a weapon of conquest and a means of keeping order both at home and abroad for the Nazis and the Romans.[15]

Hitler's visit to Rome in 1938[16] began with a "triumphal" entry into the capital along Mussolini's new grandiose roads, the Via dell'Impero (1932) and the Via dei Trionfi (1933), which had been cleared of obstacles in the interests of symmetry and, in the case of the Via dell'Impero, to give Mussolini a view of the Colosseum from the balcony of the Palazzo Venezia. Five churches and many homes were demolished in the interests of "grandezza."[17] It was perhaps with these demolitions in mind that Luigi Huetter pointed out in *Capitolium* for 1938 that when Charles V entered Rome in triumph in 1536, three churches and more than two hundred houses were demolished to improve his regal progress through the city and "liberate" the triumphal arches in the forum and near the Colosseum.[18]

When the two dictators visited the *Mostra Augustea* on 6 May 1938, the first exhibit to confront them in the vestibule of the Palazzo dell'Esposizione was a model of the winged Victory of Brescia, a copy of which had been placed at the entrance of the Brenner Pass.[19] The statue was supposed to represent the destiny of imperial and Fascist Rome. The next room of exhibits contained replicas of monuments glorifying Rome's conquests and power: triumphal reliefs from Adamklisi, Beneventum, Carpentras, and elsewhere, and in the hall devoted to the Roman army was, as Eugènie Strong described it at the time, "the lovely little chapel of the eagle,"[20] and the Victory of Calvatone, celebrating the victory of Rome over Parthia (Iran) in A.D. 165.

Mussolini's victory in his "Fourth Punic War"[21] against Ethiopia was dramatized by the erection of an obelisk (brought from the ancient Ethiopian capital of Axum)[22] on the Via dei Trionfi in front of the Circus Maximus, the *spina* of which had been decorated with obelisks from early imperial times onward. Hitler's cavalcade on 3 May 1938 passed this monument dedicated to the Duce. Other obelisks were erected to Mussolini in other parts of Rome.[23]

14. A. J. Marshall, "Symbols and Showmanship in Roman Public Life: The Fasces," *Phoenix* 38 (1984): 123, 138.

15. J. M. Steiner, "The SS," in Dimsdale, ed., *Survivors, Victims*, 438; Hitler, *Table Talk*, 87: "It's not a bad idea, by the way, that public rumor attributes to us a plan to exterminate the Jews. Terror is a salutary thing." Cf. Polybius 1.37.7: "In general the Romans rely on violence in all their undertakings," W. V. Harris, *War and Imperialism in Republican Rome*, Oxford, 1979, 17; Simone Weil, *Ecrits historiques et politiques*, Paris, 1960, 23–50, where many parallels are drawn between Nazi and Roman uses of terror as an important instrument of government.

16. See page 24.

17. Cederna, *Mussolini*, 58; cf. 257f. Insolera, Perego, *Archeologia e città*, 77–129.

18. "Ingressi trionfali di Roma," *Capitolium* 13 (1938): 239f.

19. E. Strong, "The Augustan Exhibition in Rome and Its Historical Significance," *The 19th Century and After* 124 (1938): 170.

20. E. Strong, "Romanità through the Ages," *Journal of Roman Studies* 29 (1939): 150f.

21. Insolera, Di Majo, *L'EUR e Roma*, 61.

22. "Stele di Axum," *Capitolium* 13 (1938): 604–7.

23. At Foro Mussolini; see G. B. Colonna, "Mentre l'obelisco dedicato al Duce viaggia verso Roma," *Capitolium* 5 (1929): 270–77; this obelisk was on its way to Stadio della Farnesina. For other victory monuments, ancient and modern in Fascist Italy, see M. Piacentini, "Di alcune particolarità del monumento alla Victoria in Bolzano," *Architettura e Arti Decorative* 8 (1928): 255–64; G. Q. Giglioli, "Il trofeo di Augusto alla Turbia," *Palladio* 4 (1940): 147–54; cf. G. Giovannoni, "Pel il parco della Vittoria a Monte Mario," *Capitolium* 1 (1925): 76–81.

There can be little doubt that Hitler's state architecture, even when seen today in photographs of architectural models, conveys a sense of "Macht und Gewalt," which of course Hitler wanted it to embody.[24] Inevitably, after Hitler's defeat, the colossal dimensions of his buildings tended to be seen, as they were by Speer in his memoirs, as symbols of Hitler's megalomania (though Giesler denies this). This is perhaps a valid viewpoint, but it is also something of an oversimplification, since at the time the buildings were planned and erected, they were valid symbols of Germany's rapidly rising power and expressed the optimism generated by Hitler's spectacular initial victories. The vast public buildings of ancient Rome have rarely been explained as symptoms of imperial megalomania, except perhaps for the *Domus Aurea*, since Roman imperialism, which generated the money and labor necessary for the erection of Rome's monumental buildings, was supremely successful and long-lived.

Hitler's architecture is sometimes misjudged because he was building for the future in anticipation of a greatly enlarged Reich. Here it is worth noting that Vitruvius perceived that Augustus was building on a large scale for future greatness.[25] Hitler's optimistic expectations were thankfully frustrated, and in the aftermath of catastrophe his architectural plans seemed to many to be those of a madman. However difficult it may be to view these plans objectively, it would be a mistake to regard his buildings as either psychologically ineffective or symbolically impotent. This is certainly not the impression given by Speer or Giesler at the time they were articulating Hitler's architectural plans.[26]

Had Hitler achieved all his political and military aims and had his successors consolidated and perhaps even expanded his territorial gains, the art and architecture of Germany would undoubtedly have reflected the sentiment that pervaded much of Rome's art in the Augustan period, that is, a confidently assumed right to dominate others, which Virgil elegantly, if brutally, expressed in *Aeneid* 6.851–53: "Remember, Roman, to exercise dominion over nations. These will be your skills: to impose culture on peace, to spare the conquered, and to war down the proud."[27] These very lines were seen by Eberhardt in

24. Taylor, *The Word in Stone*, concludes his book with the claim that Nazi monumental architecture failed to achieve what many writers of the Nazi period claimed it could do: to express the authority of the new Führerstaat, reflect the greatness of the German Volk, and reinforce the people's sense of unified purpose as directed by the will of a national leader. This conclusion was rightly questioned by R. Wiedenhoeft, *Journal of the Society of Architectural Historians* 34 (1975): 159.

25. 1 *Praef.* 3.

26. Giesler, even after the event, is not repentant, like Speer, and is highly critical of Speer's postwar hypocrisy (as Giesler interprets Speer's apologetic tone). Likewise Arno Breker, interviewed in the autumn of 1945 in Munich's Führerbau, was advised to make a public confession of guilt, even though no political charge was brought against him. He refused on the grounds that "Je n'étais que sculpteur . . . sans jamais

souffrir d'influences extérieures. . . . Nous ne sommes pourtant que des artistes." *Hitler et moi*, 196.

27. "Tu regere imperio populos, Romane, memento / hae tibi erunt artes, pacique imponere morem / parcere subiectis et debellare superbos." In the preceding lines Virgil says the arts can be left to the Greeks. The skills of world domination are more important. This passage, so much in tune with Nazi aspirations in Germany and Fascist hopes in Italy, is repeatedly referred to in the political literature of both countries. For example, Rodenwaldt, "Kunst um Augustus," 2, 24; F. P. Mulè, "Virgilio," *Capitolium* 6 (1930): 469–81 ("per Benito Mussolini possiamo oggi nominare Virgilio senza arrossire," 481); G. Q. Giglioli, "Roma e Virgilio," ibid., 483–92; G. Marchetti-Longhi, "La Via dell' Impero," *Capitolium* 10 (1934): 84; C. Cecchelli, "Itinerario Imperiale," *Capitolium* 13 (1938): 168.

1935 as embodying a "Herrschaftsidee," the exercise of which by the Romans had cut the ancient Germans off from Roman civilization: "We think of the expeditions of Drusus and Tiberius and the punitive expedition of Germanicus and feel the wall which separates us from Roman cultural ideas. We make a bridge to the present and discover that it was always basically the Latin idea of civilization supported and enlarged by arguments of the French Revolution, under the banner of which 1900 years later the first world war was waged against us, the barbarians on the far bank of the Rhine."[28]

A major difference between the "neoclassical" state architecture of Nazi Germany and neoclassical architecture in other modern countries in Europe and America[29] is that in Germany it was but one facet of a severely authoritarian state. Its dictator aimed to establish architectural order (gridiron town plans plus *cardo/decumanus*, axial symmetry, hierarchical placement of state structures within urban space) on a scale intended to reinforce the social and political order desired by the Nazi state, which anticipated the displacement of Christian religion and ethical values by a new kind of worship based on the cult of Nazi martyrs and leaders, and with a value system close to that of pre-Christian Rome. Thus buildings like the Congress Hall in Nuremberg and the Volkshalle in Berlin, inspired by the Colosseum and the Pantheon, respectively, were not merely symbols of tradition, order, and reliability,[30] but signaled a far more sinister intention on the part of the autocrat who commissioned them: a return to "Roman" ethics, which recognized the natural right of a conqueror to enslave conquered peoples in the most literal sense of the word, a right already made manifest even within the sphere of architecture by the creation of concentration camps, whose inmates were forced to quarry the stone for the Reich's buildings.[31]

28. "Wir denken an die Züge des Drusus und Tiberius und die Strafexpeditionen des Germanicus und spüren die Wand, die uns von der römischen Zivilisationideologie trennt. Wir schlagen den Bogen zur Gegenwart und stellen fest, dass es im Grunde immer noch die lateinische Zivilisationsidee war, gestützt und erweitert durch Argumente der französischen Revolution, unter deren Zeichen 1900 Jahre später der Weltkrieg gegen uns, die Barbaren jenseits des Rheins geführt wurde"; "Die Antike und Wir," *Nationalsozialistische Monatshefte* 6 (1935): 26f. Unlike Mussolini, Hitler had something of a problem in reconciling his admiration of Roman culture with the traditional attitude of the Romans toward Germans. See page 32 above for remarks on Hitler's recognition of this tradition in his speech given in the Palazzo Venezia in May 1938. Cf. P. A. Brunt, "Reflections on British and Roman Imperialism," *Comparative Studies in Society and History* 7 (1965): 279f.

29. For other remarks on neoclassicism in Nazi Germany and other Western countries, see Larsson, *Albert*

Speer, 220–23; idem, in *Albert Speer, Architektur,* 152, where he rightly states that classicism is far from being always equatable with autocracy; idem, in Krier, ed., *Albert Speer,* 224; P. Davey, "Authority and Freedom," *Architectural Review* 168 (1980): 74–77, where classicism (= authority) is contrasted with the Gothic (= freedom); Giesler, 205f.

30. "Der Bau sollte Sicherheit, Stolz, Selbstbewusstsein, Klarheit, Disziplin und damit den Begriff des neuen Deutschland verkörpern"; W. Rittich (1938), in A. Teut, ed., *Architektur im Dritten Reich 1933–1945,* Frankfurt/M., 1967, 294.

31. Here "the alliance between art and barbarity took its most extreme form"; Hinz, *Art in the Third Reich,* 111. The return to slavery on a massive scale (if Hitler had won the war) would also have had an impact on the German economy and raised issues about free and slave labor that had affected the ancient world; J. Dülffer, J. Thies, J. Henke, *Hitlers Städte: Baupolitik im Dritten Reich,* Cologne, 1978, 19.

Bibliography

[Anon.] "Il Pantheon dei caduti siracusani." *Architettura* 16 (1937): 563–70.

[Anon.] "Le giornate romane del Führer," *L'Urbe* 3 (1938): 40–45.

[Anon.] "Palestra del Duce alle Terme del Foro Mussolini." *Architettura* 19 (1940): 583–94.

Anderson, Andrew Runni. "Hercules and His Successors." *Harvard Studies in Classical Philology* 39 (1920): 7–58.

Andrazzi, C. "Le palude pontine nella storia." *La conquista della terra*, 3, 4 April 1932, 41–53.

Andreae, Bernard. *The Art of Rome*. London, 1978.

Architettura, Fascicolo speciale: La città universitaria di Roma. Milan, 1935.

Arenhövel, Willmuth, and Christa Schreiber, eds., *Berlin und die Antike*, 2 vols., Berlin, 1979.

Arndt, Karl. "Filmdokumente des Nationalsozialismus als Quellen für architekturgeschichtliche Forschungen." In Günter Moltmann and Karl Friedrich Reimers, eds. *Zeitgeschichte im Film und Tondokument*. Göttingen, 1970, 39–68.

Aurigemma, Salvatore. *Villa Adriana*. Rome, 1962.

Backes, Klaus. *Adolf Hitlers Einfluss auf die Kulturpolitik des Dritten Reiches*. Heidelberg, 1984.

Badian, Ernst. "Some Interpretations of Alexander." In *Alexandre le Grand: Image et réalité*. Geneva, 1975.

Balland, André, "La Casa Romuli au Palatin et au Capitole," *Revue des Etudes Latines* 62 (1984): 57–80.

Bartetzko, Dieter. *Zwischen Zucht und Ekstase: Zur Theatralik von NS-Architektur*. Berlin, 1985.

Baynes, Norman H., ed. *The Speeches of Adolf Hitler, 1922–1939*, 2 vols. Oxford, 1942.

Bek, Lise. *Towards Paradise on Earth*. Odense, 1980.

Bendiscioli, Mario. *Romanesimo e germanesimo*. Brescia, 1933.

Berlin und seine Bauten. Herausgegeben von Architikten-Verein zu Berlin. Berlin, 1877.

Berve, Helmut. "Antike und nationalsozialistischer Staat." *Vergangenheit und Gegenwart* 24 (1934): 257–72.

———. *Sparta*. Leipzig, 1937.

———, ed. *Das Neue Bild der Antike*. Leipzig, 1942.

Berve, Helmut, and G. Grube. *Greek Temples, Theatres and Shrines*. London, 1963.

Blake, Marion Elizabeth. *Roman Construction in Italy from Tiberius through the Flavians*. Washington, D.C. 1959.

Blouet, Guillaume Abel. *Restauration des thermes d'Antonin Caracalla à Rome*. Paris, 1828.

Bodei Giglioni, Gabriella. *Lavori pubblici e occupazione nell' antichità classica*. Bologna, 1974.

Boethius, Axel. "Nero's Golden House." *Eranos* 44 (1946): 442–59.

Bollinger, Traugott, *Theatralis Licentia*. Basel, 1961.

Bonatz, Paul. *Leben und Bauen*. Stuttgart, 1950.

Boralevi, Alberto. "Le 'città dell' impero': Urbanistica Fascista in Etiopia, 1936–1941." In

Alberto Mioni, ed. *Urbanistica fascista: Ricerche e saggi sulle città e il territorio e sulle politiche urbane in Italia tra le due guerre.* Milan, 1986, 235–86.

Borbein, Adolf H. "Gerhart Rodenwaldt. Gedenkwort zur 100. Wiederkehr seines Geburtstages." *Archäologischer Anzeiger,* 1987, 697–700.

Böhringer, Erich, and Friedrich Krauss. *Das Temenos für den Herrscherkult.* Berlin, 1932.

Brachmann, Wilhelm. "Der 'humanistische' Gedanke." *Nationalsozialistische Monatshefte,* 1937, 490–504.

Breker, Arno. *Hitler et moi.* Paris, 1970.

———. *Schriften.* Bonn, 1983.

Brilliant, Richard, "Roman Art and Roman Imperial Policy," *Journal of Roman Archaeology,* 1 (1988): 110–14.

Brinckmann, Alfred E. "Modellräume vom Neubau der Reichskanzlei." *Deutsche Bauhütte,* 1939, 52f.

Brödner, Erika. *Die römischen Thermen und das antike Badewesen.* Darmstadt, 1983.

Brunt, Peter A. "Reflexions on British and Roman Imperialism." *Comparative Studies in Society and History* 7 (1965): 279f.

Burns, Alfred. "Hippodamus and the Planned City." *Historia* 25 (1976): 414–28.

Cagnetta, Mariella. "Il mito di Augusto e la 'rivoluzione' fascista." *Quaderni di Storia* 2 (1976): 139–81.

———. *Antichisti e impero fascista.* Bari, 1979.

Calza, Gian Piero. "L'Espansione e la vita di Roma antica sulla spiaggia ostiense." *Capitolium* 12 (1937): 332–37.

Cameron, Alan. *Circus Factions.* Oxford, 1976.

Canfora, Luciano. "Classicismo e fascismo." *Quaderni de Storia* 3 (1976): 15–48.

———. *Ideologie del classicismo.* Turin, 1980.

Carabba, Claudio, *Il fascismo a fumetti,* Rimini, 1973.

Casson, Lionel. *Ancient Trade and Society.* Detroit, 1984.

Castagnoli, Ferdinando. *Orthogonal Town Planning in Antiquity.* Cambridge (Mass.), 1971.

Cecchelli, Carlo. "L'Ara della Pace sul Campidoglio." *Capitolium* 1 (1925): 65–71.

———. "Itinerario imperiale." *Capitolium* 13 (1938): 167–96.

Ceccherini, Ricardo V. "Dallo studium urbis alla città degli studi." *Capitolium* 9 (1933): 581–607.

Cecil, Robert. *The Myth of the Master Race: Alfred Rosenberg and Nazi Ideology.* London, 1972.

Cederna, Antonio. *Mussolini urbanista: Lo sventramento di Roma negli anni del consenso.* Rome and Bari, 1981.

Cenciarini, Francesco. "Per le nuove terme." *Capitolium* 1 (1925): 89–92.

Chevallier, Raymond. "Cité et territoire, solutions romains aux problèmes de l'organisation de l'espace." In *Aufstieg und Niedergang der römischen Welt,* 2.1. Berlin, 1974, 649–788.

Christ, Karl. *Römische Geschichte und deutsche Geschichtswissenschaft.* Munich, 1982.

Cianetti, Marina M. "L'uso dei materiali costruttivi nella realizzazione delle opere per L'E42." In Maurizio Calvesi, Enrico Guidoni, and Simonetta Lux, eds. *Utopia e scenario del regime,* Venice, 1987, II, 168–75.

Civico, Vincenzo. "La Casa Littoria." *Capitolium* 13 (1938): 15–17.

Clavel-Lévêque, Monique. *L'empire en jeux: Espace symbolique et pratique sociale dans le monde romain.* Paris, 1984.

Clavel-Lévêque, Monique and Pierre. *Villes et structures urbaines dans l'Occident Romain.* Paris, 1984.

Coarelli, Filippo. *Roma sepolta.* Rome, 1984.

Colini, Antonio M. "Il Mausoleo di Augusto." *Capitolium* 4 (1928): 11–22.

———. *Il fascio littorio ricercato negli antichi monumenti.* Rome, 1933.

———. "Lo Stadio di Domiziano." *Capitolium* 16 (1941): 209–23.

———. *Stadium Domitiani.* Rome, 1943.

Colonna, Giovanni B. "Mentre l'obelisco dedicato al Duce viaggia verso Roma." *Capitolium* 5 (1929): 270–77.

Colonna, Piero. (Preface) *Bozzetti di addobbo dell' Urbe per la visita del Führer.* Rome, 1938.

Cozzo, Giuseppe. *The Colosseum: The Flavian Amphitheatre.* Rome, 1971.

Curtius, Ludwig. "Mussolini e la Roma antica," *Nuova Antologia* 16 (April 1934): 3–16. (= *Mussolini und das antike Rom,* Cologne, 1943).

Dal Co, Francesco, and Sergio Polano. "Interview with Albert Speer, October 1977." *Oppositions* 12 (1978): 39–53.

Dal Co, Francesco. "The Stones of the Void." *Oppositions* 26 (1984): 99–116.

Danesi, Silvia, and Luciano Patetta, eds., *Il razionalismo e l'architettura in Italia durante il Fascismo*. Venice, 1976.

Darré, Walter. *Das Bauerntum als Lebensquell der nordischen Rasse*. Munich, 1938.

Davey, Peter. "Authority and Freedom." *Architectural Review* 168 (1980): 74–77.

Davies, Roy William. "The Daily Life of the Roman Soldier." In *Aufstieg und Niedergang der römischen Welt*, 2.1. Berlin, 1974, 299–338.

De Seta, Cesare, ed. *Giuseppe Pagano, Architettura e città durante il Fascismo*. Bari, 1976.

Del Debbio, Enrico. "Per l'incremento del' educazione fisica nell' Urbe." *Capitolium* 6 (1930): 389–92.

Delius, H. "Vitruvius und der deutsche Klassizismus: C. F. Schinkel and F. Weinbrenner." *Architectura* 1 (1933): 56–62.

Demandt, Alexander. "Politische Aspekte im Alexanderbild der Neuzeit." *Archiv für Kulturgeschichte* 54 (1972): 325–63.

Deubner, Otfried. "Pergamon und Rom." *Marburger Jahrbuch für Kunstwissenschaft* 15 (1949): 95ff.

Die Strassen Adolf Hitlers in der Kunst, Ausstellung Breslau Dez. 1936–Jan. 1937. Breslau, 1937.

Domarus, Max. *Hitler. Reden und Proklamationen 1932–1945*, 4 vols. Würzburg, 1962/63.

Drerup, Heinrich. *Zum Ausstattungsluxus in der römischen Architektur*. Münster, 1957.

———. "Architektur als Symbol. Zur zeitgenössischen Bewertung der römischen Architektur." *Gymnasium* 73 (1966): 181–200.

Dressler, Enno. "Die Kongresshalle auf dem ehemaligen Reichsparteitagsgelände in Nürnberg." Magisterarbeit, Würzburg, 1988.

Dülffer, Jost; Jochen Thies; and Josef Henke. *Hitlers Städte: Baupolitik im Dritten Reich*. Cologne, 1978.

Eberhardt, Walter, "Die Antike und wir," *Nationalsozialistische Monatshefte* 6 (1935): 115–127.

Elderfield, John. "Total and Totalitarian Art." *Studio International*, April 1970, 153f.

Fears, J. Rufus. "The Theology of Victory at Rome." In *Aufstieg und Niedergang der römischen Welt*, 2.17.2. Berlin, 1981, 736–826.

Fedele, P. "Risonanze storiche degli Accordi del Laterano." *Capitolium* 5 (1929): 58–62.

Fehl, Gerhard. "Die moderne unterm Hakenkreuz." In H. Frank, ed., *Faschistische Architekturen*. Hamburg, 1985, 88–122.

Fest, Joachim C. *Hitler*, London, 1974.

———. *Cäsar Pinnau Architect*. Hamburg, 1982.

Fidenzoni, F. "La liberazione del Teatro Marcello." *Capitolium* 2 (1926): 594–600.

Finley, Moses I. *The Ancient Economy*. London, 1985.

Florio, Giovanni. "La mostra dell' abitazione dell' E42." *Capitolium* 14 (1939): 371–96.

Forster, Kurt, and Diane Y. Ghirardo. "I modelli delle città di nuova fondazione in epoca fascista." *Annali Storia d'Italia*, ed. C. de Seta. Turin, 1980.

Frédérix, Pierre. "Hitler manieur des foules." *Revue des Deux Mondes* 20 (1934): 53–70.

Fried, Robert C. *Planning the Eternal City*. New Haven, 1973.

Fütterer, Hilmar. "Problem der Vergangenheitsbewältigung: Die Kongresshalle auf dem Reichsparteitagsgelände in Nürnberg." Magisterarbeit, Erlangen, 1989.

Gagé, Jean. "La théologie de la Victoire impériale." *Revue Historique* 17 (1933): 1–34.

Gamm, Hans Jochen. *Der braune Kult. Das Dritten Reich und seine Ersatzreligion*. Hamburg, 1962.

Garcia y Bellido, Antonio. *Urbanistica de las grandes ciudades del mundo antiguo*. Madrid, 1985.

Gatti, Guido. "Il Mausoleo di Augusto." *Capitolium* 10 (1934): 457–64.

———. "Nuove osservazioni sul Mausoleo di Augusto." *L'Urbe* 3 (1938): 1–17.

Ghirardo, Diane Y. "Italian Architects and Fascist Politics: An Evaluation of the Rationalist's Role in Regime Building." *Journal of the Society of Architectural Historians* 39 (1980): 109–27.

———. "Politics of a Masterpiece: The *Vicenda* of the Decoration of the Façade of the Casa

del Fascio, Como, 1936–1939." *Art Bulletin* 62 (1980): 465–78.

Giesler, Hermann. *Ein anderer Hitler: Bericht seines Architekten Hermann Giesler. Erlebnisse, Gespräche, Reflexionen.* Leoni, 1982.

Giglioli, Giulio Quirino. "Fontana marmorea al Foro Mussolini in Roma." *Architettura* 14 (1935): 129–35.

———. "Relazione della prima campagna di scavo nel Mausoleo d'Augusto." *Bullettino Commissione* 54 (1926): 191–234.

———. "Roma e Virgilio." *Capitolium* 6 (1930): 483–92.

———. "La Mostra Augustea della Romanità." *Palladio* 1 (1937): 203.

———. "Il trofeo di Augusto alla Turbia." *Palladio* 4 (1940): 147–54.

Gillet, Louis. "Hitler à Rome. Choses vues." *Revue des Deux Mondes* 45 (1938): 669–83.

Giovannetti, Eugenio. "Dioniso contro Cristo." *Capitolium* 12 (1937): 225–30.

Giovanni, B. "I concerti romani e l'Augusteo." *Capitolium* 10 (1934): 361–84.

Giovannoni, Gustavo. "Lo stabilimento balneare 'Roma' alla marina di Ostia." *Architettura e Arti Decorative* 6 (1926/27): 495–510.

———. "Pel il parco della Vittoria a Monte Mario." *Capitolium* 1 (1925): 76–81.

Gosebruch, Martin, and L. Dittman, eds. *Argo-Festschrift für K. Badt.* Cologne, 1970.

Graefe, Rainer. *Vela erunt. Die Zeltdächer der römischen Theater und ähnlicher Anlagen,* 2 vols. Mainz, 1979.

Grant, Michael. *Erotic Art in Pompeii.* London, 1975.

Gregorovius, Ferdinand. *Geschichte der Stadt Rom im Mittelalter,* vol. 1. Stuttgart, 1922.

Grimal, Pierre. *Les jardins romains.* Paris 1983.

Guattani, Giuseppe Antonio. *Roma descritta ed illustrata.* Rome, 1805.

Gustavo, B. C. "Il Pantheon." *Capitolium* 14 (1939): 240–49.

Hamsher, William. *Albert Speer. Victim of Nuremberg.* London, 1970

Hannestad, Niels. *Roman Art and Imperial Policy.* Aarhus 1986.

Hansch, Wolfgang, *Die Semperoper: Geschichte und Wiederaufbau der Dresdener Staatsoper,* Stuttgart, 1986.

Hansen, Esther V. *The Attalids of Pergamon.* Munich, 1982.

Hansen, Heinrich, ed. *Der Schlüssel zum Frieden, Führertage in Italien,* Berlin, 1938.

Harris, William V. *War and Imperialism in Republican Rome.* Oxford, 1979.

Heinz, Werner. *Römische Thermen: Badewesen und Badeluxus im römischen Reich.* Munich, 1983.

Hellack, Georg. "Architektur und bildende Kunst als Mittel nationalsozialistischer Propaganda." *Publizistik* 5 (1960): 77–95.

Herrmann, Wolfgang. *Gottfried Semper: In Search of Architecture.* Cambridge (Mass.), 1984.

Hinz, Berthold. *Art in the Third Reich.* Oxford, 1980.

Hirsch, Martin; Diemut Mayer; and Jurgen Meinck, eds. *Recht, Verwaltung und Justiz im Nationalsozialismus.* Cologne, 1984.

Hitler in Italia/Hitler in Italien. Maggio XVI. A cura del Ministero della Cultura Popolare. Direzione della Propaganda. Rome, 1938.

Hitler, Adolf. *Mein Kampf.* Munich, 1933.

———. *Table Talk,* trans. Norman Cameron and R. H. Stevens. London, 1973.

Hochmann, Elaine S. Letter to the Editor. *Journal of the Society of Architectural Historians* 33 (1974): 272.

Hoeber, Fritz. *Peter Behrens.* Munich, 1913.

Hoffman, Herbert. "Die Neue Reichskanzlei in Berlin." *Moderne Bauformen* 38 (1938): 521–32.

Hoffmann, Heinrich. *Hitler in Italien.* Munich, 1938.

Homze, Edward L. *Foreign Labor in Nazi Germany.* New Jersey, 1967.

Hönle, Augusta, and Anton Henze. *Römische Amphitheater und Stadien. Gladiatorenkämpfe und Circusspiele.* Feldmeilen, 1981.

Huetter, Luigi. "Gli ingressi trionfali di Roma." *Capitolium* 13 (1938): 235–45.

Humphrey, John H. *Roman Circuses: Arenas for Chariot Racing.* London, 1986.

Insolera, Italo and Francesco Perego. *Archeologia e città. Storia moderna dei fori di Roma.* Rome and Bari, 1983.

Institut für den wissenschaftlichen Film. Göttingen Filmdokumente zur Zeitgeschichte. G17/1959. "Das Wort aus Stein." Göttingen, 1965.

Isler, Hans Peter. "Die Residenz der römischen Kaiser auf dem Palatin." *Antike Welt*, 9 (1978): 2–16.

Jaczynowska, Maria. "Le culte de l'Hercule romain au temps du Haut Empire." In *Aufstieg und Niedergang der römischen Welt*, 2.17.2. Berlin, 1981, 631–61.

Jung, Franz. "Gebaute Bilder." *Antike Kunst* 27 (1984): 71–122.

Kawerau, Gustav, and Theodor Wiegand. *Die Paläste der Hochburg*. Berlin, 1930.

Kolendo, Jerzy. "Deux amphithéâtres dans une seule ville." *Archeologia* 30 (1979): 54f.

Kostof, Spiro. "The Emperor and the Duce: The Planning of Piazzale Augusto Imperatore at Rome." In Henry A. Million and Linda Nochlin, eds. *Art and Architecture in the Service of Politics*. Cambridge (Mass.), 1978.

König, Ewald, ed. *Arno Breker*. Paris, 1943.

Köthe, K. "Die Trier Baslika." *Trierer Zeitschrift* 12 (1937): 151–79.

Kraft, Konrad. "Der Sinn des Mausoleums des Augustus." *Historia* 16 (1967): 189–206.

Krencker, Daniel M. *Vom Kolossalen in der Baukunst*, 1926.

Krencker, Daniel M., and E. Kruger. *Die Trierer Kaiserthermen*, Augsburg, 1929.

Krier, Leon, ed. *Albert Speer: Architecture 1932–1942*. Brussels, 1985.

Kroll, Bruno. "Die neue deutsche Gobelin." *Kunst im Deutschen (Dritten) Reich* 2 (1938): 372ff.

Kuby, Erich. *Il tradimento tedesco*. Milan, 1983.

Kuenzl, Ernst. *Der römische Triumph: Siegesfeiern im antiken Rom*, Munich, 1988.

Kunst, Hans-Jochen. "Architektur und Macht Überlegungen zur NS-Architektur." *Marburg. Philipps-Universität. Mitteilungen, Kommentare, Berichte* 3 (1971): 51f.

Kuptsch, Julius. *Nationalsozialismus und positives Christentum*. Weimar, 1937.

Ladd, Brian K. "Public Baths and Civic Improvement in Nineteenth-Century German Cities." *Journal of Urban History* 14 (1988): 372–93.

L'Orange, Hans Peter. *Studies on the Iconography of Cosmic Kingship in the Ancient World*. Oslo, 1953.

La "Sapienza" nella città universitaria, 1935/1985. Rome, 1985.

Larsson, Lars Olof. *Albert Speer: Le plan de Berlin, 1937–1943*. Brussels, 1983.

Lärmer, Karl. *Autobahnbau in Deutschland 1933–1945*. Berlin (DDR), 1975.

Lees, Andrew. *Cities Perceived: Urban Society in European and American Thought 1820–1940*. Manchester, 1985.

Lehmann-Haupt, Hellmut. *Art under a Dictatorship*. New York, 1954.

Lenzi, Luigi. "Architettura del III Reich." *Architettura* 18 (1939): 472–80.

Losemann, Volker. *Nationalsozialismus und Antike: Studien zur Entwicklung des Faches Alte Geschichte*. Hamburg, 1977.

Lotz, Wolfgang. "Das Deutsche Stadion für Nürnberg." *Moderne Bauformen* 36 (1937): 491–93.

Lugli, Giuseppe. "In attesa dello scavo dell' Ara Pacis Augustae." *Capitolium* 11 (1935): 365–83.

———. *Roma antica: Il centro monumentale*. Rome, 1946.

———. *The Flavian Amphitheatre*. Rome, 1960.

MacDonald, William L. *The Architecture of the Roman Empire*, vol. 1. New Haven, 1982; vol. 2, *An Urban Appraisal*. New Haven, 1986.

———. "Empire Imagery in Augustan Architecture." *Archaeologica Transatlantica* 4 (1985): 137–48.

MacDougall, Elizabeth B., and Wilhelmina Jashemski, eds. *Ancient Roman Gardens*. Dumbarton Oaks, 1981.

Mack Smith, Denis. *Mussolini*. London, 1981.

Magi-Spinetti, Carlo. "Il Foro Mussolini." *Capitolium* 10 (1934): 85–101.

———. "Nuove opere al Foro Mussolini." *Capitolium* 13 (1938): 197–205.

———. "Tradizione e autarchia nel materiale edilizio." *Capitolium* 15 (1940): 575–78.

Manderscheid, Hubertus. *Die Skulpturenausstattung der kaiserzeitlichen Thermenanlagen*. Berlin, 1981.

Mansuelli, Guido Achille. *Architettura e città*, Bologna, 1970.

Marchetti-Longhi, Giuseppe. "La Via dell' Impero nel suo sviluppo storico-topografico e nel

suo significato." *Capitolium* 10 (1934): 53–84.

Marconi, Plinio. "W. March, Il Foro sportivo germanico a Berlino." *Architettura* 15 (1936): 465–86.

Mariani, Riccardo. *Fascismo e "città nuove."* Milan, 1976.

Marsalek, Hans. *Mauthausen.* Milan, 1977.

Marshall, Anthony J. "Symbols and Showmanship in Roman Public Life, The Fasces." *Phoenix* 38 (1984): 120–41.

Martin, Roland. *L'urbanisme dans la Grèce antique.* Paris, 1974.

———. "Agora et Forum." *Ecole Français à Rome, Mélanges, antiquité* 84 (1973): 903–33.

Marvin, Miranda. "Freestanding Sculptures from the Baths of Caracalla." *American Journal of Archaeology* 87 (1983): 347–84.

Maser, Werner. *Hitler's Letters and Notes.* London, 1974.

———. *Mein Kampf: Der Fahrplan eines Weltoberers.* Esslingen, 1974.

Mastrigli, Federico. "Roma Pavesata." *Capitolium* 13 (1938): 219–34.

Mazois, François. *Les ruines de Pompéi,* 4 vols. Paris, 1824–38.

Middleton, Robin, ed. *The Beaux-Arts and Nineteenth-Century French Architecture.* London, 1982.

Millar, Fergus. "Condemnation to Hard Labour in the Roman Empire." *Papers of the British School at Rome* 52 (1984): 124–47.

Miller Lane, Barbara. *Architechture and Politics in Germany, 1918–1945.* Cambridge (Mass.), 1968.

———. Review of Speer's *Inside the Third Reich. Journal of the Society of Architectural Historians* 32 (1973): 341–45.

———. "Architects in Power: Politics and Ideology in the Work of Ernst May and Albert Speer." *Journal of Interdisciplinary History* 17 (1986): 282–310.

Millon, Henry A. "The Role of History of Architecture in Fascist Italy." *Journal of the Society of Architectural Historians* 24 (1965): 53–59.

Miltner, F. "Sparta, Vorbild und Mahnung." *Die Antike* 19 (1943): 1–29.

Montani, C. "Il Pantheon e i suoi recenti restauri." *Capitolium* 8 (1932): 417–26.

Moretti, Giuseppe. "Lo scavo e la ricostruzione dell' Ara Pacis Augustae." *Capitolium* 13 (1938): 479–90.

Morford, Mark P. O. "The Distortion of the Domus Aurea Tradition." *Eranos* 66 (1968): 159–62.

Mosse, George L. *Le origini culturali del Terzo Reich.* Milan, 1968.

Mosse, George L. and S. G. Lampert. "Weimar Intellectuals and the Rise of National Socialism." In J. E. Dimsdale, ed., *Survivors, Victims and Perpetrators.* Washington, D.C., 1980, 85.

Much, Rudolf. *Die Germania des Tacitus.* Heidelberg, 1937.

Mule, Francesco Paolo. "Per l'allacciamento dei fori imperiali col Colosseo." *Capitolium* 6 (1930): 378–88.

Muñoz, Antonio. "Le Corbusier parla di Roma e di urbanistica." *L'Urbe* 1.2 (1936): 28–38.

———. "Marcello Piacentini parla di Roma e di architettura." *L'Urbe* 2.5 (1937): 19–28.

———. "Sistemazione del Mausoleo di Augusto." *Capitolium* 13 (1938): 491–508.

Mussolini, Benito. *Scritti e discorsi dal 1925 al 1926.* Milan, 1934.

Müller-Mehlis, Reinhard. *Die Kunst im Dritten Reich.* Munich, 1976.

Neue Gesellschaft für Bildende Kunst (NGBK). Nishen. *Inszenierung der Macht: Ästhetische Faszination im Faschismus.* Berlin, 1987.

Niccolini, Fausto, and F. Niccolini. *Le case ed i monumenti di Pompei disegnati e descritti,* vols. 1–4. Naples, 1854–96.

Norden, Eric. "Albert Speer: Interview," *Playboy,* June 1971, 69–96; 168f., 202f.

Pagano, Giuseppe. "Potenza del marmo." *Casabella* 110 (1937): 6–10.

———. "L'America dei grattacieli." *Domus* 122 (1938): 2.

———. "Partenone e partenoidi." *Domus* 168 (1941): 26–31.

———. "Potremo salvarci dalle false tradizioni e dalle ossessioni monumentali?" *Casabella* 157 (1941): 2–7.

Pallottino, Massimo. "Profili di Augusto." *Roma* 18 (1940): 168–78.

Pelletier, André. *L'urbanisme romain sous l'empire.* Paris, 1982.

Perouse de Montclos, J.-M. *Etienne Louis Boullée,*

1728–1799: Theoretician of Revolutionary Architecture. New York, 1974.

Petersen, Jens. *Hitler-Mussolini: Die Entstehung der Achse Berlin-Rom 1933–1936.* Tübingen, 1973.

Petsch, Joachim. *Baukunst und Stadtplanung im Dritten Reich.* Munich, 1976.

Pfister, Friedrich. "Der politische Humanismus." *Bayerische Blätter für das Gymnasialschulwesen.* 70 (1934): 65–77.

Pfister, Rudolf. "Hitlers Baukunst." *Baumeister* 43 (1946): 25–31.

Piacentini, Marcello. "La grande Roma." *Capitolium* 1 (1925): 413–20.

———. "Di alcune particolarità del monumento alla Victoria in Bolzano." *Architettura e Arti Decorative* 8 (1928): 255–64.

———. "Il progetto definitivo della Casa Littoria a Roma." *Architettura* 16 (1937): 699–706.

———. "Aprilia." *Architettura* 17 (1938): 393–416.

———. "Premesse e caratteri dell'architettura attuale tedesca." *Architettura* 18 (1939): 467–71.

———. "Classicità dell' E42," *Civiltà* 1.1 (1940): 23–32.

Picard, Charles Gilbert. *Les trophées romains.* Paris, 1957.

Piccinato, Luigi. "Il momento urbanistico alla Prima Mostra Nazionale dei Piani Regolatori." *Architettura e Arti Decorative* 9 (1929/30): 195–235.

Picker, Henry. *Hitlers Tischgespräche im Führerhauptquartier.* Stuttgart, 1976.

Posener, Julius. *From Schinkel to the Bauhaus.* London, 1972.

Price, George Ward. *Year of Reckoning.* London, 1939, 182–200 ("Hitler in Italy").

Probst, Volker G. *Der Bildhauer Arno Breker.* Bonn, 1978.

Rasp, Hans-Peter. *Ein Stadt für tausend Jahre: München-Bauten und Projekte für die Hauptstadt der Bewegung.* Munich, 1981.

Rawson, Elizabeth. *The Spartan Tradition in European Thought.* Oxford, 1969.

———. "Discrimina Ordinum: The Lex Julia Theatralis." *Papers of the British School at Rome* 55 (1987): 83–114.

Reichhardt, Hans J., and Wolfgang Schäche. *Von Berlin nach Germania: Über die Zerstörungen der Reichshauptstadt durch Albert Speers Neugestaltungsplanungen.* Berlin, 1985.

Reif, Adelbert, ed. *Albert Speer: Kontroversen um ein deutsches Phänomen.* Munich, 1978.

Renner, Paul. "Die monumentale Inschrift." *Die Kunst im Deutschen Reich* 8 (1944): 62–88.

Rizzo, Giulio Emanuele. "Per la ricostruzione dell' Ara Pacis Augustae." *Capitolium* 2 (1926): 457–73.

Roddaz, Jean-Marcel. *Marcus Agrippa.* Rome, 1984.

Rodenwaldt, Gerhart. "Via dell'Impero in Rom." *Zentralblatt der Bauverwaltung vereinigt mit Zeitschrift für Bauwesen* 23 (1934): 309–12.

———. "Römische Staatsarchitektur." In Helmut Berve, *Das neue Bild der Antike.* Leipzig, 1942, II, 356–75.

———. "Kunst um Augustus." *Die Antike* 13 (1937): 1–40 (= *Kunst um Augustus.* Berlin, 1942).

Roma capitale: Dalla mostra al museo. Dalla mostra archeologica del 1911 al Museo della civiltà romana. Rome, 1983.

Romano, David G. "The Panathenaic Stadium and Theater of Lykourgos." *American Journal of Archaeology* 89 (1985): 441–54.

Rosenau, Helen. *The Ideal City.* London, 1983.

Rosenberg, Alfred. *Der Mythus des 20. Jahrhunderts.* Munich, 1935.

———. "Weltanschauung und Glaubenslehre." *Nationalsozialistische Monatshefte* 9 (1938): 1042–49.

Rousseau, Jean-Jacques. *Confessions,* trans. J. Grant, vol. 1. London, 1931.

Roux, Henri, and Louis Barré. *Herculaneum et Pompéi,* vols. 1–8. Paris, 1840.

Roxan, David, and Ken Waustall. *The Jackdaw of Linz.* London, 1964.

Rykwert, Joseph. *The Idea of a Town: The Anthropology of Urban Form in Rome, Italy, and the Ancient World.* London, 1976.

Sarfatti, Margherita. "Grattacielo." *Architettura* 16 (1937): 333–44.

Saumagne, Charles. "Le plan de Timgad." *Revue Tunisienne* (1933): 35–56.

Schinkel, Karl F. *Collected Architectural Designs.* New York, 1982.

Schmidt, Evamaria. *The Great Altar of Pergamum.* London, 1961.

Schmidt, Matthias. *Albert Speer: The End of a Myth*. London, 1985.

Schoenebeck, H. von. "Die Stadtplanung des römischen Thessalonika." In *VI. Internationaler Kongress für Archäologie. 21–26 Aug. 1939*. Berlin, 1940, 478–82.

Schönberger, Angela. *Die Neue Reichskanzlei von Albert Speer*. Berlin, 1981.

Schuller, Sepp. *Das Rom Mussolinis*. Düsseldorf, 1943.

Schweizer, Bernhard. "Die griechische Kunst und die Gegenwart." *Die Antike* 13 (1937): 91–117.

Scobie, Alex. "Slums, Sanitation and Mortality in the Roman World." *Klio* 68 (1986): 399–433.

Serra, Joselita R., *Paestum and the Doric Revival, 1750–1830*, Florence, 1986.

Sieglin, Wilhelm. *Die blonden Haare der indogermanischen Völker des Altertums*. Munich, 1935.

Smith, Earl Baldwin. *Architectural Symbolism of Imperial Rome and the Middle Ages*. Princeton 1950.

Speer, Albert. "Die Bauten des Führers." In *Adolf Hitler: Bilder aus dem Leben des Führers*, herausgegeben vom Cigaretten Bilderdienst. Hamburg and Barenfeld, 1936, 72–77.

———. "Stein statt Eisen." *Der Vierjahresplan* 1 (1937): 135–38.

———. *Die Neue Reichskanzlei*. Munich, 1940.

———. *Neue deutsche Baukunst*. Berlin, 1941.

———. *Erinnerungen*. Berlin, 1969.

———. *Inside the Third Reich*. New York, 1970.

———. *Spandauer Tagebücher*. Berlin, 1975.

———. *Albert Speer: Architektur-Arbeiten 1933–1942*. Berlin, 1978.

———. *Infiltration: How Heinrich Himmler Schemed to Build an SS Industrial Empire*. New York, 1981.

Strong, Eugènie. "The Augustan Exhibition in Rome and Its Historical Significance." *The 19th Century and After* 124 (1938): 170.

———. "Romanità through the Ages." *Journal of Roman Studies* 29 (1939): 137–66.

Stürzenacker, E. "Die deutsche Baukunst und die Antike." *Baugilde* 20 (1938): 623f.

Syme, Ronald. *The Roman Revolution*. Oxford, 1939.

Tamm, Birgitta. *Auditorium and Palatium*. Stockholm, 1962.

Tamms, Friedrich. "Das Grosse in der Baukunst." *Die Kunst im Dritten Reich* 8 (1944): 47–60.

Tanzer, Helen H. *The Villas of Pliny the Younger*. New York, 1924.

Taylor, Robert R. *The Word in Stone*. Los Angeles, 1974.

Ternite, Wilhelm. *Wandgemälde aus Pompeji und Herculaneum*, vols. 1–11. Berlin, 1839–58.

Teut, Anna. *Architektur im Dritten Reich 1933–1945*. Berlin, 1967.

Thies, Jochen. *Architekt der Weltherrschaft: Die Endziele Hitlers*. Düsseldorf, 1976.

———. "Hitler's European Building Programme." *Journal of Contemporary History* 13 (1978): 413–31.

———. "Nazi Architecture—A Blueprint for World Domination: The Last Aims of Adolf Hitler." In David Welch, ed., *Nazi Propaganda: The Power and the Limitations*. London, 1983, 45–64.

Thomae, Otto. *Die Propaganda-Maschinerie: Bildende Kunst und Öffentlichkeitsarbeit im Dritten Reich*. Berlin, 1978.

Thouvenot, Raymond. "L'urbanisme romain dans le Maroc." *Revista de la Universidad de Madrid* 118 (1979): 333–36.

Travlos, John. *A Pictorial Dictionary of Ancient Athens*. London, 1971.

Troost, Gerdy. *Das Bauen im neuen Reich*. Bayreuth, 1939.

Vacano, Otto-Wilhelm von, ed. *Sparta: Der Lebenskampf einer nordischen Herrenschicht*. Kampten, 1940.

Valle, Cesare. "Programma urbanistico per Addis Abeba." *Architettura* 16 (1937): 755–68.

Verduchi, Patrizia. "Lavori ai rostri del Foro Romano." *Rendiconti della Pontificia Accademia Romana di Archeologia* 55/56 (1982/84): 338.

Versnel, H. S. *Triumphus*. Leiden, 1970.

Verspohl, Franz-Joachim. *Stadionbauten von der Antike bis zur Gegenwart*. Giessen, 1978.

Vietti, Luigi. "Grattacieli." *Architettura* 11 (1932): 189–201.

Villard, Pierre. "Antiquité et Weltanschauung Hitlérienne." *Revue d'histoire de la deuxième guerre mondiale* 22 (1972): 1–18.

Vitruvius. *De architectúra.* 2 vols., trans. F. Granger. London, 1970.

Vogt, Adolf Max. "Orwell's Nineteen-Eighty-four and E. L. Boullée's Drafts of 1784." *Journal of the Society of Architectural Historians* 43 (1984): 60–64.

Vogt, Joseph. "Unsere Stellung zur Antike." *110. Jahresbericht der schlesischen Gesellschaft für vaterländische Cultur, 1937.* Geisteswissenschaftliche Reihe no. 3, 3–15.

Völckers, Otto. "Neues Bauen in Italien." *Wasmuths Monatsheft für Baukunst* 2 (1938): 49–56.

Vondung, Klaus. *Magie und Manipulation: Ideologischer Kult und politische Religion des Nationalsozialismus.* Göttingen, 1971.

Vorschläge über Verwendungsmöglichkeiten der ehemalige Kongresshalle, Hauptamt für Hochbauwesen. Nuremberg, 1955.

Walbank, Frank William. *A Historical Commentary on Polybius,* 1. Oxford, 1984.

Ward-Perkins, John Bryan. "Nero's Golden House." *Antiquity* 30 (1963): 209–19.

——. "From Republic to Empire: Reflexions on the Early Provincial Architecture of the Roman West." *Journal of Roman Studies* 60 (1970): 6–13.

——. *Cities of Ancient Greece and Italy.* London, 1974.

——. *Roman Imperial Architecture.* Harmondsworth, 1981.

Warren, Larissa Bonfante. "Roman Triumphs and Etruscan Kings." *Journal of Roman Studies* 60 (1970): 49–66.

Watkin, David and Tilman Mellinghoff. *German Architecture and the Classical Ideal.* Cambridge (Mass.), 1987.

Watson, George Ronald. *The Roman Soldier.* London, 1969.

Weil, Simone. "Hitler et la politique extérieur de la Rome antique"; "Hitler et la régime intérieur de l'empire romain." In idem, *Ecrits historiques et politiques.* Paris, 1960.

Weinberg, Gerhard Ludwig, ed. *Hitlers Zweites Buch.* Stuttgart, 1961.

Wenk, Silke. "Die Arbeit eines deutschen Archäologen an der Modernisierung des antiken Ideals." In *Ausstellungskatalog. Auf den Spuren der Antike. Theodor Wiegand, ein deutschen Archäolog.* Städtische Museum, Bendorf/Rhein, 1985, 41–56.

Werner, Peter. *Pompeji und die Wanddekoration der Goethezeit.* Munich, 1970.

Wescher, Paul. *Kunstraub unter Napoleon.* Berlin, 1976.

Wiedenhoeft, Robert. Review of R. R. Taylor, *The Word in Stone.* In *Journal of the Society of Architectural Historians* 34 (1975): 157–59.

Windsor, Alan. *Peter Behrens, Architect and Designer, 1868–1940.* London, 1981.

Wolters, Rudolf. *Albert Speer.* Oldenburg, 1943.

Wühr, Hans. "Mosaik der Gegenwart." *Kunst im Dritten Reich* 2 (1938): 214–20.

Zahn, Wilhelm. *Die schönsten Ornamente und merkwürdigsten Gemälde aus Pompeji.* Berlin, 1829–58.

Zanker, Paul. "Das Trajansforum als Monument imperialer Selbstdarstellung." *Archäologischer Anzeiger,* 1970, 491–544.

Zavrel, John B. *Arno Breker: His Art and Life.* New York, 1985.

INDEX